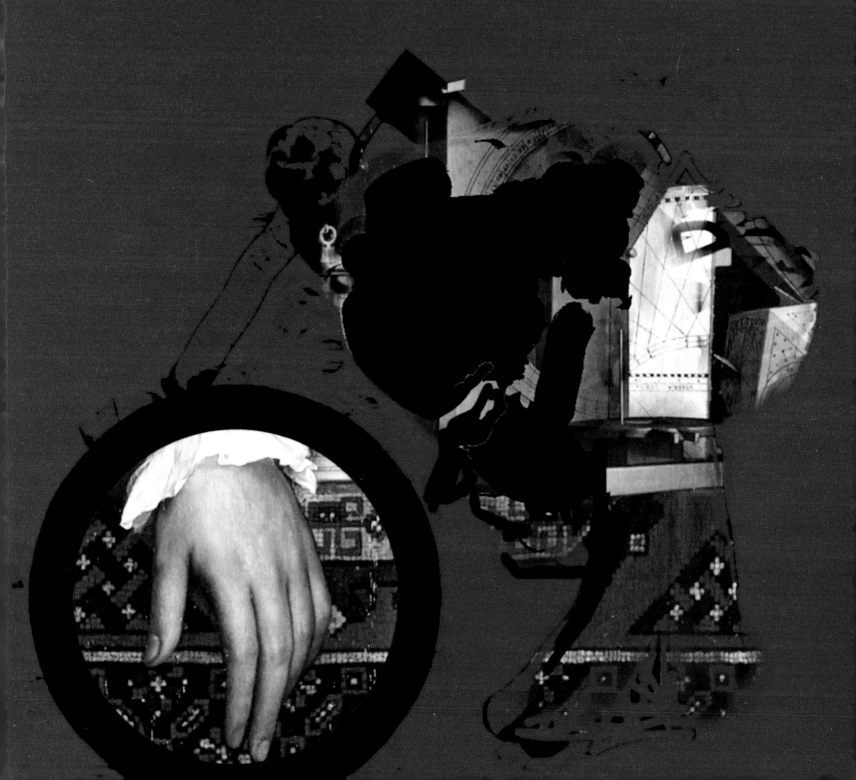

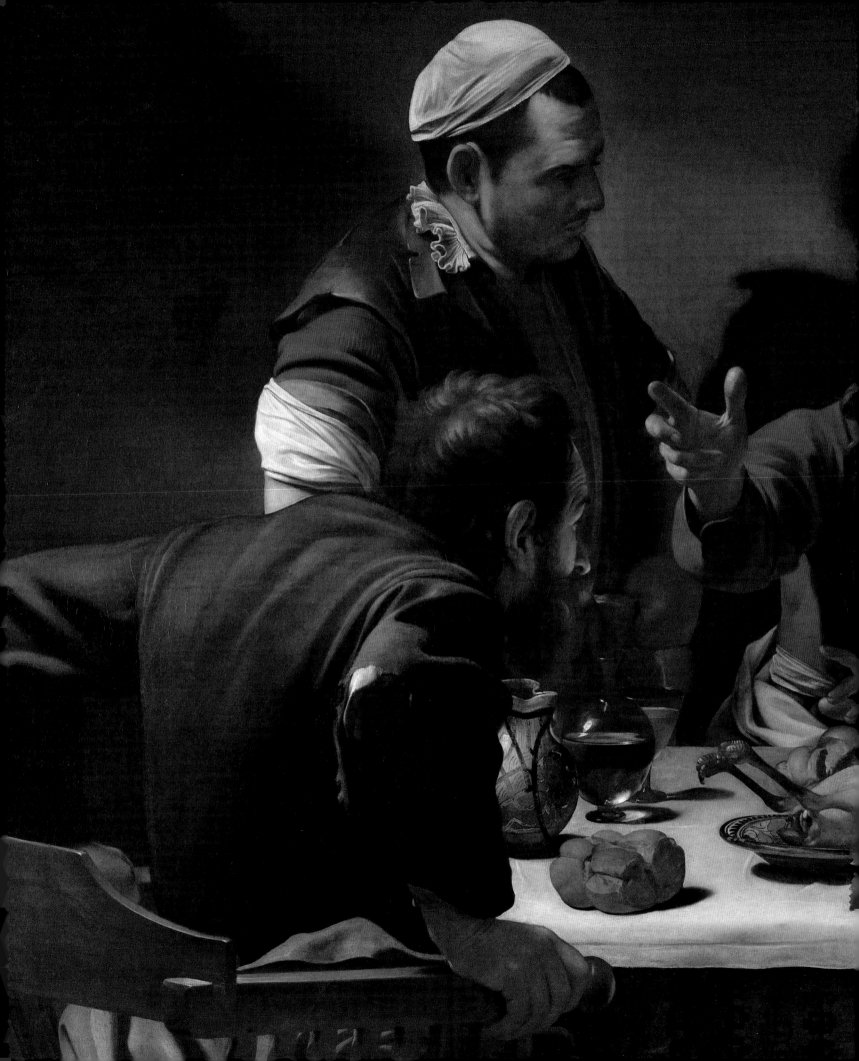

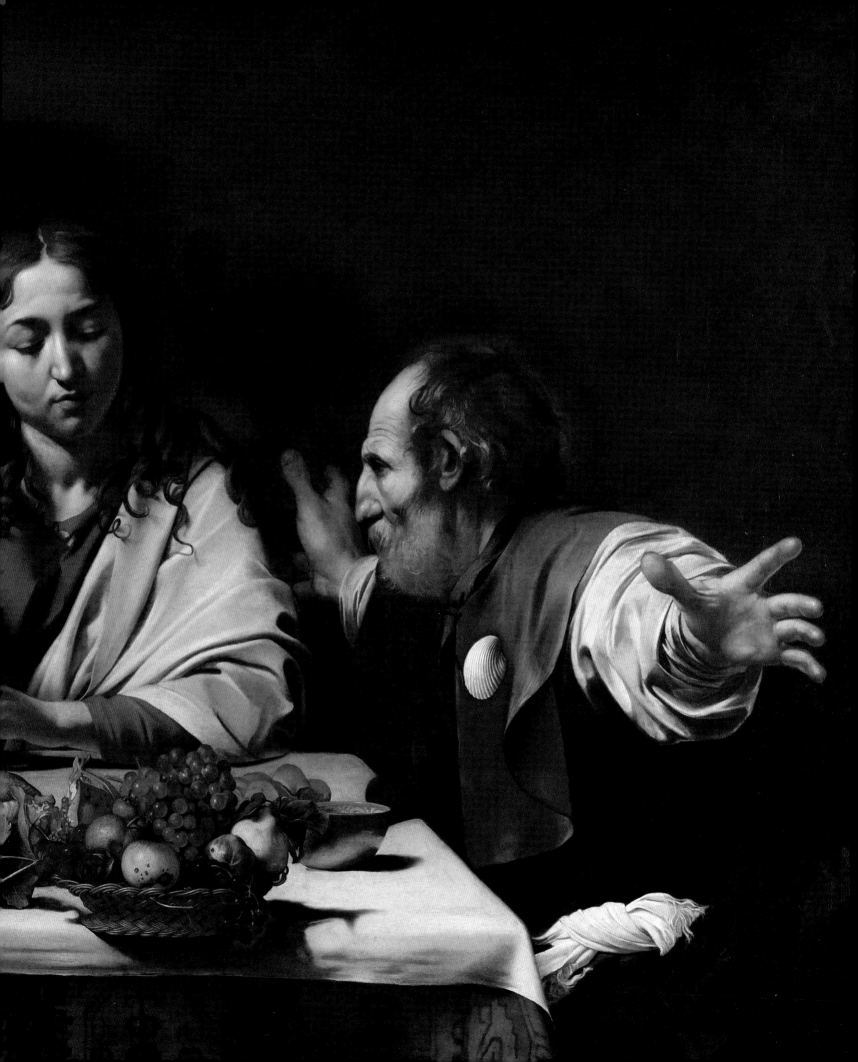

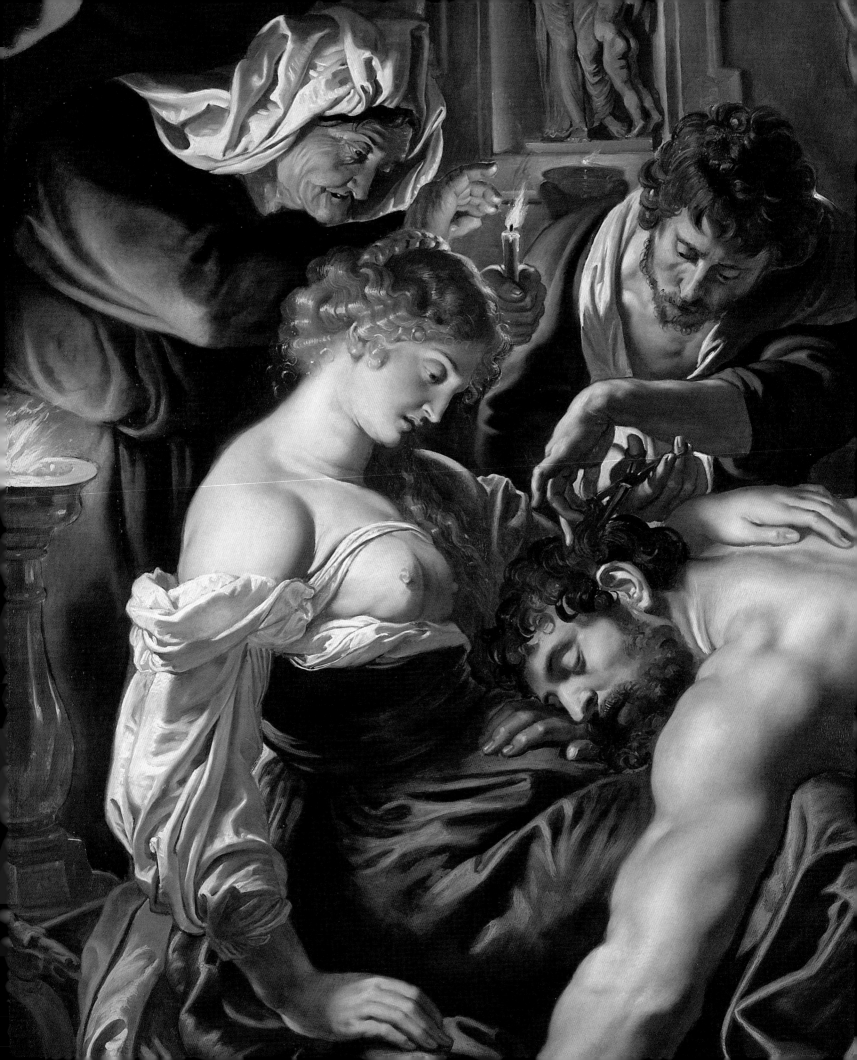

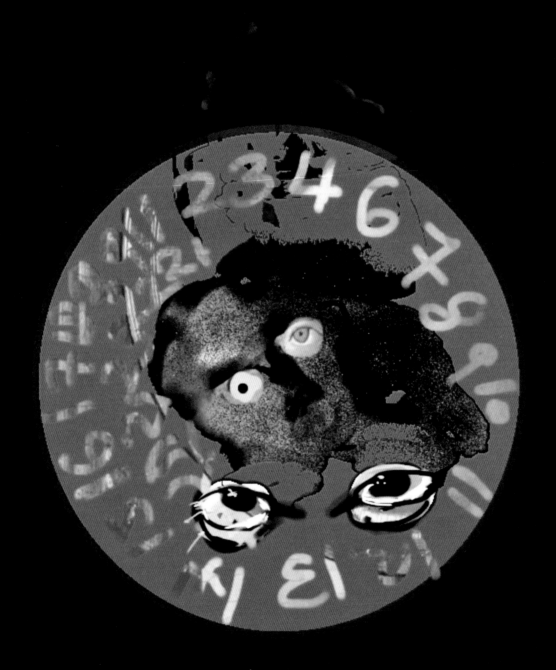

Nalini Malani
My Reality is Different

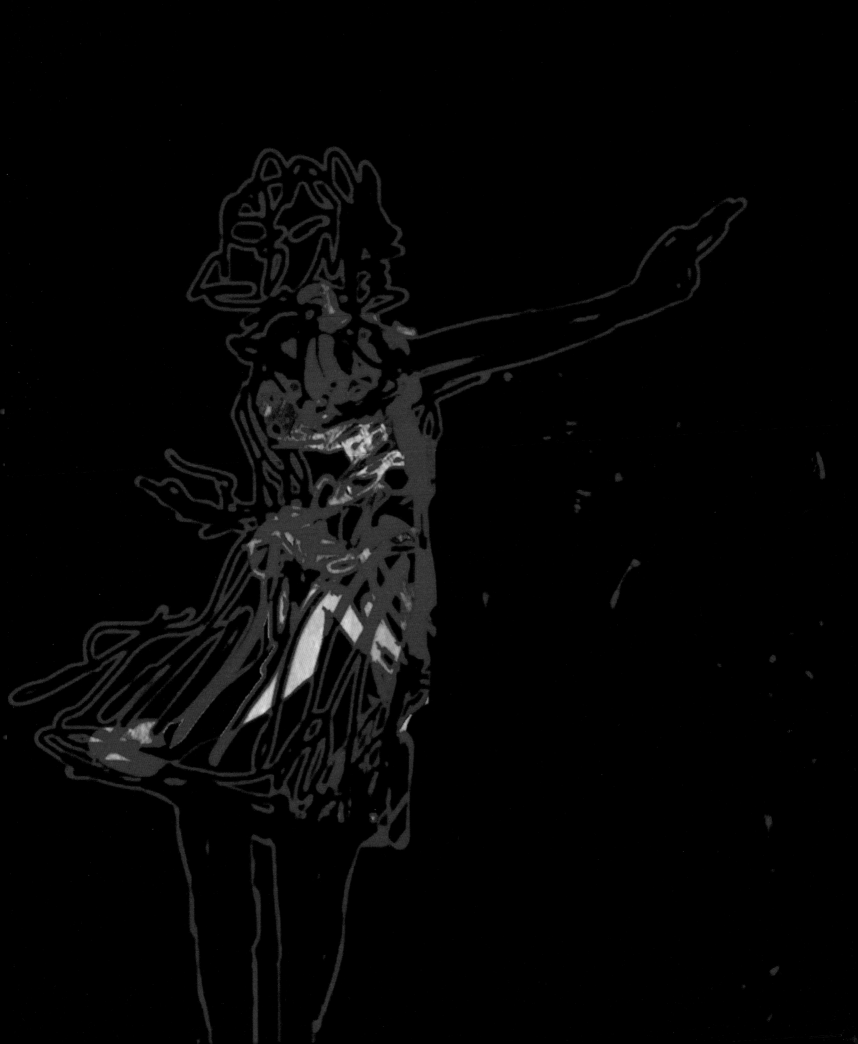

Nalini Malani
My Reality is Different

National Gallery Contemporary Fellowship with Art Fund

Will Cooper and Priyesh Mistry
With contributions by Mieke Bal, Daniel F. Herrmann,
Zehra Jumabhoy and Nalini Malani

National Gallery Global, London
Distributed by Yale University Press

Published to accompany

Nalini Malani: My Reality is Different
National Gallery Contemporary Fellowship
with Art Fund

The Holburne Museum, Bath,
7 October 2022–8 January 2023
The National Gallery, London,
2 March–11 June 2023

The National Gallery's Contemporary
Fellowship is supported by Art Fund, with
an additional contribution from Dasha
Shenkman OBE

The Leading Philanthropic Supporter of the
National Gallery Modern and Contemporary
Programme is

The Contemporary Programme is sponsored by

HISCOX

Contemporary Art Partner
of the National Gallery

The Sunley Room exhibition programme is
supported by the Bernard Sunley Foundation

This exhibition has been made possible by
the provision of insurance through the
Government Indemnity Scheme. The National
Gallery would like to thank HM Government
for providing Government Indemnity and the
Department for Digital, Culture, Media and
Sport and Arts Council England for arranging
the indemnity.

First published in 2022 by
National Gallery Global Limited
Trafalgar Square
London WC2N 5DN
www.shop.nationalgallery.org.uk

ISBN: 978 1 85709 690 3
1051428

British Library Cataloguing-in-Publication Data
A catalogue record is available from the
British Library
Library of Congress Control Number:
2022946536

Publisher: Laura Lappin
Copy-editor: Karen Tengbergen-Moyes
Picture Researcher: Rebecca Thornton
Production: Jane Hyne and Justine Montizon
Designed and typeset in Arnhem Pro by
Willem Morelis
Printed and bound in the Netherlands by
Wilco Art Books

All measurements give height before width.
All works are by Nalini Malani unless stated
otherwise.

Cover: still from *My Reality is Different*, 2022,
animation chamber, 9-channel installation,
sound: 25:15 mins
Images pp. 1, 4–5, 8, 10, 14, 16–23, 36–43, 100–7,
118–25, 140–1, 144: stills from *My Reality is
Different*, 2022
Images pp. 56–85: installation views of
My Reality is Different, 2022

Authors
Mieke Bal is Professor Emeritus of Theory
of Literature and founding director of the
Amsterdam School for Cultural Analysis,
Amsterdam.

Will Cooper is Curator of Modern &
Contemporary Projects at the Holburne
Museum, Bath.

Daniel F. Herrmann is Curator of Modern &
Contemporary Projects at the National
Gallery, London.

Zehra Jumabhoy is a Lecturer in the History
of Art at the University of Bristol. She is an art
historian, curator and writer specialising in
modern and contemporary South Asian art
and its diasporas.

Priyesh Mistry is Associate Curator of
Modern & Contemporary Projects at the
National Gallery, London.

Contents

15 Directors' Foreword

24 Zehra Jumabhoy and Priyesh Mistry
Telling Tales: Narrating Nalini Malani

44 Nalini Malani
My Reality is Different

86 Mieke Bal
Inter-ships with Nalini Malani: The Foreshortening of Time

108 Will Cooper and Daniel F. Herrmann
From Certainty to Doubt: Exploring the Palimpsest in the Work of Nalini Malani

127 Artist's Biography
128 Exhibited Artwork
129 Audio Transcription
132 List of Visual Sources
136 References

Directors' Foreword

As the inaugural recipient of the National Gallery Contemporary Fellowship, Nalini Malani was invited to respond to the collections of the National Gallery, London, and the Holburne Museum, Bath. Weaving together references from diverse cultures and different media, Malani's works interlace myth, history and contemporary politics. Constantly evolving, her artistic practice has always sought to confront oppression and persecution, and to give a voice to marginalised people across the globe.

Taking inspiration from the pictures as well as the histories of our two museums, the artist has created an immersive installation or 'animation chamber', as she calls it, in which her hand-drawn animations overlay details taken from a selection of old master paintings from both the collections.

Malani is a commanding storyteller. It comes as no surprise, then, that she was drawn to artworks which have mythological or religious narratives at their heart. Her animations tease out the stories in her chosen paintings, adding multiple layers and a chorus of fictional characters to create new and challenging narratives. Focusing on works which evoke an imbalance of power to their contemporary audiences, her interventions re-write traditional myths and biblical scenes with a twist that allows for alternative endings.

The collections of museums such as the National Gallery and the Holburne are historically rooted in character, bound up with questions of reception, politically charged subjects and the legacies of past ownership. As public institutions, we must reflect on how these stories are presented and how historically marginalised voices can be heard.

We would like to thank Nalini Malani for her profound engagement with our collections and her creation of such a rich and thought-provoking body of new work. Her partner Johan Pijnappel has been invaluable for his keen eye and dedication to production quality. We are also grateful to the curators, Daniel F. Herrmann and Priyesh Mistry at the National Gallery and Will Cooper at the Holburne Museum, for steering the project and the institutional collaboration to full realisation.

We are grateful to Aarti Lohia and the SP Lohia Foundation as the Leading Philanthropic Supporter of the National Gallery's Modern and Contemporary Programme. We would also like to express our thanks to Art Fund, for their partnership of the National Gallery Contemporary Fellowship, and to Dasha Shenkman OBE for additional support. Furthermore, we are grateful to Hiscox for their ongoing and much valued sponsorship as Contemporary Art Partner of the National Gallery, and the Bernard Sunley Foundation for their generous, continuing support of the Sunley Room exhibition programme.

Gabriele Finaldi
Director, The National Gallery

Chris Stephens
Director, The Holburne Museum

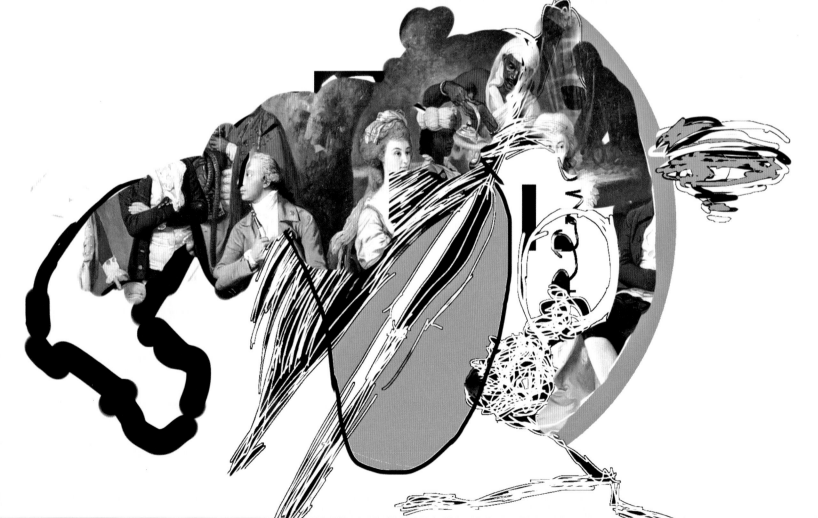

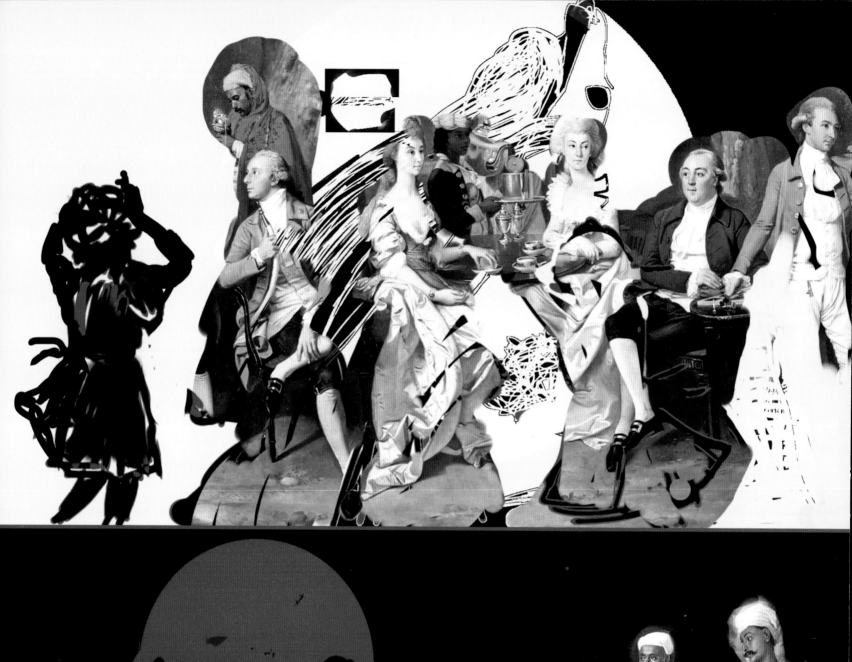
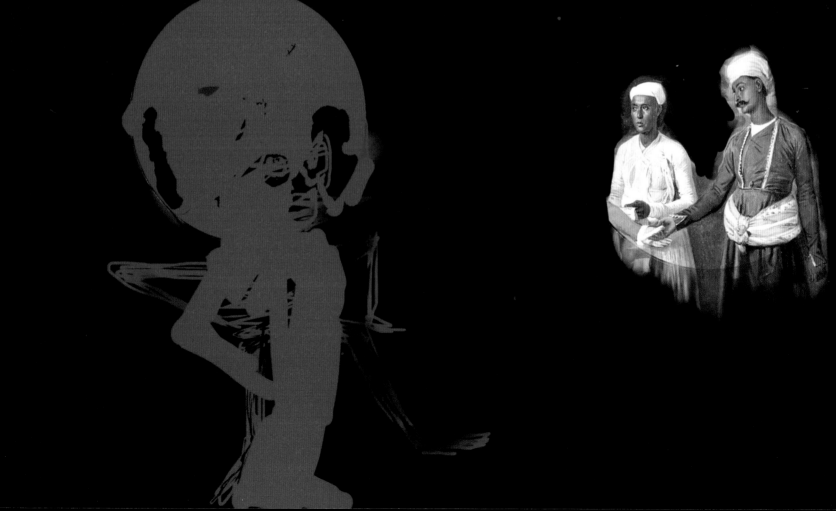

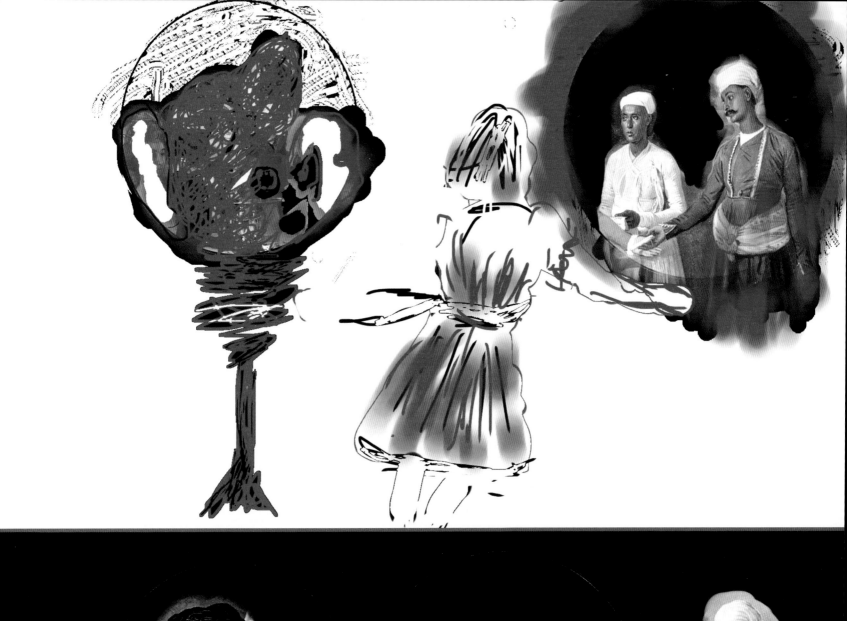
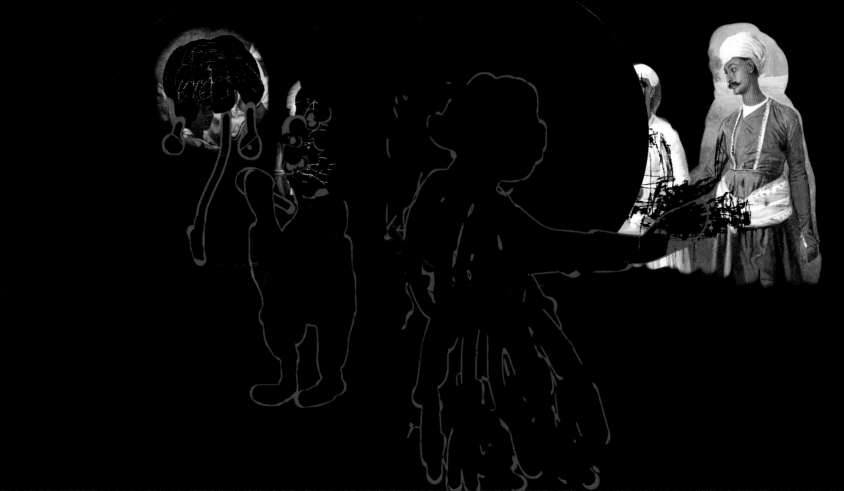

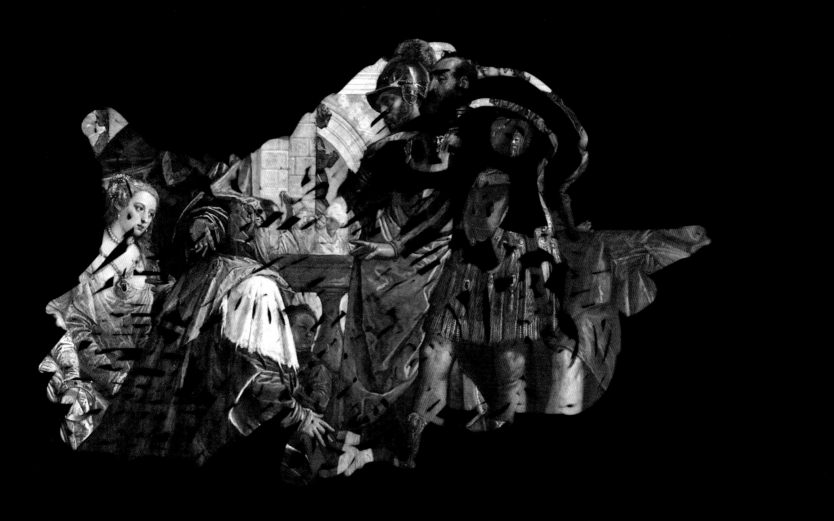
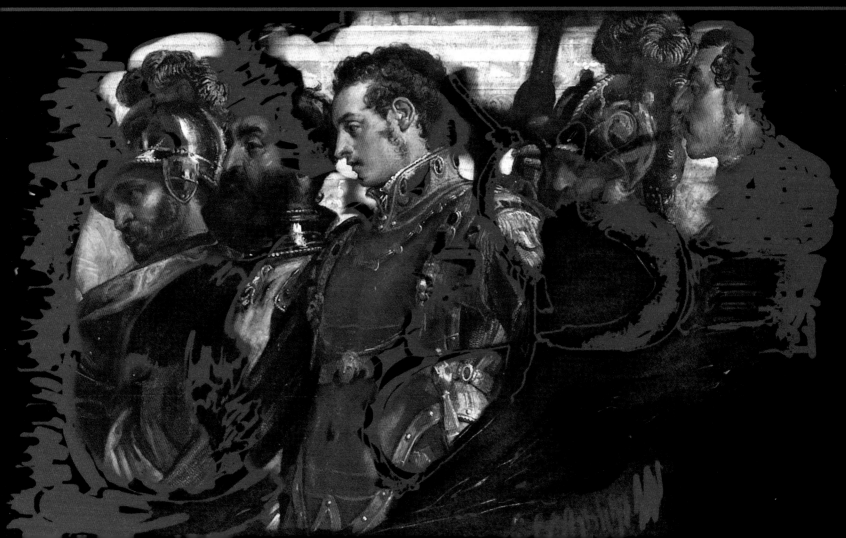

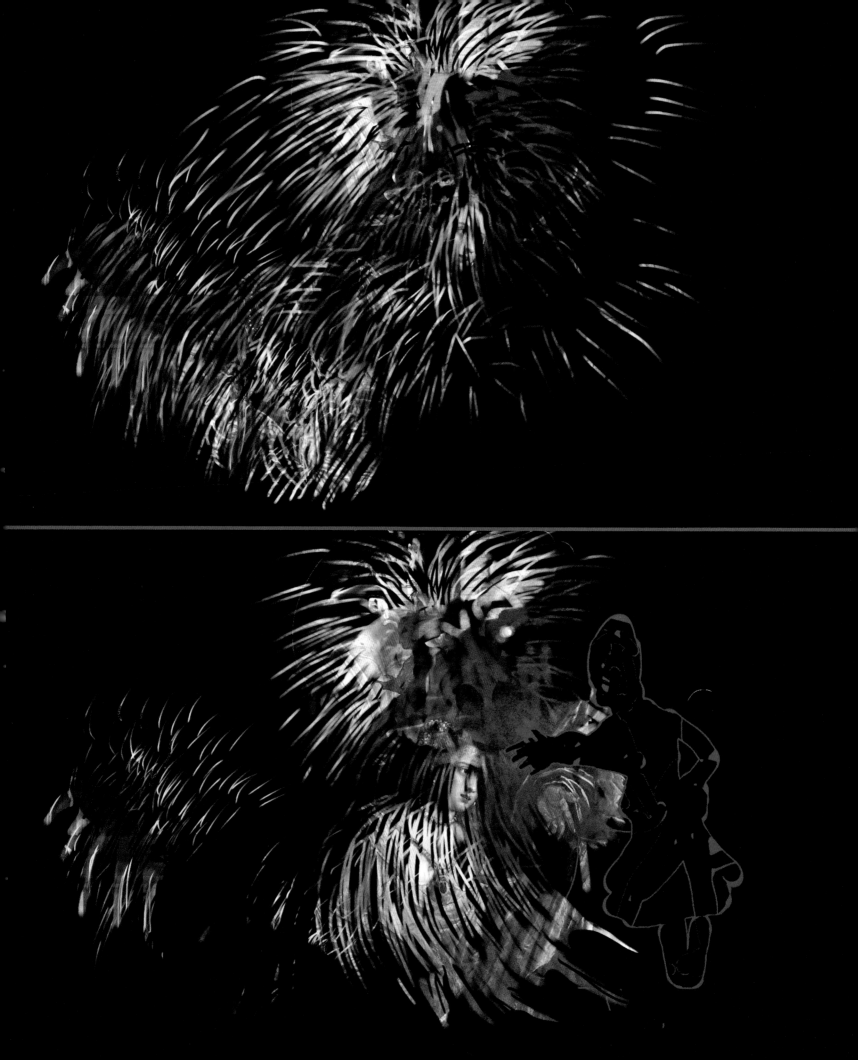

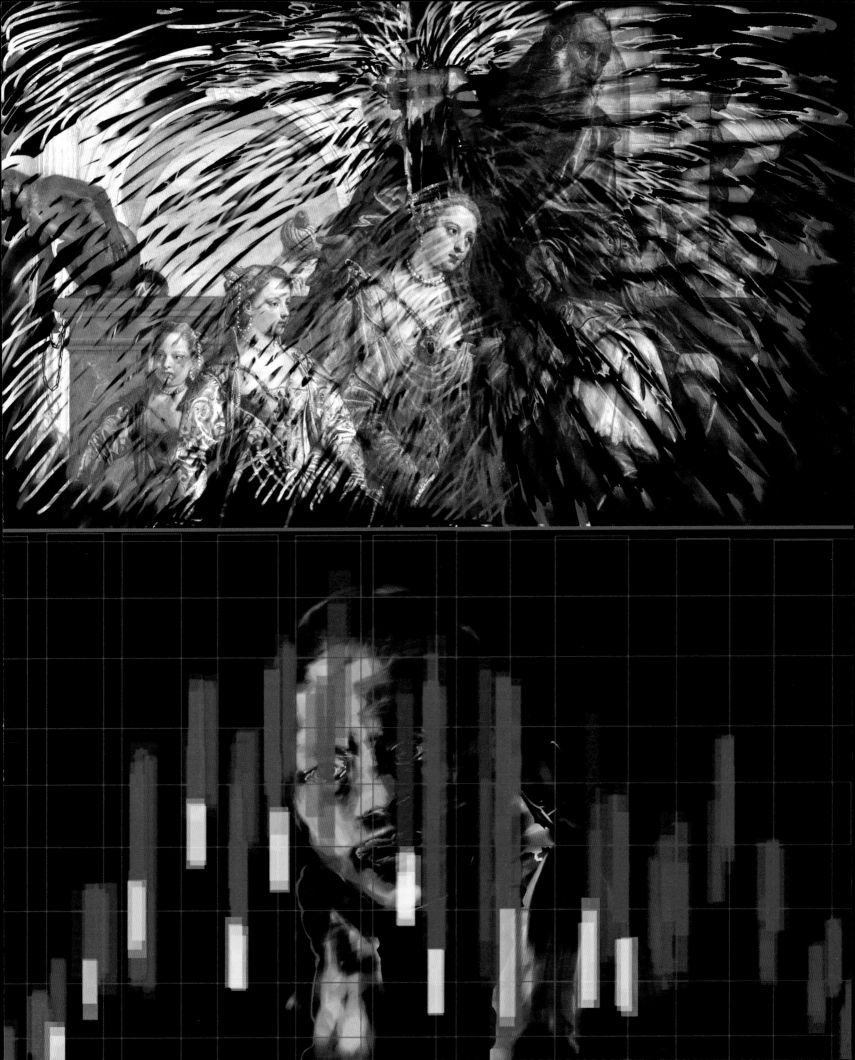

Telling Tales:
Narrating Nalini Malani

Zehra Jumabhoy and Priyesh Mistry

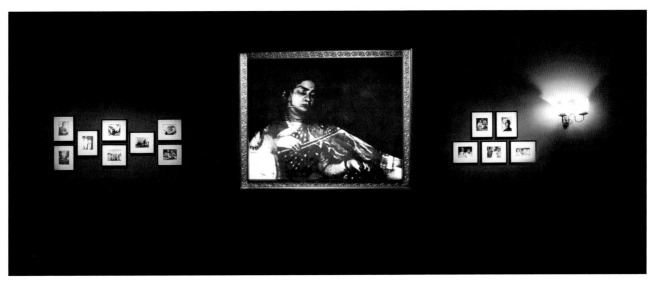

Fig. 1 *Unity in Diversity*, 2003
Single-channel video play inside a gilt frame, colour, sound, mid-twentieth-century lounge and pair of lamps, 13 framed black-and-white photographs, olive grey or crimson walls, 7 mins
Centre Pompidou, Paris, 2017

In Nalini Malani's video play *Unity in Diversity* (2003) (fig. 1), the visitor enters an immersive installation in the gallery only to feel as if they have walked into a private dwelling; the living room of an upper-middle-class Indian family. The walls are painted an olive grey, and photographs of the 'Father of the Indian Nation', Mahatma Gandhi, and the first Prime Minister of India, Jawaharlal Nehru, adorn the walls in black frames under softly glowing lamps. On one wall hangs a large, ornate gilded frame, into which is projected the painted image of 11 women from different parts of India wearing dresses and embroidered saris, tied and draped in the various regional styles of the subcontinent. The women are seated with a range of instruments as if they are part of an orchestra, symbolising a harmonious unity in the face of the nation's multiplicity. The title of the work derives from Nehru's famous book and speech, *The Discovery of India* (published 1946), which encouraged the burgeoning country to embrace 'unity' and celebrate the diversity of its many castes, creeds, languages and religions.

Suddenly, at the ringing sound of a gunshot, one of the women comes alive in animation. Through the ensuing stop-motion film, the women's memories are recounted through narration, reflecting on political violence as well as the personal traumas of abortion and loss. A voice akin to that of Nehru deliberates on the difficulties in establishing a democratic agenda as the animations become increasingly bloody (fig. 2). Later a girl's voice announces that she is 'the Angel of Despair' before relating, in Hindi, an eye-witness account of a horrific act of violence. The women's instruments are replaced by guns, as they themselves change from demure musicians into the soldiers of a modern conflict. Our perceptions of the painted women are permanently altered.

This type of absorbing yet visceral experience recurs in Malani's ever-evolving practice. In 2020, Malani was invited to become the inaugural artist of the National Gallery Contemporary Fellowship programme, responding to the collections and site-specific histories of both the National Gallery, London, and the Holburne Museum, Bath. As an artist primarily based in Mumbai, India, and within a former colony of the British Empire, *Unity in Diversity* is an example of her subversive appropriation of paintings in the old master tradition, to re-examine and re-interpret their narratives. Malani's art challenges the Euro-American canon of art history, even as she undermines gender stereotyping. While universal in its thematic reach, her work is rooted in her unique historical context.

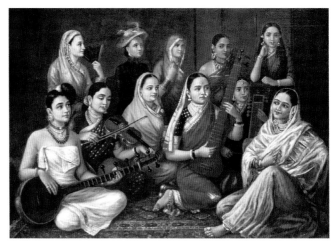

Fig. 2 *Unity in Diversity*, 2003
Video still, single-channel video play, 7 mins

Fig. 3 **Raja Ravi Varma** (1848–1906)
Galaxy of Musicians, 1889
Oil on canvas, 109 × 124.5 cm
Jaganmohan Palace, Mysore

Malani was born in 1946 in Karachi, just a year before the Partition that split the subcontinent along the Radcliffe Line. Named after the British lawyer, Sir Cyril Radcliffe, who was charged with dividing British India in just six weeks, the Radcliffe Line of 1947 created two nations: a Muslim Pakistan and a secular India. As millions migrated across the new borders in haste and fear, sectarian violence broke out between Hindus, Muslims and Sikhs, leading to the death of millions of people. Malani and her family were uprooted by Partition, forced to move from her birthplace, which became part of Pakistan, to Kolkata before she later settled in Mumbai. Her own history is thus intertwined with the legacy of colonial rule, one that permeated the educational institutions of her youth and whose authority continues to dominate the international art world in which she operates.

It is telling, then, that the basis of the projected animation in *Unity in Diversity* is the painting *Galaxy of Musicians* (1889) (fig. 3) by the Indian painter Raja Ravi Varma (1848–1906), known for his academic realist depictions of Hindu mythology. While Ravi Varma's style was derived from colonial academies, his subject matter was uniquely Indian. His romanticised goddesses became mascots for early anti-colonial nationalism. The painting itself is celebrated for having been presented in Chicago in 1893 as part of an exhibition that coincided with the Parliament of Religions, a symposium that introduced the charismatic Hindu monk Swami Vivekananda to international audiences. Vivekananda's speeches at the events warned of the dangers of religious bigotry. While the title of the work gestures directly to this history, Malani alludes to the connection between Varma's painting and Vivekananda's forewarnings in a series of text frames at the beginning of the video play. The slogan 'unity in diversity' was central to Nehruvian Secularism, linked to the first Prime Minister's vow to promote religious tolerance post-Independence. Malani's installation, ending in a bloodbath, gestures to the rise of sectarian strife across South Asia; a reminder that utopian aspirations do not always lead to peace.

In this context, it is unsurprising that Malani's oeuvre takes the viewer through narratives that emphasise marginalised or suppressed voices, that she dismantles the patriarchal dominance of history. If much of her visual language is rooted in South Asia, it is not limited to it. Her own background as a Mumbai-based practitioner encourages multicultural references. After all, the port city, known previously as Bombay, was a pivotal trading centre for the British Empire, a cosmopolitan melting pot of diverse cultures and beliefs.[1] Malani's mixed-media work enmeshes a range of visual and textual sources, including philosophy, literature, mythology, art and a crossfire of histories from different, often competing, global contexts.

Modes of Storytelling

Spanning five decades, Malani's practice has encompassed painting, drawing, film, animation, photography, video, wall drawings/erasure performances and theatre. Her techniques of display have consistently probed patriarchal structures and investigated zones of conflict. Essential to Malani's art is her method of relaying stories, using them to expose and undermine chauvinistic certainties. In her works, epic narratives and mythologies are never fixed or essentialised: she foregrounds their shifting evolution over time and through morphing social realities.[2]

Malani has been associated with the narrative figurative painters of the Baroda School of Art in the 1980s, including Gulammohammed Sheikh, Jogen Chowdhury, Sudhir Patwardhan and Bhupen Khakhar. While the Baroda Group's plural politics were often expressed through the medium of painting in the 1980s, Malani's own work has always enacted a merger between pictorial space and cinematic interventions. It was Malani's early experiments in lens- and light-based media at the Vision Exchange Workshop (VIEW), Mumbai in 1969, as well as her work in theatre, that shaped much of her subsequent practice.

Utopia (1969–76) (fig. 4) is the revision of a film first made during her time as the youngest and only female member of VIEW. Founded by the Modern Indian artist Akbar Padamsee, the Mumbai-based workshop gave Malani access to camera equipment that enabled her to develop a new visual idiom grounded in film. Experimenting with a cardboard architectural model, based on plans by the architect Charles Correa, together with editing techniques and lighting, the original animation on 8 mm reversal film deliberated on the utopian vision of modern architecture. In 1976, Malani paired the film with another projection, this time a 16 mm black-and-white filmed portrait of a woman staring disillusioned from an apartment block at the dystopic landscape of a Mumbai suburb. One of the first experiments in double projection, Malani's discovery heralded a fresh way to tell stories.

The installation of *Alleyway, Lohar Chawl* (1991) marked another watershed in Malani's career. Taking inspiration from the poverty-stricken inhabitants of the overcrowded Chawl (an area of wholesale markets and cramped housing where her studio was located), Malani created her first immersive installation,

Fig. 4 *Utopia*, 1969–76
16 mm black-and-white film and 8 mm colour stop-motion animation film, transferred on digital medium, double video projection, 3:49 mins

borrowing techniques from film, theatre and painting. *Alleyway, Lohar Chawl* used transparent film known as Mylar, on which Malani made ink drawings of the people she encountered in the area, as well as a quote of the small etching *A Man making Water (Peeing Man)* (1631) by the Dutch Golden Age artist Rembrandt (1606–1669), which was reconfigured to life-size scale. The resulting transparent scroll drawings were suspended in such a way as to force visitors to walk between them and be confronted by the hard lives of their protagonists. As painted figures mingled with visitors, the real and imaginary collided. A new form of interactive display was created, one which merged performative and painterly tropes.

The 1990s saw Malani push her interdisciplinary experiments still further. In 1993, she collaborated with the actress and dramaturg Alaknanda Samarth on the theatrical *Medeamaterial*, the documentation of which was later made into a film (fig. 5). The work used the German playwright Heiner Müller's fragmented and violent retelling of the Greek myth of Medea. Re-interpreted by Malani and Samarth, the play progressed through a series of installations, starting outside the Max Mueller Bhavan in Mumbai where it was presented over seven evenings. The audience was led by Samarth, as Medea, through a space with wall drawings and painted panels, positioned to resemble an enlarged accordion-style book. Viewers travelled into a darkened space with slide projections and video screens on which ghostly images of Medea's husband, Jason, appeared. Interspersed as vignettes throughout the performance, Samarth would hold a position suggestive of an image from an old master painting. Art historian Chaitanya Sambrani says of these moments in the performance:

> This manner of representation constitutes the most voyeuristic gaze, for the viewer is invited to share the artist's vantage point, looking at a woman who is either unaware of being watched or complies to being thus objectified. The representation of the female form in such paintings as Ingres's *Turkish Bath* or Velazquez's *Rokeby Venus*, came up for comment throughout the performance.[3]

Through embodied performance, Malani and Samarth inverted the power relations inherent in the act of looking, re-interpreting the Medea of the myth for contemporary times. Malani's rendition is an allegorical warning against greed and avarice; reminding us that capitalism's fetishisation of the 'exotic' female body is another form of colonial exploitation.

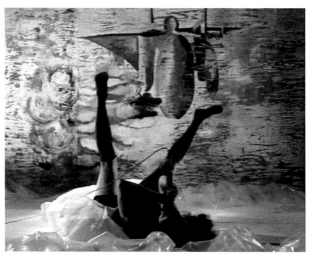

Fig. 5 *Medeamaterial*, 1993
Video stills of artist documentary on the theatre play *Medeamaterial*, performed at the Goethe-Institut / Max Mueller Bhavan, Mumbai, 1993
Digital colour video, sound, 58 mins

The interlacing of myth, history and contemporary politics has become a feature of Malani's practice. In some cases, TV monitors are inserted into displays, making them simultaneously surreal and topical. For instance, *Remembering Toba Tek Singh* (1998) (fig. 6) re-stages writer Saadat Hasan Manto's short story about the traumatic absurdity of Partition: a four-projection video play is juxtaposed with 12 TV monitors, housed within tin trunks facing upwards and placed on a mirrored floor. The disorientating experience of chimerical images and their fractured reflections in the immersive installation was to resonate with that of those displaced by Radcliffe's Line.

Such multi-media experiments took Malani towards the development of her own unique fusion of painting, film and narrative in the late 1990s and 2000s. The most intriguing among these are her 'video/shadow plays' where films are projected through painted transparent cylinders of Mylar that rotate to form ever-changing layers of video with multi-hued shadows. It is arguably this innovation that performs the most politically affecting conjoining of artistic forms in Malani's oeuvre.

History and Feminist Tales

Among the most celebrated of Malani's video/shadow plays is *Remembering Mad Meg* (2007) (fig. 7). The 'Mad Meg' in question is Dull Gret (Dulle Griet), an ill-tempered peasant woman from Flemish folklore, who dons a knight's armour and sword to attack the mouth of hell. She is battling the forces of evil,

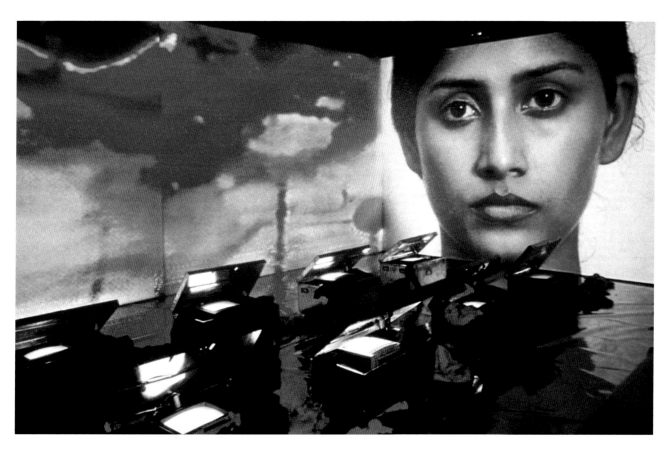

Fig. 6 *Remembering Toba Tek Singh*, 1998
16-channel video play, sound, 20 mins
World Wide Video Festival, Amsterdam, 1998

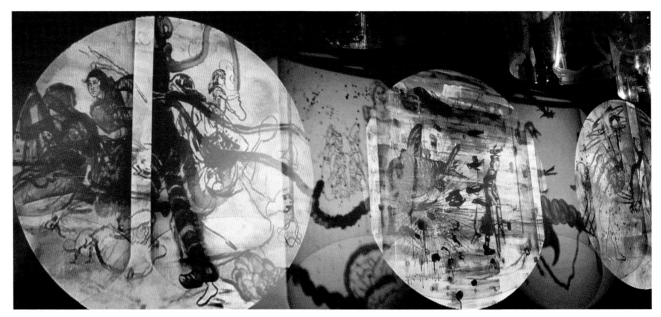

Fig. 7 *Remembering Mad Meg*, 2007
4-channel video/shadow play, 16 light projections, 8 reverse-painted rotating Lexan cylinders, 4 rpm, sound, 43:11 mins
Centre Pompidou, Paris, 2017

which, for Malani, stand for patriarchy in all its manifestations, including India's own form of macho-nationalism. India has witnessed the steady rise of the Hindu Right (also known as Hindutva), which achieved political success with the election of the Bharatiya Janata Party (BJP) in 2014, and again in 2019. As an ideology, it has been reported that Hindutva instigates sectarian strife and as a political entity has fuelled Hindu–Muslim riots that took place in Bombay (1992), across Gujarat (2002) and most recently in Delhi (2020); according to Indian historian Ramachandra Guha, communal tensions have generated indelible rifts within Hindu–Muslim relations with 'suspicion and hostility' becoming its 'governing idioms'.[4]

As a cultural counter to this climate of intolerance, Malani proposes an alternative. Sambrani has argued that plurality remains the core strength of Indian tradition and that Malani uses the diversity of its myths and legends to 'resist their reification into univalent tropes (such as those generated by the Hindu Right through its political campaigns and public festivals)'.[5] Malani's installations propose a more inclusive, composite vision of Hinduism in the subcontinent. In her work, characters from its epics, such as the *Rāmāyaṇa*'s Sita, meet and merge with multicultural voices and global feminist concerns.

Remembering Mad Meg, as with Malani's other video/shadow plays, encompasses female voices, folk art and Islamic iconography that political theorists, such as Jyotirmaya Sharma, have argued are consistently erased from Hindutva's 'monochromatic' vision.[6] The installation includes kinetic paintings, light, sound and stop-motion video animation. Here the shadows of the painted forms, caused by projections and spotlights through the cylinders, are cast onto the walls of the gallery, recalling Balinese shadow puppetry as well as old-fashioned magic lantern displays. The illusion is created with the help of eight rotating transparent Mylar cylinders that have been painted with a range of cross-cultural images. The installation references and combines Northern Renaissance art, such as the 1563 oil painting by Flemish artist Pieter Bruegel the Elder, *Dulle Griet*, with illustrations in medical manuals (e.g. brains, animal skeletons, a curling, snake-like intestine), Kalighat temple painting that originated in Kolkata in the mid-nineteenth century, and Lewis Carroll's *Alice's Adventures in Wonderland* (1865).[7] Unlike Carroll's pre-pubescent girl, in Malani's oeuvre the figure of Alice is often depicted disfigured as a result of war (her leg lost to a

landmine in *Remembering Mad Meg*) or menstruating. Spools of her blood connect her metaphorically if not literally with formidable female figures. In Malani's renditions, Alice's form often swirls into others, fusing symbolically with powerful heroines such as Cassandra from Greek mythology and goddesses from Hindu myth, like the steadfast Sita and the ferocious Kali.

In *Remembering Mad Meg*, the avenging Meg is embedded in the crimson swirls of Malani's paintings on Mylar, recalling Kali on the rampage, much like the rendition of the mother goddess on early Indian nationalist posters in which a bloody-tongued Kali is invariably garlanded with severed male heads dripping gore. Likewise, Malani's translucent female figures are often painted with fluid fusions of acrylic paint which recall streaks of blood. Are they references to childbirth, to menstruation or to bloodshed? Their soiled, ageing bodies are rooted in an earthy physicality. They are not ethereal symbols of Mother India, but corporeal deities that are powerful in their ugliness. The bloodied forms of Malani's Sita, Medea, Cassandra, Alice and Mad Meg bear a close resemblance to the deadly tantric goddess Bhairavi Devi, whose name means 'terror' or 'awe-inspiring'. In other words, they have more in common with the rebellious tantric Devis, associated with female power and sexuality, than the submissive femininity celebrated by patriarchal superstructures. Stepping out of a nationalist context, Malani makes a case for the coming together of female forces: the Devis' dances merge into a multilayered spectacle of feminine defiance. Moreover, Malani's morphing Sita–Medea–Devis harness a plural past. In the reverse-sided painting on acrylic *Sita/Medea* (2006), the goddess Sita, from the epic *Rāmāyaṇa*, is paired with the Greek deity Medea, their bleeding forms at times indistinguishable, at others resembling storybook illustrations from the *Arabian Nights* or the minute folk from Indo-Persian miniature painting. Similarly, the rotating *Remembering Mad Meg* mingles multicultural traditions on the walls, permeating into the viewers' space and propelling them into a palimpsest of syncretic histories, the assimilation of diverse cultural traditions that have evolved at the same time.

Malani's comments and installations conjure an inclusive India, a past of communal cohesion before the arrival of the British and their policies of sectarian divide and rule, which continue to cast a long shadow in India's current political climate.[8] Malani's five-channel video installation, *Mother India: Transactions in the Construction of Pain* (2005) (fig. 8), is ambiguous about the possibility of unity, tracing the subcontinent's current strife to its colonial past, specifically to the legacy of Partition. In *Mother India*,

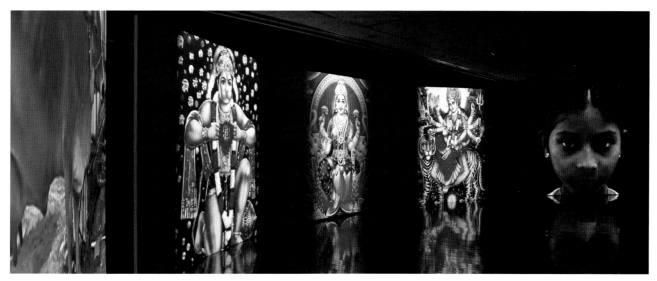

Fig. 8 *Mother India: Transactions in the Construction of Pain*, 2005
5-channel video play, black and white, colour, sound, 5 mins
5th Taipei Biennial, Taipei, 2006

images of the Mother Goddess are interspersed with carnage: as the monkey god Hanuman rips open his chest to reveal the deities Sita and Ram on one vast screen, scenes of violence unfold on another. Malani's artworks are generally filled with allusions to thresholds and the borderline of identity that makes birth and death simultaneously possible. The female subject's role in *Mother India* is mixed. As a cipher for national identity, the birth of the nation, on the one hand, she is also the body on which masculine will is inscribed. Malani's title quotes directly from sociologist Veena Das's essay 'Language and Body: Transactions in the Construction of Pain' (1996).[9] Das's significance is reiterated on Malani's website with another quote:

> ... the project of nationalism in India came to include the appropriation of bodies of women as objects on which the desire for nationalism would be brutally inscribed and a memory for the future made.[10]

Das puts a dark spin on the body of the nation when it is configured as a woman, and Malani's quotation suggests that such narratives are ineradicably haunted. In the words of *Mother India*'s voiceover: 'I die at the border of the new nations, a bloody rag as my flag.' Malani's *Mother India* is a reminder that the legacy of the Line and Britain's culpability for subsequent bloodshed need to be addressed.

Alighting on the Institution

The most recent of Malani's video/shadow plays, *In Search of Vanished Blood* (2012) (fig. 9), also addresses contemporary conflict. Taking its title from a 1965 poem by the revolutionary Pakistani poet Faiz Ahmed Faiz, Malani's six-channel, all-encompassing room installation gives voice to Cassandra, the Greek prophetess.[11] Interspersed in the myriad of stop-motion animations and performance-based footage, projected through five rotating Mylar cylinders, Malani's references are typically varied: ranging from

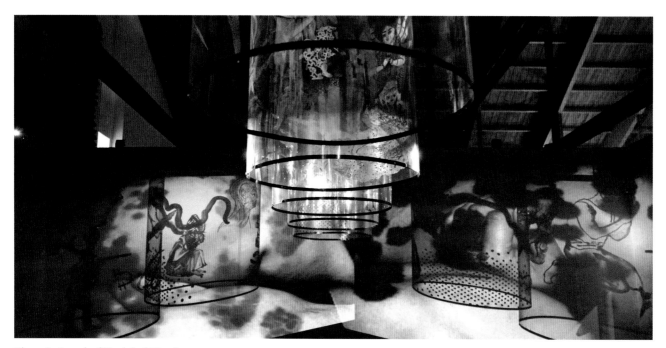

Fig. 9 *In Search of Vanished Blood*, 2012
6-channel video/shadow play, 5 reverse-painted Mylar cylinders, 4 rpm, sound, 11 mins
Castello di Rivoli Museo d'Arte Contemporanea, Rivoli, 2018

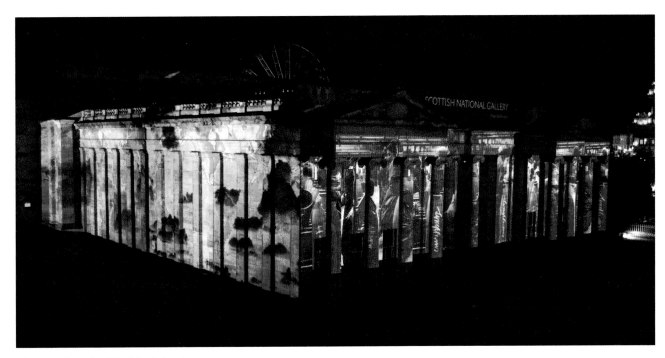

Fig. 10 *In Search of Vanished Blood*, 2014
8-channel video play, sound, 12 mins
Scottish National Gallery, Edinburgh, 2014

Goya's *The Disasters of War* series to writers Mahasweta Devi, Samuel Beckett, Bertolt Brecht and Rainer Maria Rilke, the Iraq War and allusions to India's troubled North-East. During the video/shadow play, the words of Faiz's poem scroll over the bandaged head of a brutalised Cassandra, whose prophecies of doom were disbelieved until too late. Through their hybrid narratives of victimisation, Malani's site-specific installations increasingly take on institutions which symbolise colonial domination: she unpacks the forgotten baggage of the British Empire.

In the summer of 2014, commissioned by the Edinburgh Arts Festival and the '14–18 Now' programme that commemorated the centenary of the First World War, Malani decided to project her work onto two sides of the iconic facade of the Scottish National Gallery in the centre of the city, part of the 'Lights Out' event (fig. 10). During the evening, footage from the archives of the Imperial War Museum, of women working in the ammunition war factories during the First World War and of military training exercises of the 5th Battalion, Royal Scots who fought during the Second Boer War (1899–1908), for example, were projected along one side. Meanwhile, the longer wall presented a new edit of *In Search of Vanished Blood*, with Cassandra forewarning audiences of the disaster of a potential Third World War, and included sequences from the video plays *Remembering Toba Tek Singh* and *Mother India*. Screened directly after the ceremonial Royal Edinburgh Military Tattoo, the work highlighted Scotland's military heritage, one which is connected to Britain's imperial incursions into South Asia. Malani's projection, both literally and metaphorically, shone a light on institutionalised violence, and the way symbols of nationalism in Britain cannot (and should not) be allowed to forget their roots in Empire.

In 2018 Malani started a series of animated drawings that she describes as taking the form of a 'notebook'. Each one was produced almost daily using an animation app on an iPad, creating the drawings directly with her fingers and adding sound using GarageBand, then disseminated to the world via her Instagram account (@nalinimalani). They reflect on current affairs, engaging with a multitude of characters and philosophical or literary references. Later developed to take the form of a room-sized installation, that

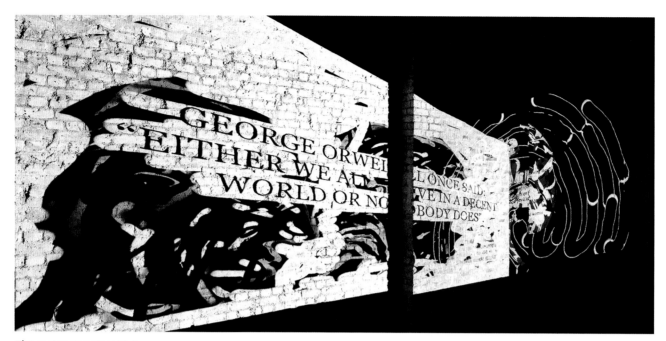

Fig. 11 *Can You Hear Me?*, 2020
Animation chamber, 9-channel installation with 88 single-channel stop-motion animations, sound
Whitechapel Gallery, London, 2020

Malani calls an 'animation chamber', the digital drawings are projected to overlap with each other at random, so that endless juxtapositions occur without repetition. Her first animation chamber, *Can You Hear Me?* (fig. 11), gives voice to Asifa Bano, an eight-year-old Muslim girl in Kashmir. A victim of sectarian violence, Bano was gang-raped and murdered in 2018.[12] The work was presented in London's Whitechapel Gallery in 2020 where it occupied the space of a former library. The animations were projected across the gallery's bare Victorian brick walls, as if marking the building's history with graffiti in motion.

The animation chamber was, however, first installed at the Max Mueller Bhavan in Mumbai in 2019, where over the course of one evening an adapted version of the notebook animations was also projected onto the facade of the Taj Mahal Palace Hotel in Mumbai, a beloved symbol of old-world luxury in the city that was the site of the 2008 terror attacks. The animations stretched to 60 metres in height on the side of the building, and could be seen and heard from a distance. The event served to ensure that Asifa Bano's cry was not erased from public consciousness, while linking the child's demise to the colonial past: the Taj's grand Indo-Saracenic precincts stand beside the Gateway of India. The Gateway was built in the early twentieth century to mark the first visit of a British monarch to the city, when George V stopped over in 1911. It was subsequently used as a ceremonial entrance to the country for significant guests of the Raj. Malani's projected animations reminded viewers of the interconnections between past and present manifestations of pomp, ceremony and power. The work addresses the poisoned fruits of Empire in all their painful contemporary iterations.

Malani's morphing practice has sought to retell histories and tales from an *alternative* perspective, that of those silenced and marginalised. She self-identifies as a 'socio-political female artist', a citizen of a nation that continues to suffer from what South Asian historian Vazira Fazila-Yacoobali Zamindar has termed 'the long Partition'.[13] Yet Malani *herself* is less victim than witness. Her art challenges monolithic histories as it holds multiplicity at its core. Formally, it combines film, drawing and painting through projected theatrical installations, which undercut conventional divisions between disciplines. Conceptually, it is committed to combating histories of oppression with reference to a global lexicon of images.

Malani's work has always been embroiled in politically charged art-historical conversations. *Unity in Diversity*'s quotation of Ravi Varma's historic painting is an example of her complex relationship with the 'old master' tradition, one that places allegorical history painting at the forefront of the canon. Malani is sceptical of this kind of canonisation of a heroic macho past, but she is also keen to revise its claim to an authentic 'European' art history. She reveals the latter's often overlooked entanglement with Empire. After all, Ravi Varma's oils were deeply influenced by the Raj's art institutions, and their insistence on scientific realism and chiaroscuro in the production of 'fine art'. Yet, in Ravi Varma's paintings, these 'Western' representational techniques were utilised to reimagine ancient India, turning him into an early flag-bearer for *Indian* nationalism. As signifiers of the complex history of European colonialism, Malani's references to venerable old masters are always immersed in ambiguous dialogues. Thus, Malani's cinematic references to canonical masterpieces at the two museums will celebrate the dramatic aesthetic properties of these iconic, 'masterly' works, even as they are put into play with numerous other cultural quotations, especially those that spotlight colonial prejudices and racial blind spots. Malani's new work promises to enact a provocative disruption of the categories of East and West.

1 The city was forced to change its name from Bombay to Mumbai in 1995, as a result of identitarian politics.
2 The discourse on the evolution of epic narratives in India was first explored by Malani through the essays of A.K. Ramanujan, notably 'Three Hundred Rāmāyaṇas: Five Examples and Three Thoughts on Translation'; see Ramanujan 1987.
3 Sambrani 1997, p. 158.
4 Guha 2007, pp. 641 and 645.
5 See Sambrani 2004.
6 Sharma 2003, p. 8.
7 Pieter Bruegel the Elder, *Dulle Griet* (1563), Collection of Museum Mayer van den Bergh, Antwerp.
8 Discussed in interviews with Nalini Malani by Zehra Jumabhoy, on 1 March 2012 and 8 February 2014, for the as yet unpublished PhD thesis, *Homi Bhabha's Concept of National Identity and Contemporary Indian Art*, The Courtauld Institute of Art, London 2017.
9 See Das 1996b.
10 As quoted in 'Nalini Malani: Mother India: Transactions in the Construction of Pain': www.nalinimalani.com/video/motherindia.htm (accessed 22 July 2022).
11 This iteration of Cassandra in Malani's work is based on the German writer Christa Wolf's novel about the Trojan priestess who, in Greek mythology, was cursed by the god Apollo so that no one would believe her prophecies which predicted Troy's destruction. See Wolf 1984.
12 Kashmir, once deemed a 'paradise on earth', has continued to be a battle zone between India and Pakistan since the 1947 Partition.
13 See Zamindar 2007.

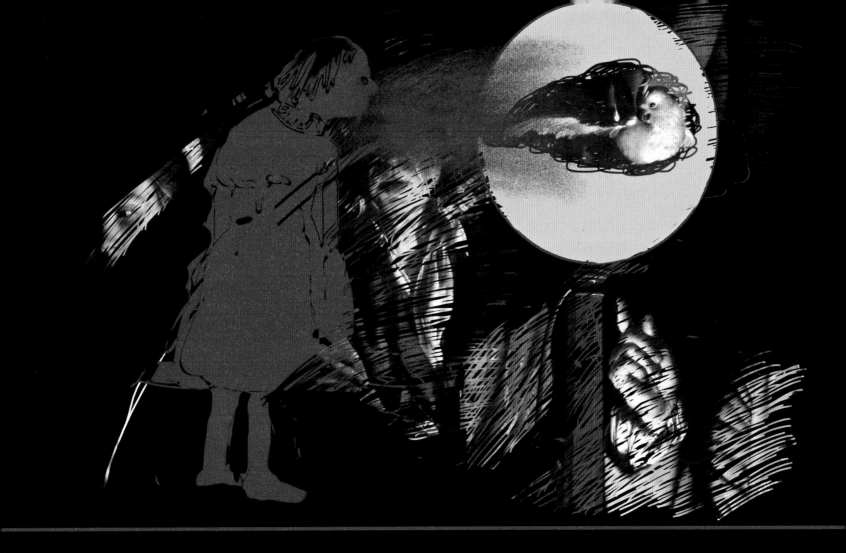
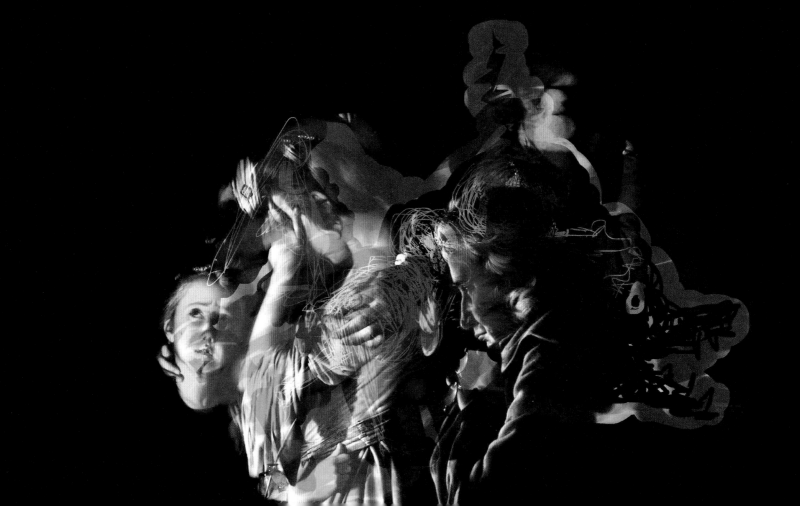

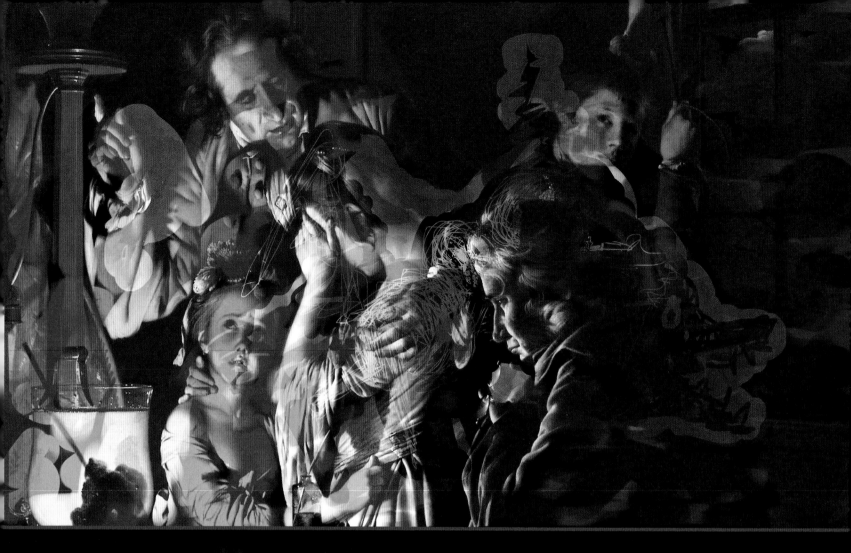
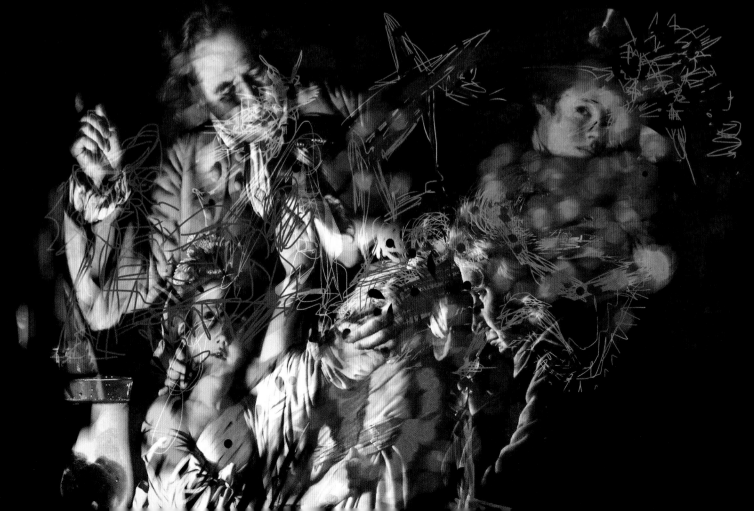

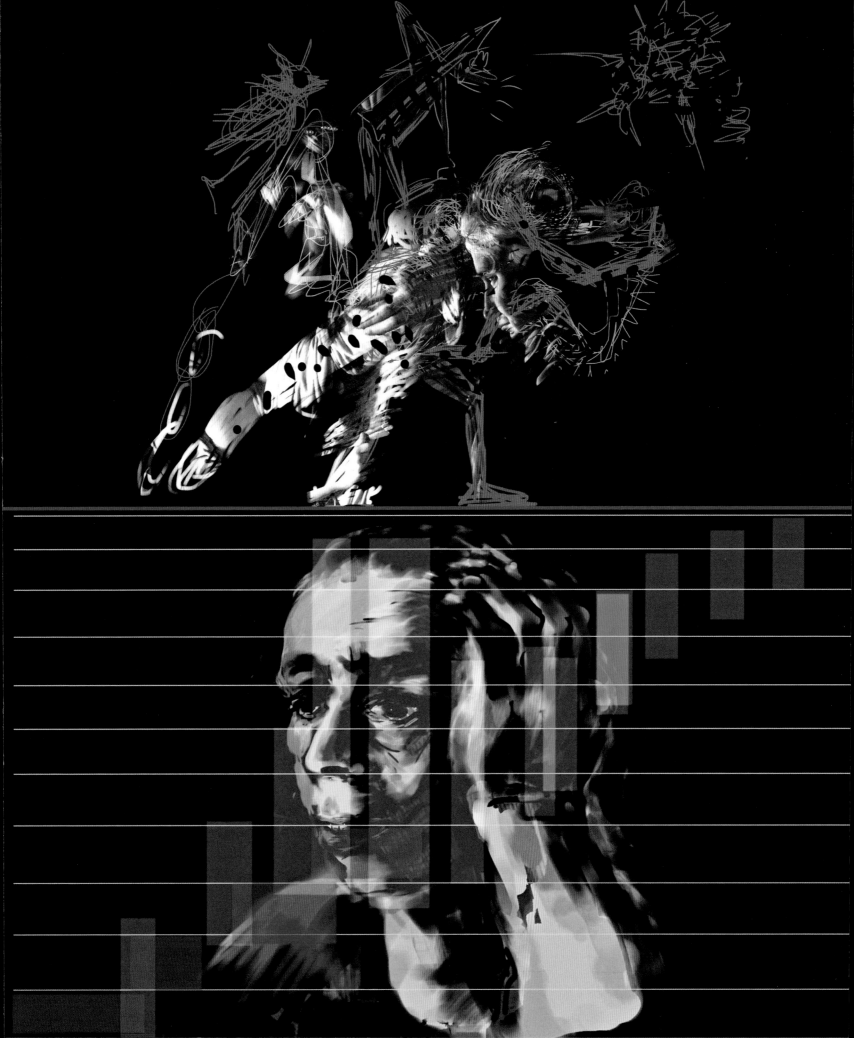

My Reality is Different

Nalini Malani

[The] passages between Eastern and Western cultures are parts of a vast array of intercultural transactions in the world today which together comprise a great process of reorganization and seeking. In a shrinking yet terrifying world, we have to learn – and use – each other's languages, for the future is an unknown language that we will compose together. [1]

Thomas McEvilley, *Art & Otherness: Crisis in Cultural Identity*, 1992

On 12 May 2020, Gabriele Finaldi invited me to become the inaugural artist for the National Gallery Contemporary Fellowship. In his letter he stated: 'Since its foundation in 1824, the National Gallery has been an inspiration for the making of new art in dialogue with the art of the past.'

At my stage of life in my mid-seventies, I may have very little time left. I therefore doubted whether I should accept this invitation. What could I contribute in this day and age with a confrontation with these collections of old masters? Would this be a waste of time, and had I better go on with my series of iPad animations *Can You Hear Me?*, posted on Instagram since 2018, a series like 'thought bubbles', functioning as critically engaged reactions to our bewildering twenty-first century? A daily commitment, an almost ritual process, which helps me to remain sane.

My main motivation and protagonist in the past two decades has become *Cassandra*, in the re-interpretation by the novelist Christa Wolf, where Cassandra questions herself: 'When did the feeling of having a homeland disappear?'[2] For me, Cassandra represents the insights people have but are hard put to collate and act upon. A woman's thoughts and premonitions are not understood and taken cognisance of. The resulting artwork, the video/shadow play *In Search of Vanished Blood* (2012), commissioned by dOCUMENTA (13), is about the brutal gang rape of a woman and its metaphors for the nation and the earth. It aims at a visual storytelling, where in the words of Wolf, 'Storytelling is humane and achieves human effects, memory, sympathy, understanding – even when the story is in part a lament for the destruction of one's father's home, for the loss of memory, the breakdown of sympathy, the lack of understanding'.[3]

What convinced me to accept the invitation was a combination of thoughts about the past and the future. Thomas McEvilley wrote the words above on the eve of a new century; a future of hope and disillusion of a kind that no one wanted to foresee. A world about which Winin Pereira and Jeremy Seabrook had already in 1995 concluded in their publication *Global Parasites: Five Hundred Years of Western Culture*: 'Injustice, through exploitation and oppression, has been the foundation on which Western civilization has built its enormous structure of affluence'.[4] A world in which Gayatri Chakravorty Spivak asked the question 'Can the subaltern speak?'[5] It was this pertinent question which I combined with the line of Finaldi 'the making of *new* art in dialogue with the art of the past', and the introductory epigraph by McEvilley, 'for the future is an unknown language that we will compose together'.[6]

The Shadow Side of the Collections

What did the National Gallery and Holburne Museum expect when their international jury chose me for the inaugural fellowship? An artist who is described as 'the pioneer of video art in India, embodying the role of the artist as a social activist, who in her art places inherited iconographies and cherished cultural stereotypes under pressure. Whose point of view is unwaveringly urban and internationalist, and unsparing in its condemnation of a cynical nationalism that exploits the beliefs of the masses.'[7] How would a socio-political female artist from a former colony react in new artwork connected to their collections?

Due to the Covid-19 pandemic, I was unable to visit and study the collections in person. In March 2020, trying to avoid the lockdown in Spain, I was stranded in Amsterdam on my return journey from the Joan Miró Prize exhibition in Barcelona. As a result, at the very inception the collections were only available to me as digital and printed images. A restriction, no doubt; however, although we may not want to admit it, replicated, printed and digital images have the most influence on how we construct our reality, more than our contact with the original. This is how I had lived with printed images of these paintings throughout my life, starting as a student at the Sir J.J. School of Art in Bombay, established by the British in 1857.[8]

When finally visiting the collections in spring 2022, I could feel the sense and the thrill of standing in front of the original artworks. There is an aura and aesthetic in these paintings, from Fra Angelico, Mantegna, Leonardo da Vinci, Bruegel and Caravaggio to Rembrandt and many more which dominate the canon of Western art, presented in these institutions as the universal values of humanism. How often had I used images from the Western art canon in my own work, integrated with Asian images from India and Japan? I started to develop what I call a 'link language', in which a lexicon of cross-cultural images is used to create a collective meaning. This idea is based on how images migrate and have been interlocked in the past and at the dawn of the global world. An idea I found confirmed in *The Shape of Ancient Thought: Comparative Studies in Greek and Indian Philosophies*, in which McEvilley demonstrates that Eastern and Western civilisations have not always had separate, autonomous metaphysical schemes, but have mutually influenced each other over a long period of time.[9]

This desire for a 'link language' started in the late eighties when I felt the need to make an art of resistance which went beyond borders. This was a statement against the growing international oppression and social suffering of women and the marginalised, who are always the first victims when orthodoxy takes over. Already in my first shadow play, *Alleyway, Lohar Chawl* (1991), I wanted to steer the visitor to take an active part and be engulfed, to shake things up as in a theatrical experience such as Antonin Artaud's *Theatre of Cruelty*.[10] Here the spectator could only 'see' the work by walking into a narrow lane, in which five transparent Mylar scrolls were hung, becoming one with the intermix of painted images. Rembrandt's *A Man making Water* (1631), a small etching (8.2 × 4.8 cm), appears daunting in life size. Here, a seventeenth-century character could well be living among the pavement dwellers in Bombay in the second part of the twentieth century.

My way of apprehending is different, unlike what Western hegemony wants us to believe, starting with the Partition in 1947. Mine is a different reality which grew as the result of an endless string of uprooting experiences and alternative ideas. As a young child, the visits to the refugee camps in Calcutta where my mother volunteered to teach the women; the blunt racism experienced as a teenager on my visits to Kenya and the USA; the voluntary work as a student for the West African illegal emigrants in the slums outside Paris during my scholarship in 1970–2; the overnight demolition of a Muslim slum by the Bombay municipality in 1973, abruptly ending my experimental documentary film project as a young artist. These experiences, along with lectures by Claude Lévi-Strauss and Yasser Arafat and reading Frantz Fanon and Veena Das, already gave me at a young age a completely different understanding of the modern Western world, the Enlightenment and its pictorial history. How had this turned into a world of global parasites?

During my fellowship I felt like a *passante*, the female equivalent of the *flâneur*, where the female social role is expanded from the domestic and private into the public and urban spheres; or as twenty-first-century Gender Studies propose, a *flâneuse*, a feminine version of the word to emphasise that women do experience public space differently.[11] After all, museums did become a public space when they were established out of private collections. Despite the gender awareness introduced by modernity, women were still excluded from public spaces, as the gender imbalance of these museum collections likewise clearly shows.

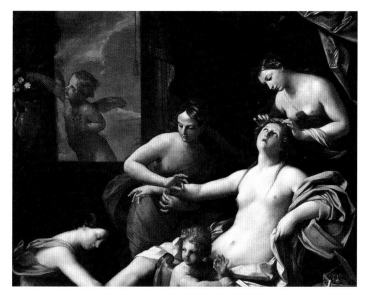

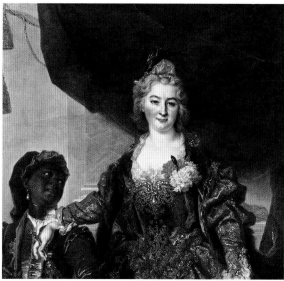

Fig. 12 **Guido Reni and Studio** (1575–1642)
The Toilet of Venus (detail), about 1620–5
Oil on canvas, 281 × 206 cm
The National Gallery, London, NG 90

Fig. 13 **Nicolas de Largillierre and Studio** (1656–1746)
Mme de Souscarrière (?) and her Page (detail), probably 1729
Oil on canvas, 136.5 × 104.1 cm
The National Gallery, London, NG 3883

It's no use describing in detail the endless rows of paintings of classical myths which depict women's naked bodies only for the titillation of the male gaze, as in *The Toilet of Venus* (about 1620–5) from the studio of Guido Reni (fig. 12). Nor to point out the many paintings which portray women as a negative influence – the moralistic paintings of Jan Steen, like *The Effects of Intemperance* (1663–5), where not a man but a woman is shown neglecting her family; or the ongoing tales of how men are brought low by the lust of women, as in *Samson and Delilah* (about 1609–10) by Peter Paul Rubens. Is this a representation of how the world is socially constructed and represented to us in a meaningful way?

Shocking are the many paintings and objects that reflect the excessive greed and luxury that developed in the early days of Western hegemony. Extravagances such as the fashion for acquiring lacquer cabinets, imported from China and Japan, which led to the development of a craftsmanship called Japanning. To supply the demand for oriental exotica, European craftsmen made imitations or exotic variations. For example, the Witcombe Cabinet in the Holburne Museum (see fig. 30), with a silvered stand in purely European style, imitating the furniture of Louis XIV at Versailles, combined with the lacquer cabinet in the Japanning style with faux scenes from China.

Offensive are the images and curios where natives appear inserted into artefacts and objects as either droll or relegated to the level of servants. All with the mindset that slaves from the colonies were not considered to be human and were therefore traded as a commodity. A black servant, often a young page or handmaid, was seen as a status symbol, adorning the houses of the well-to-do (fig. 13). All part of the enriching of Empire and advancing capitalism. By the end of the eighteenth century, Britain was the leading trader in human lives across the Atlantic, with over one million enslaved Africans in the British West Indies.

How much these bourgeois artworks in the collections contrasted with profound humane insights, as expressed in the later paintings by Rembrandt at the National Gallery, or in delicate emotions as I found in a seventeenth-century Dutch funeral spoon at the Holburne Museum, commemorating the death of Elisabeth Boser, the eleven-year-old only daughter of a shoemaker and his wife (fig. 14). I have always

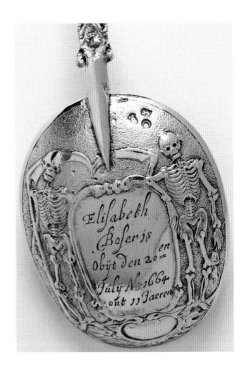 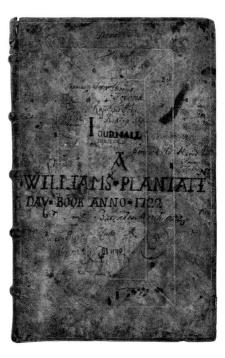

Fig. 14 Funeral spoon, Amsterdam (detail), 1664/5
Silver-gilt, 15 cm long
The Holburne Museum, Bath, S343

Fig. 15 Plantation Day Book, owned by Guy Ball (c. 1686–after 1722), great-grandfather of Sir William Holburne (1793–1874), 1722
Paper, 31.5 × 20.3 × 2 cm
The Holburne Museum, Bath, AR146

admired how Rembrandt, especially in his etchings, gave a platform for the oppressed with compassion and empathy, portraying them with a palpable dignity in poverty. This is a fundamentally different statement and understanding of human existence from what one experiences in Rembrandt's earlier commission for two life-size portraits of the young, rich celebrity couple Maerten Soolmans and Oopjen Coppit (1634), now in the Rijksmuseum and Louvre collections. Surprisingly, it was only in the recent *Slavery* exhibition at the Rijksmuseum in 2021 that these portraits were placed in a context where the deeply troubling side to the couple's wealth was related to the brutal exploitation of slaves.

On 8 November 2021, the National Gallery published online the results of an extensive research project which should help to understand and acknowledge the impact that slave ownership and profits from plantation slavery have had on its history. Out of the 199 researched persons, including trustees and donors as well as some important sitters and painters, 72 were linked to slavery, 30 to abolition, 18 to both and 79 to neither. Their report mentions the author and traveller James Forbes (1749–1819), a donor to the Gallery, who wrote in a letter of 1765 about the link of slavery to European avarice due to their 'insatiable thirst' for gold and diamonds, for which slave ships arrived daily, bringing cargoes of 'our fellow creatures' to be sold 'in the public market, like cattle'.[12]

In the Holburne Museum, prominently shown is the Plantation Day Book from Barbados (1772), which belonged to William Holburne's great-grandfather, Guy Ball (fig. 15). Next to an overview of the anti-slavery and colonial resistance in Bath and Somerset, where names such as the abolitionist Charles Ignatius Sancho appear, as well as women including the African-American feminist and anti-lynching campaigner Ida Irish, the anti-slavery speaker and author Lady Kathleen Simon, and the English Quaker and anti-racism activist Catherine Impey. Here, the wall text mentions that 'a multiracial cohort of men and women came together across social, global and physical barriers to disrupt and condemn colonialism's racist violent and dehumanising practices'.

Reading these extensive documents, one can only bitterly recall the words of Fanon: 'Imperialism leaves behind germs of rot which we must clinically detect and remove from our land but from our minds as well.'[13]

My Reality is Different

For the new artwork in the frame of this fellowship, I wanted to look from the perspective of Lewis Carroll's nonsense poem *Jabberwocky* at how parasitic globalisation has depleted democracy. When democracy is taken for granted, it deteriorates and has no meaning anymore, it just becomes an unrecognisable sound. I think this is pertinent in recognising the metamorphoses that are taking place at this moment. What is proclaimed by certain state leaders is a fake reality which brings life into danger. The words seem straightforward but then mean something else. As Polish poet Wisława Szymborska pointed out in

Hand

Twenty-seven bones,
Thirty-five muscles,
About two thousand nerve cells
in each fingertip of our five fingers.
That's enough
to write Mein Kampf
or the House at Pooh Corner.[14]

I chose to use my format of iPad animations for the new work. This would give the optimal opportunity to engage with the collections, and to adapt the work to the different dimensions of the exhibition rooms. After several try-outs it became clear that the animations worked best as a reaction to the paintings rather than the objects, for instance the collection of netsukes at the Holburne Museum. This choice excluded a total of 8,700 objects at the Holburne Museum. Trying to avoid the obvious highlights of the collections, it became an idiosyncratic selection, leaving viewers to draw their own conclusions about what is presented. Over time my choice comprised 22 out of a total of 2,500 paintings at the National Gallery, and 3 from the 300 paintings at the Holburne Museum.

From each painting I made a selection of two to four close-ups which tell a sequential story, much as how these painters guide the trajectory of one's gaze. With the overlay of my animations, I make visible what happens with my gaze over these pictures when walking through the galleries. Drawing with my index finger, I find there is a sensitivity in the fingertip, something very raw and direct – drawing, scratching and erasing, which has to do with messing around in one's mind – which then comes out at the tip of one's finger. Much like the tactile feeling of drawing over the paintings, I am despoiling or desecrating these works. These paintings are not sacrosanct. They have to be looked at in a different way, with a different archaeology.

Dreamings and Defilings, the title of an earlier artist's Leporello book that I made in 1991, now in the British Museum, sums up what I am doing here. On the concertina pages, I painted a critical overlay in reverse painting on Mylar over a series of black-and-white reproductions of Western paintings, such as Picasso's *Two Women running on the Beach* (1922), Goya's *The Naked Maja* (about 1797–1800), and Titian's *Tarquin and Lucretia* (1571).

The animations in *My Reality is Different* also perform this transgressive act of revealing and concealing. A Greek chorus is used for continuity, played out by small red, non-individualised figures. Initially, the paintings are the equivalent of a children's playground for the chorus, while they tumble all over the place. Until they realise what is happening in the paintings and start to comment on them through the dramatic dialogue of the overlay animation, expressing their fears, hopes and judgement by the citizens. Herewith, I weaponise subtlety and enjoyment. Instead of an evangelist's confrontation with direct ideological

statements, the visitor can discover the art with me and realise what is happening in these works, and in their museum constellation.

In the male constructed world, as we perceive it in these collections of Western paintings, *My Reality is Different* gives a much-needed twist to views of the oppressed. No longer does the division 'men think and reason, women feel and cry' exist, as society then believed was proper. No longer do the women watch passively in tears as the white cockatoo suffocates in *An Experiment on a Bird in the Air Pump* (1768) by Joseph Wright of Derby, but instead blow life breath into the animal. No longer do the women compete with each other for the favour of the golden apple in my *Judgement of Paris*, but form a close bond. In the *Allegory with Venus and Cupid* (about 1545) (fig. 16) by Bronzino, the two main figures in this erotic allegorical painting form a lesbian scene in the animation. In *Susannah and the Elders* (about 1622–3) by Guido Reni, Susannah is about to be molested, but in the animation overlay she does not not give in, and furiously screams and shouts back at her two male offenders. In *Lot and his Daughters leaving Sodom* (about 1614–15), the companion painting by the same artist, the animation gives a different future, where the daughters don't approve of being forced to have an incestuous relationship with their father, even when this act was for the so-called 'noble' cause of saving humankind from extinction.

Animation interventions like these remind me in hindsight of what the poet Adil Jussawalla wrote about my early paintings in my first catalogue in 1973 at the Pundole Art Gallery in Bombay:

> Nalini's bodies are all female. Put another way, Nalini presents us with the female as body and body alone, a male's-eye view which is further accentuated by the physical placement of the bodies: they are all seen from on top. In other words, the nature of the aggression, even when presented in terms of a claustrophobic room or an occluding wall, is ultimately male. These are women subject to a world made by man, the doer, the maker, the aggressor.

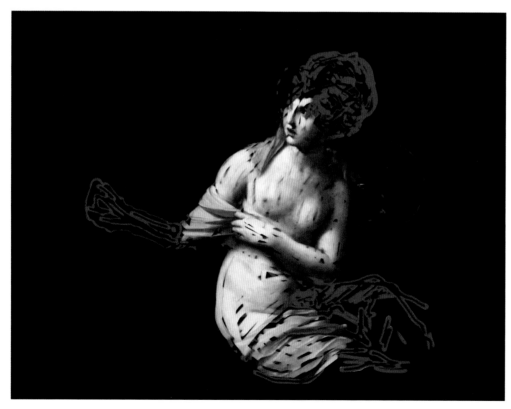

Fig. 16 Still from *My Reality is Different*, 2022

What is new is that these women fight back. They will not watch and wait, and endure with their large sad eyes as women have been shown to be doing ever since Amrita Sher-Gil. These bodies hardly have eyes to see – they fight with only a dim awareness of the nature of their aggressor, but they fight.[15]

Besides animating layers of critique, from a feminist point of view, while I was on my *flâneuse* journey, I felt a strong connection to the paintings of the martyrdom of Christ. Like Gandhi and Martin Luther King, who acted with a similar selflessness and fought for liberty from unfair and cruel oppression, whether under the guise of governmental authority or cultural censure. How much these religious paintings contrast with the portrait commissions that became popular in Britain in the eighteenth century for the newly rich, that became a genre themselves as 'conversation pieces'. When animating the painting *The Auriol and Dashwood Families* (about 1783–7) by Johann Zoffany, I wondered how these Indian house servants, and the young slave boy Nabob, would have looked at this scene of colonial life in the 1780s in Bengal. And how would the subaltern look today at these museum pieces, when they belong to postcolonial populations who are still excluded from the hierarchy of power?

Coincidentally, at that same place in India where Zoffany made good profits, after his art had become less fashionable in England, a study was started two centuries later by the Subaltern Studies Group. Active in the early eighties of the twentieth century in Calcutta, they focused on the history writing of modern India, which later became an inspiration for Postcolonial Studies. Their initial historical critique was on the elite bias of the history written by the British colonial rulers. Postcolonial critique rejects universal pretensions of humanism as ethnocentrism, as in the colonial context they lead to inhuman consequences. Where does this leave the seemingly universal Western values and ideals? Over a period of nearly 18 months, I created 63 animations of the different framings of the 25 museum paintings, as the basis of an *animation chamber* which would be shown as a nine-channel work. To this, I added portraits showing the South Asian subaltern (fig. 17), men and women from social groups marginalised to the edges of society. They seem almost devastated, in ruin, the way they look at us; staring deeply, they observe, unable to communicate, silenced in the world of parasitic capital. Their faces disappear behind colourful candlestick stock market charts, or behind even more complex graphic financial systems, which together devour their labour and their lives. Here, social suffering, the transactions in the construction of pain, mark their bodies, as described by Veena Das.[16] Here, racism is determined by the imperatives of exploitation, as we read in *Staying Power: The History of Black People in*

Fig. 17 Still from *My Reality is Different*, 2022

Britain by the author and activist Peter Fryer. [17] Here, Das's words resonate, as she writes in her publication *Critical Events*, that constructing memory through the common sharing in pain is quite a different activity from constructing it through collections in museums. [18]

A work like *My Reality is Different*, as with all my other video and shadow play works, cannot exist without sound. While in the last decade I have mostly made soundscapes and music myself on GarageBand, in this case I wanted to reconnect with Alaknanda Samarth, the theatre actor with whom I created the experimental theatre work in 1993, based on Heiner Müller's play *Medeamaterial*. Her exceptional mind and provocative sound performance have made vital contributions to my art over the past decades. Unfortunately, in 2021 she fell sick and passed away. As homage to Alaknanda, with her permission I re-used an earlier sound piece, which was part of the shadow play *The Tables Have Turned* from 2008 (fig. 18), an adaptation by Alak and myself off a text from *Cassandra: A Novel and Four Essays* by Christa Wolf, in which the lines appear:

> Nothing left to describe the world but the language of the past. The language of the present has shriveled. The language of the future, one sentence only, 'Today I'll be killed.' [19]

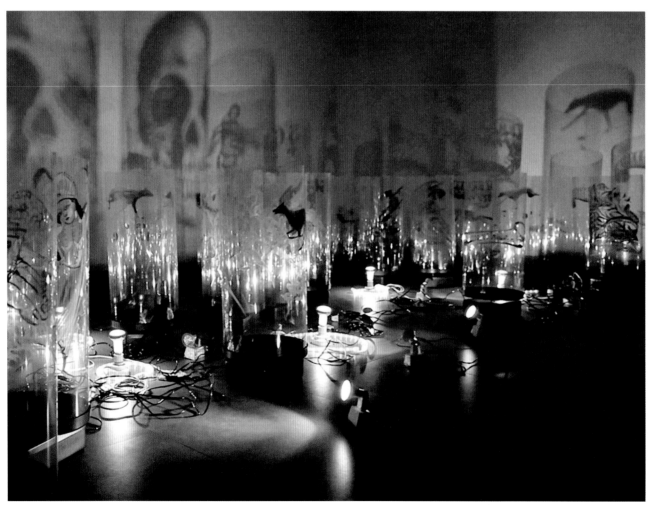

Fig. 18 *The Tables Have Turned*, 2008
32 turntables, reverse-painted Mylar cylinders, spotlights, sound, 20 mins
Art Musings, Mumbai, 2013

This became the basis of the soundscape for *My Reality is Different*, which has as an undercurrent the sound of a large sailing ship, sails and masts suffering under the rain and storm of the ocean. This is combined with music which references the patriotic song 'Rule, Britannia!', and its recurring lines 'Rule, Britannia, Britannia rule the waves: Britons never, never shall be slaves'. A song which, according to historian David Armitage in *The Ideological Origins of the British Empire*, was the most lasting expression of the conception of Britain and the British Empire that emerged in the 1730s, 'predicated on a mixture of adulterated mercantilism, nationalistic anxiety and libertarian fervour'.[20] This sound is interrupted dramatically by a totally other reality in counterpoint, that of the strong voice of an Indian woman. This voice sings a phrase from a folk song and was recorded by Sanaya Ardeshir in the Buddhist caves at Kanheri in Bombay.

The Spectator as Creator

The artists of the theatrical paintings I selected had a specific public in mind with works such as *Samson and Delilah* by Rubens, *Perseus turning Phineas and his Followers to Stone* (about 1660) by Luca Giordano, *The Execution of Lady Jane Grey* (1833) by Paul Delaroche and *An Experiment on a Bird in the Air Pump* by Wright of Derby. Whether it had to hang above the mantelpiece of the large town house of the mayor of Antwerp, or was to be seen by the large crowds of visitors to the Salon in Paris or the Society of Artists exhibition in London, these artists turned their work into a visual spectacle and immersive optical experiences.

Studying the collections, I came across the history of their presentation, as Jonathan Conlin describes in detail in *The Nation's Mantelpiece: A History of the National Gallery*.[21] In the National Gallery's first presentation at 100 Pall Mall, pictures of different periods and schools were hung crowded together, a type of display that even became a genre in itself. Originating in Antwerp, the 'kunstkammer' paintings of the seventeenth century depict rooms that were filled to the brim with artworks (fig. 19).

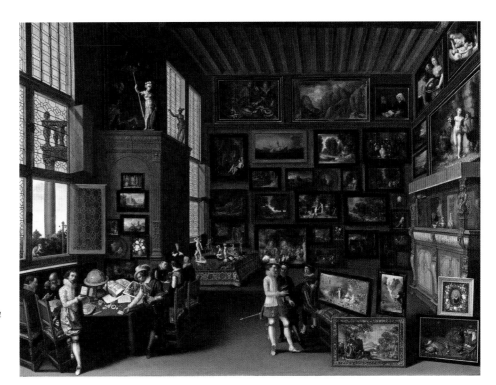

Fig. 19 **Flemish**
Cognoscenti in a Room hung with Pictures, about 1620
Oil on oak, 95.9 × 123.5 cm
The National Gallery, London, NG 1287

I have never disliked this manner of display, as these unusual pre-curatorial ways of presenting have a profound affect and effect on the viewers. Paintings were meant to be seen as a collective, multi-narrative experience, from the Buddhist Ajanta caves in Aurangabad to Giotto's large frescoes at the Scrovegni Chapel in Padua. Standing in front of these walls, looking from one work to another, the visitor unavoidably combines story lines, thus creating new narrations and meanings.

Beyond the Western linear view, too long celebrated as the only manner of display in the museums, the complexities of the human mind deserve to be presented in circular and composite experiences for our future unknown language. *My Reality is Different* does not give by its nature a fixed single-lens interpretation. The nine projections overlap and overlay in a manner that forms completely new sceneries in a panorama format of almost 40 metres, perpetually interacting beyond time, frame and subject. The moment the spectator has created a new meaning, a different configuration appears. This is due to the fact that the individual projections are looped, and none of the cycles are of the same duration.

Entering *My Reality is Different* is as if one has entered my brain, and a seemingly endless stream of thought bubbles, ideas and emotions in the form of images pop up and bounce against each other. As a result, the spectator is drawn simultaneously into three series of image reflections: fragments of the original artworks, the overlay of the projected animations, and the constantly changing collage in the panorama. I address the spectators as an 'active audience', where they have the capability to be dynamic co-creators and co-producers of meaning, rather than passive receptors. Confronting the viewer this way, a process starts, as Ernst van Alphen writes in *Francis Bacon and the Loss of Self* about the pain of the viewer, which is needed to embody the artwork, as a hyper-reflective awareness of the process of perception.[22]

My Reality is Different is a stimulant for a new way of looking. A text which describes what I have been doing in the creation of this particular artwork might be found in the writings of the Australian feminist philosophers Moira Gatens and Genevieve Lloyd, when they speak about 'Collective Imaginings'.[23] They indicate that *imagining* is central in the philosophy of Baruch Spinoza (1632–1677); in its best form it indicates an interculturality for politics and ethics. Instead of our increasingly individualistic focus, collective imaginings, as from participating spectators, can work towards inclusion. Here, Spinoza's philosophy becomes a rich resource for cultural self-understanding in the present.

The cultural theorist and artist Mieke Bal, in relation to this type of art, like my animation chamber, asks 'For a Different Mode of Thinking' in her latest book, *Image-Thinking: Artmaking as Cultural Analysis*:

> The endeavor is to enable cultural memory to be active and politically productive by distinguishing between *guilt* and *responsibility* (Spinoza). This distinction eliminates an unproductive post-colonial guilt and replaces it with contemporary responsibility in and for the migratory culture that is an affective after effect of colonialism. When the perception-image morphs into an affect-image and makes the perceiver develop the *readiness to act*. This readiness lies at the heart of the political potential of the image, film and video installation, to think visually.[24]

Afterword

How do we prepare for the worst, where global parasites have depleted democracy, and the subaltern is muted? Is it here and now that we start a new future, or are we too late and continually denying our responsibility? Can we make a new language that we will compose together?

My Reality is Different is a palimpsest multi-trace of art which operates both within and across cultures, which works for me as a link language between cultures and histories. It creates a new space where traditional art history and its European figures are no longer the unique source of meaning, the world's centre of gravity and the ontological 'reality' of the world. With a selection of these paintings, their Western pictorial language, overwritten by the animations, a critical correlation emerges, where in the combination of stories and the overlay of the projections, the spectator is stimulated to experience, discover and react by giving new meaning.

In a shrinking yet terrifying world, our Cassandra, who exists in all of us, tells what is pertinent to recognise, what *metamorphosis* is happening at the moment. Where the lives of many on our planet are in danger, due to our own actions. Where words have ceased to signify their intrinsic meaning but mean something else. Tapping into the Cassandra in each of us leads to profound insights and truths, forming a new path for the unfinished business of the women's revolution. Without women there is no future.

> One never returns home as one left it, and hence home can never be experienced again exactly as we remember leaving it. It is perhaps in the midst of catastrophic change, or in a time of anguished endings and beginnings, that artists have the greatest opportunity to offer something of crucial value to the culture around them, by seeking, through the image, ways to deal with the deconstruction of an old identity and to begin forth a new one.[25]
>
> Thomas McEvilley, *Art & Otherness: Crisis in Cultural Identity*, 1992

The following notes have been compiled by Priyesh Mistry.

1 McEvilley 1992, p. 125.

2 Wolf 1984, p. 162.

3 Ibid., p. 173.

4 Pereira and Seabrook 1994, p. 228.

5 See Spivak 1988. Postcolonial theorist Gayatri Chakravorty Spivak defines 'subalterns' as those who cannot speak due to cultural or semiotic violence that restricts people in certain lower social positions. They are members of colonised populations who are socially and politically excluded from hierarchies of colonial power, and their agency and voice denied.

6 McEvilley 1992, p. 125.

7 Quoted from the artist's biography.

8 The artist uses the old term for cities, Bombay and Calcutta, throughout this essay for cultural reasons.

9 See McEvilley 2002.

10 See Artaud 1958.

11 The term *flâneur* was used by Charles Baudelaire in his 1863 essay 'The Painter of Modern Life' to describe a dilettante observer or a wandering explorer of urban life.

12 As referenced in the National Gallery's report 'James Forbes (1749–1819)': www.nationalgallery.org.uk/people/james-forbes (accessed 22 July 2022).

13 Fanon 1963, p. 249.

14 Szymborska 2015, p. 426.

15 Mumbai 1973, n.p.

16 See Das 1998.

17 See Fryer 2018.

18 Das 1996a, p. 196.

19 Wolf 1984, p. 14.

20 Armitage 2000, p. 173.

21 See Conlin 2006.

22 Van Alphen 1993, p. 15.

23 Gatens and Lloyd 1999, p. 83.

24 Bal 2022, p. 397.

25 McEvilley 1992, p. 124.

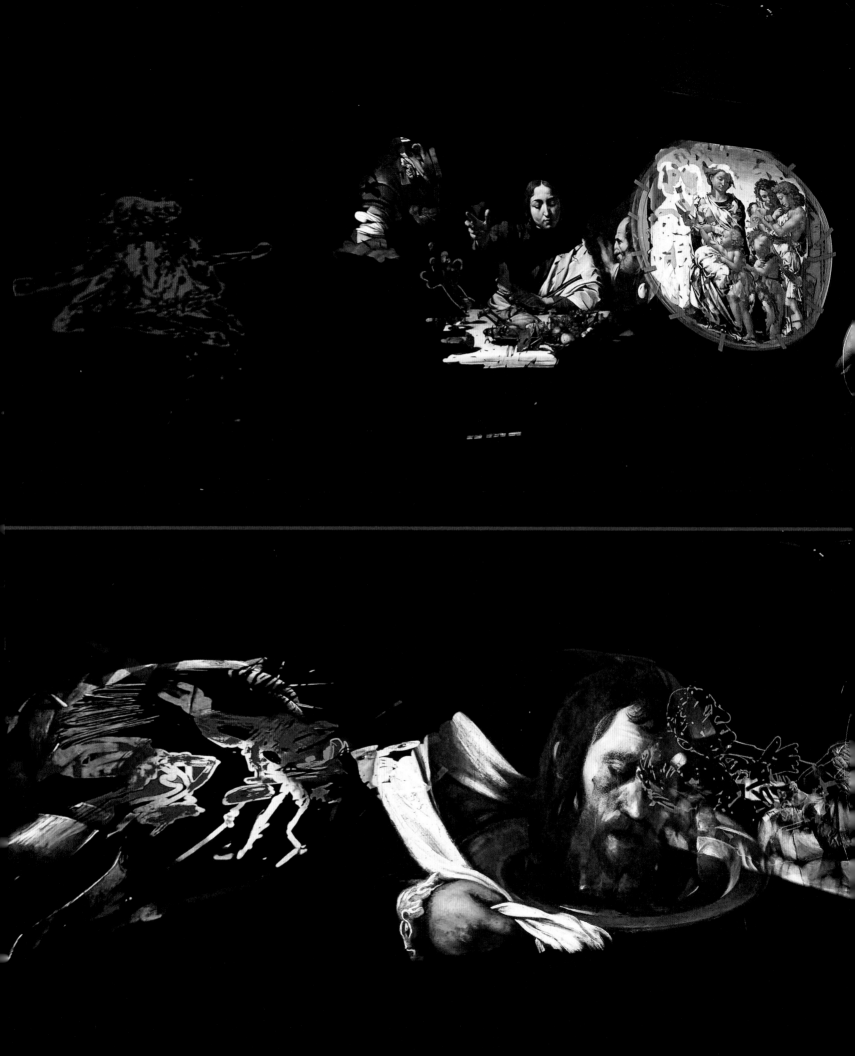

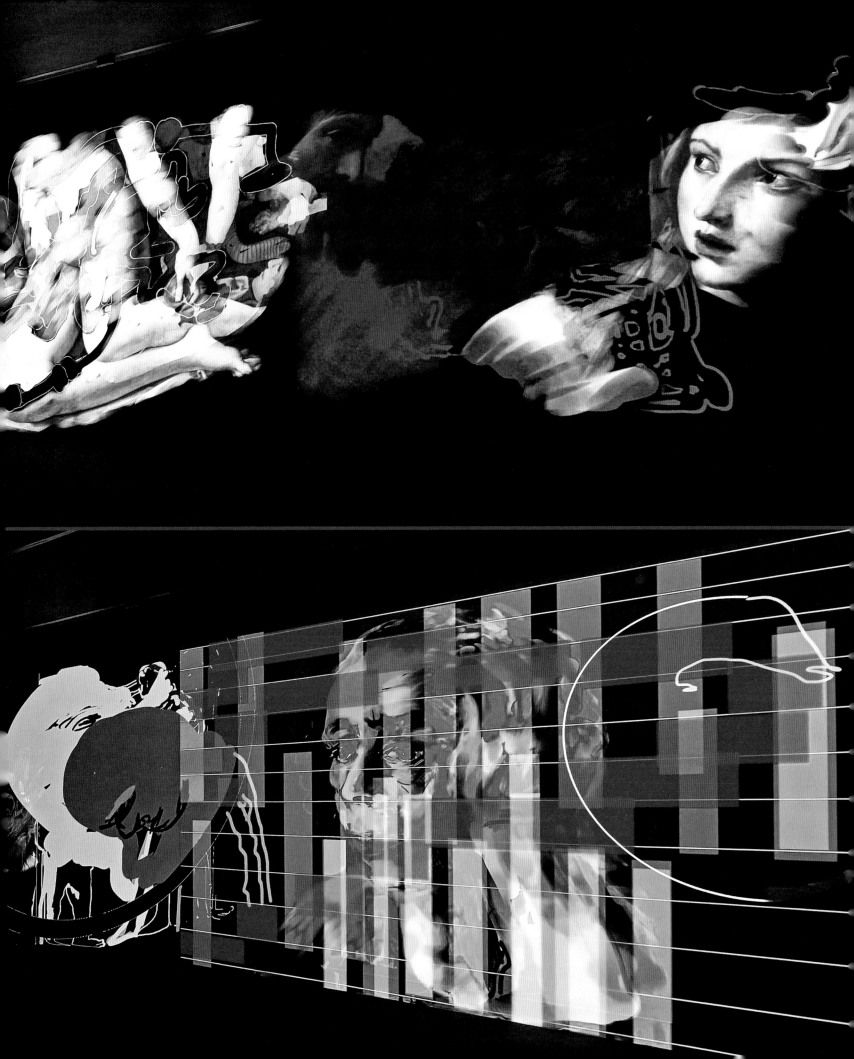

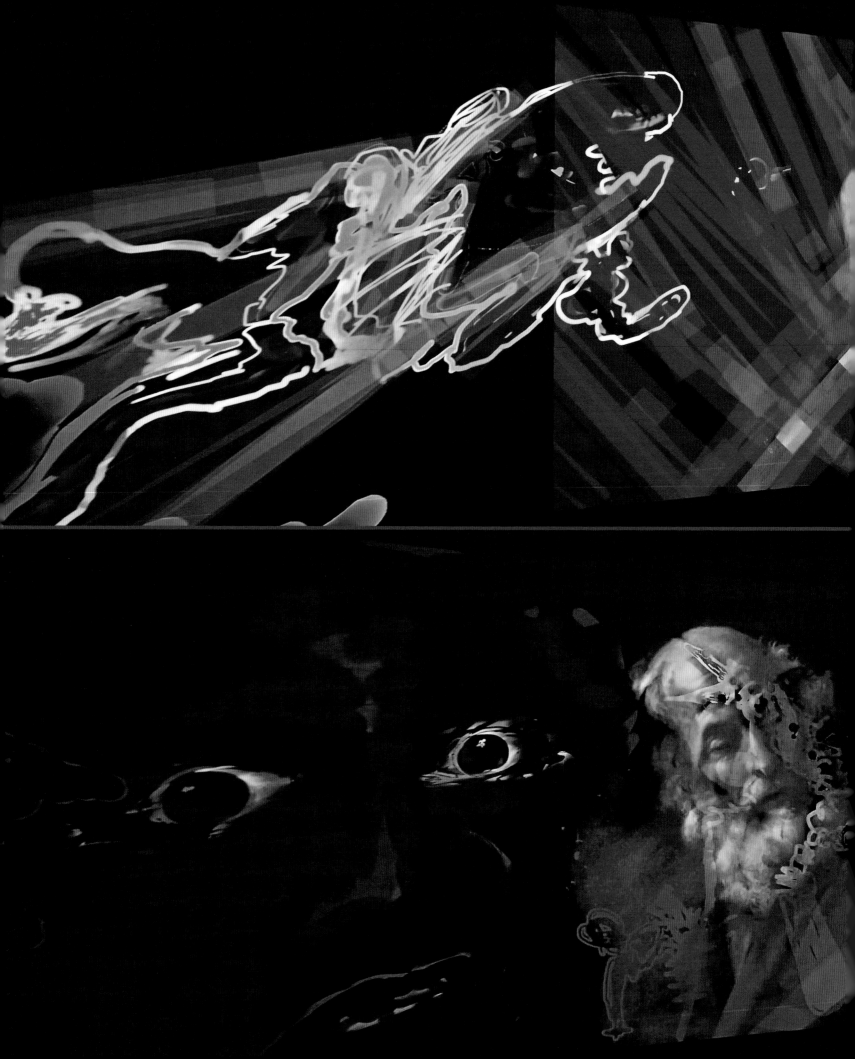

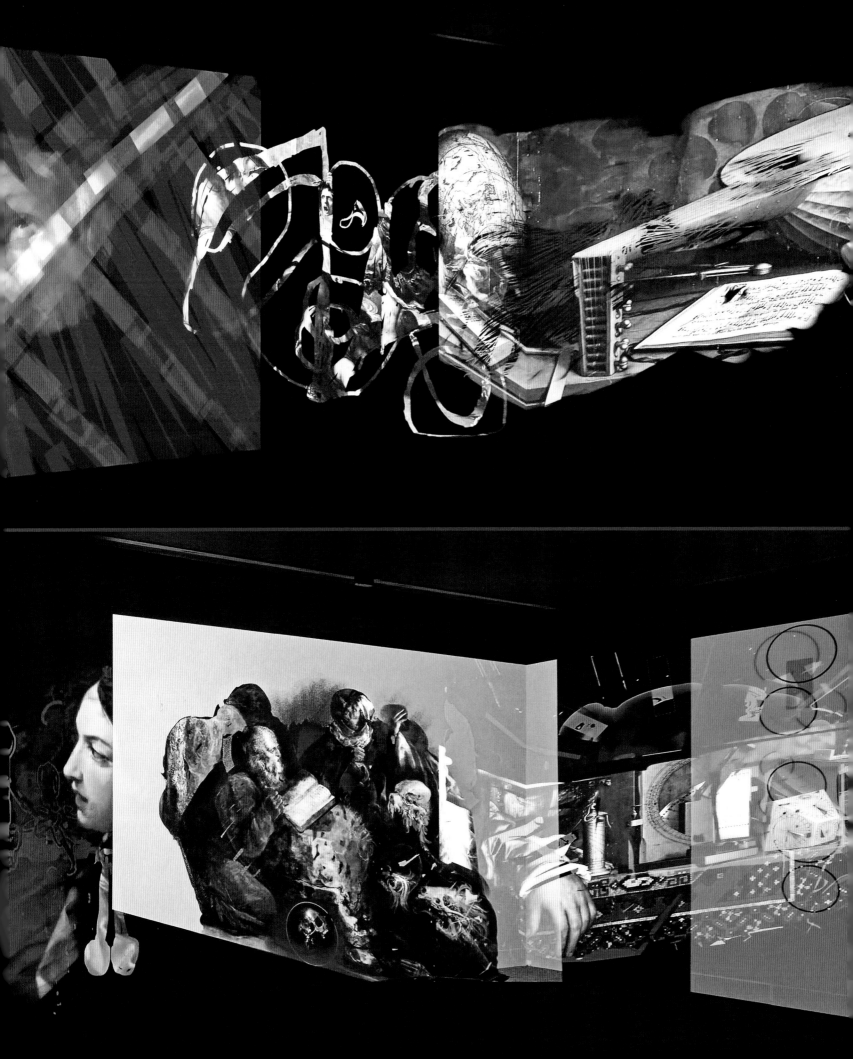

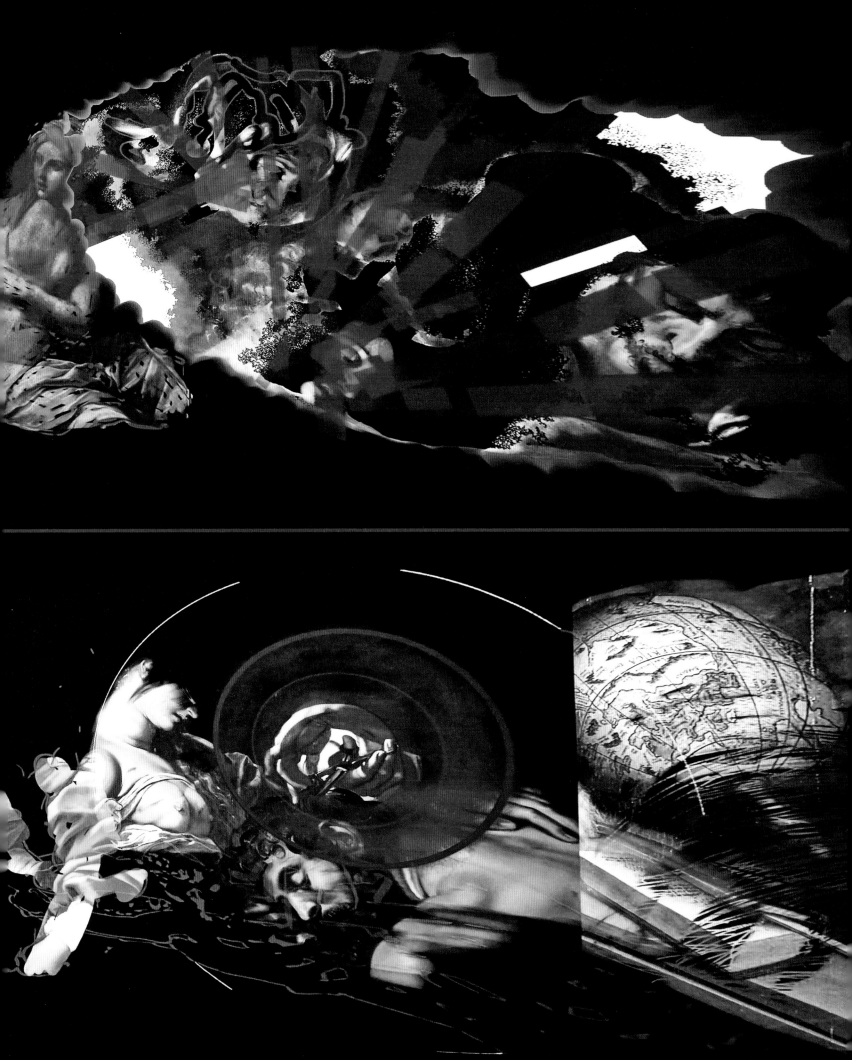

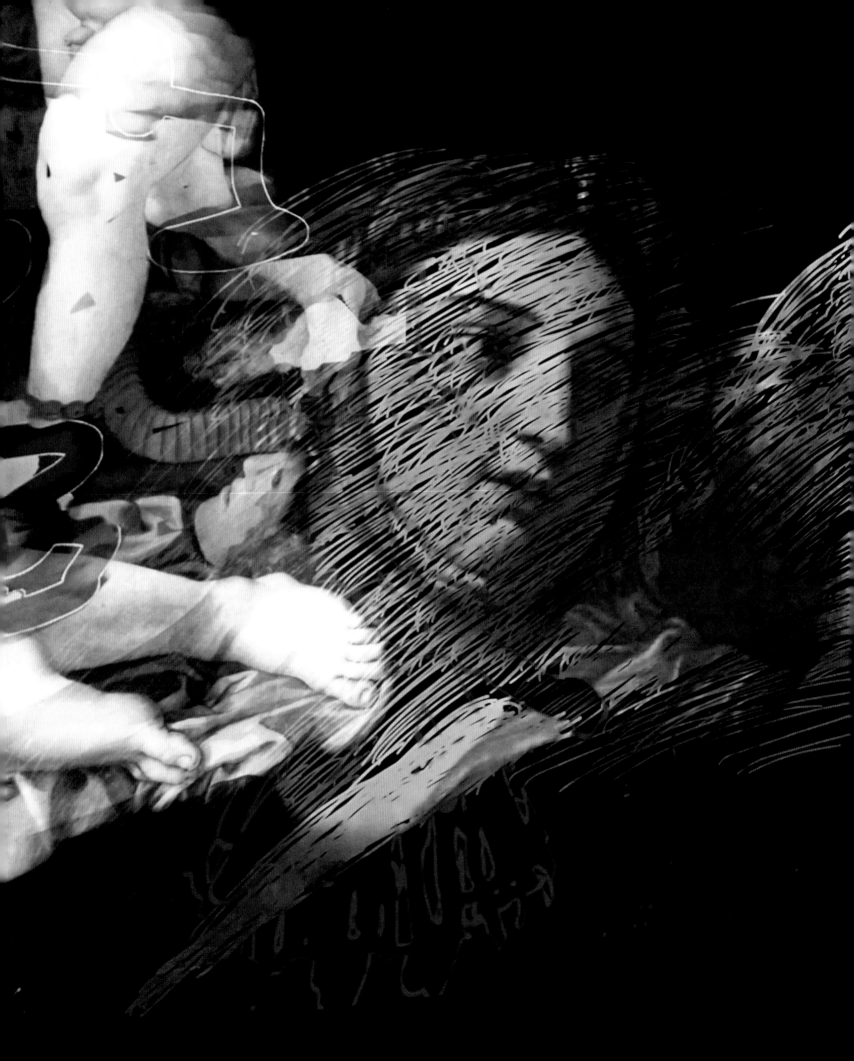

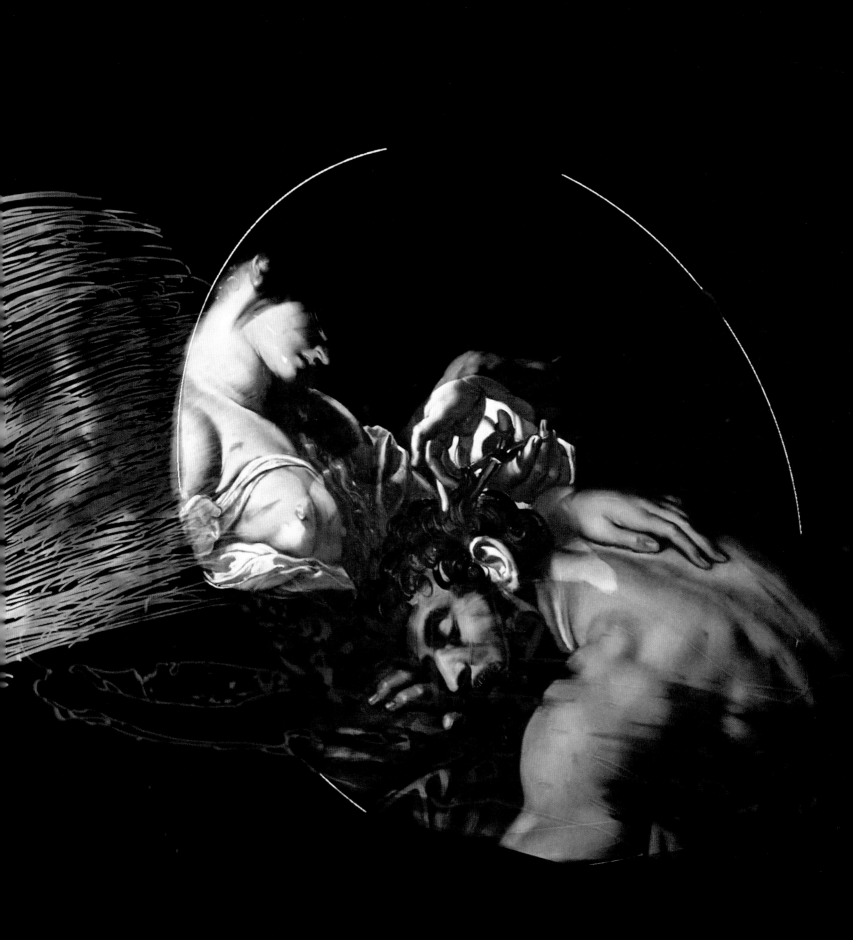

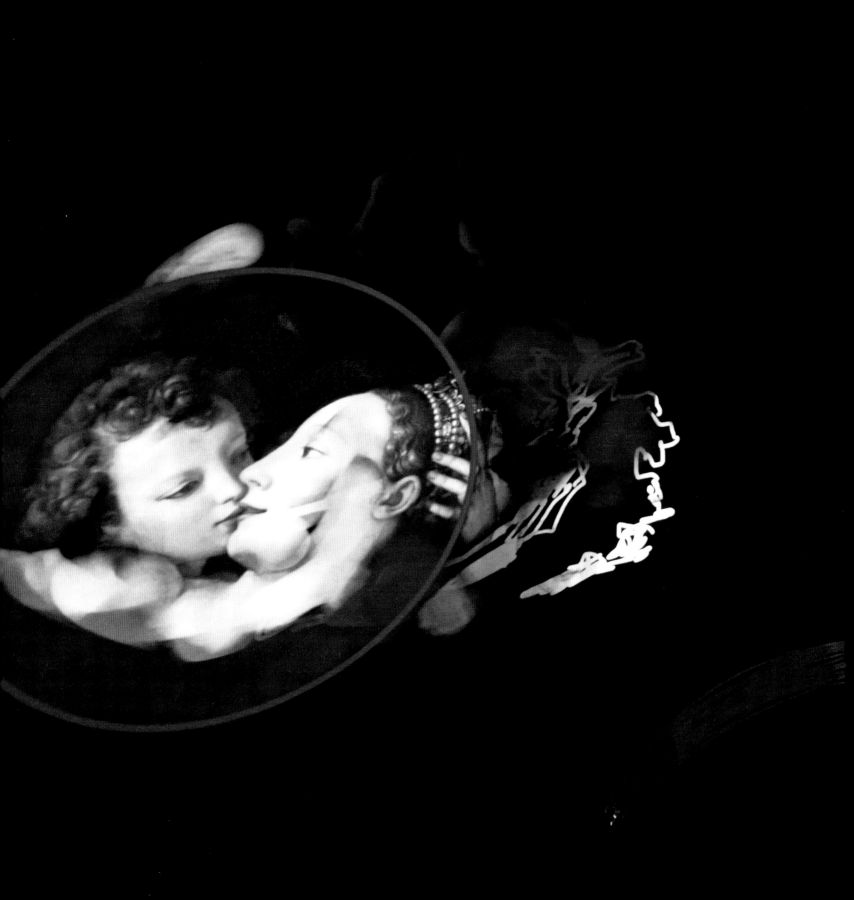

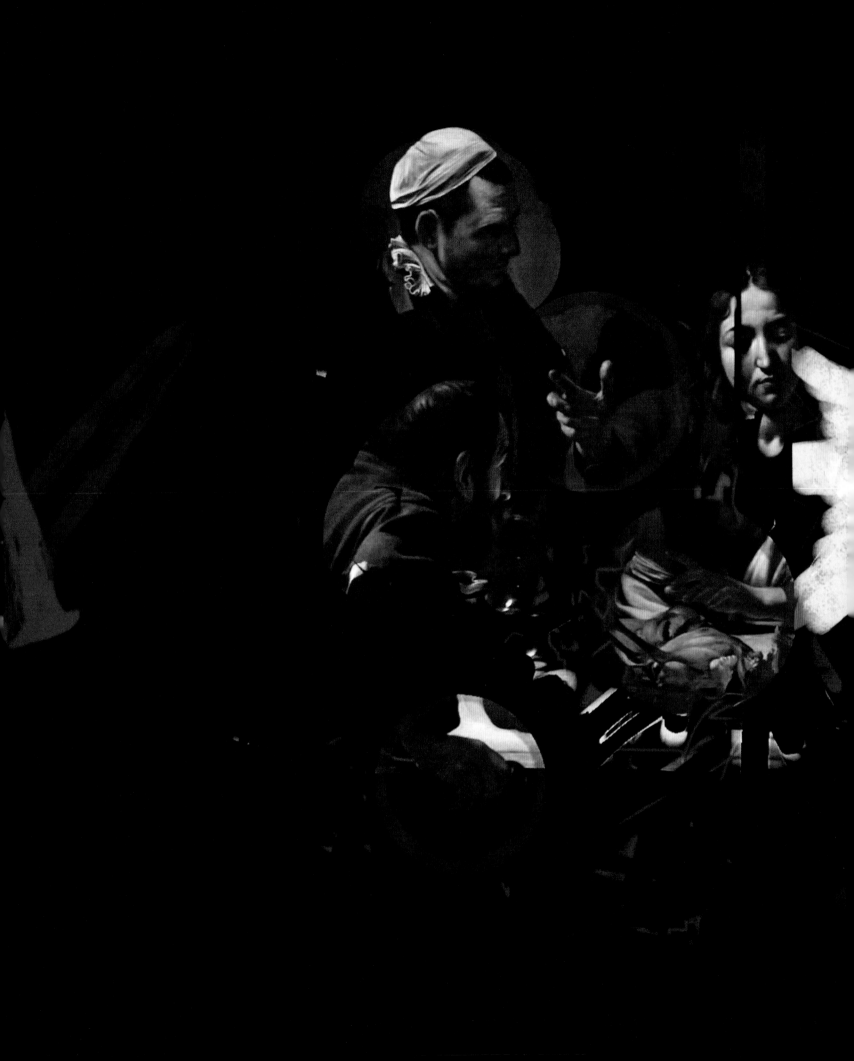

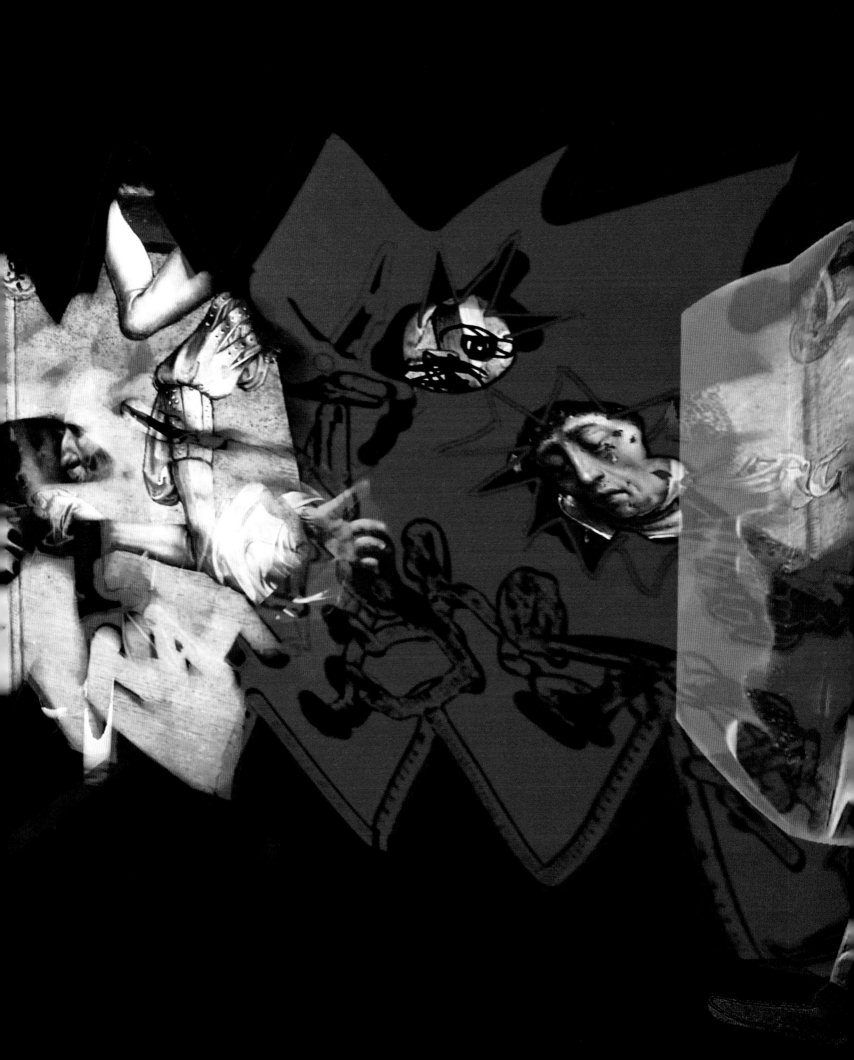

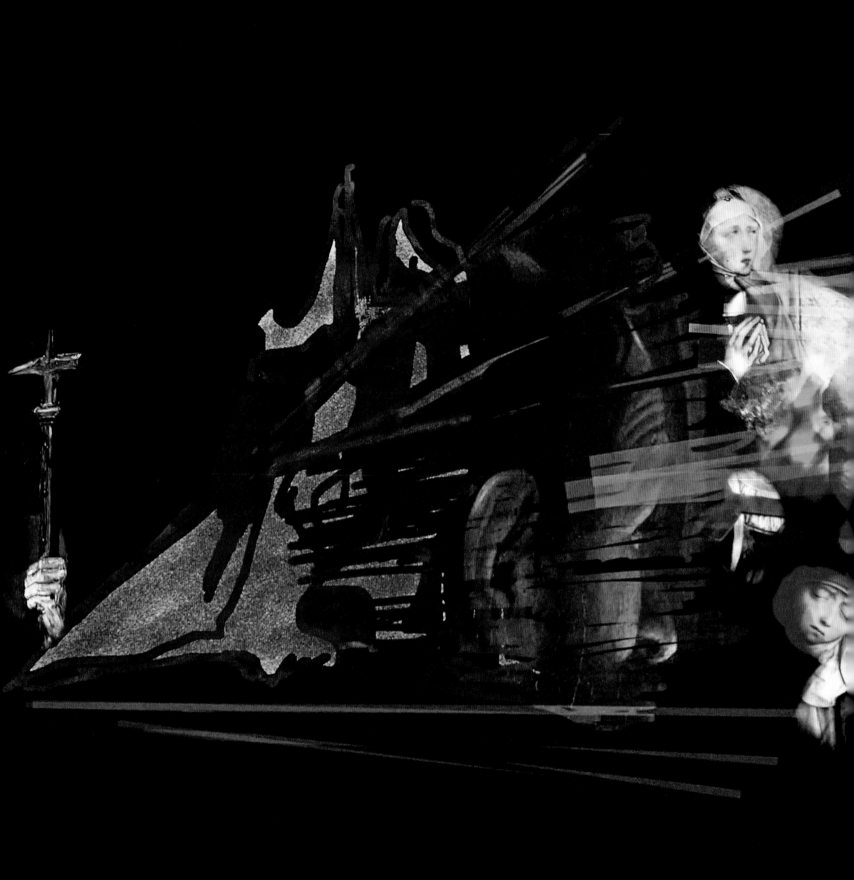

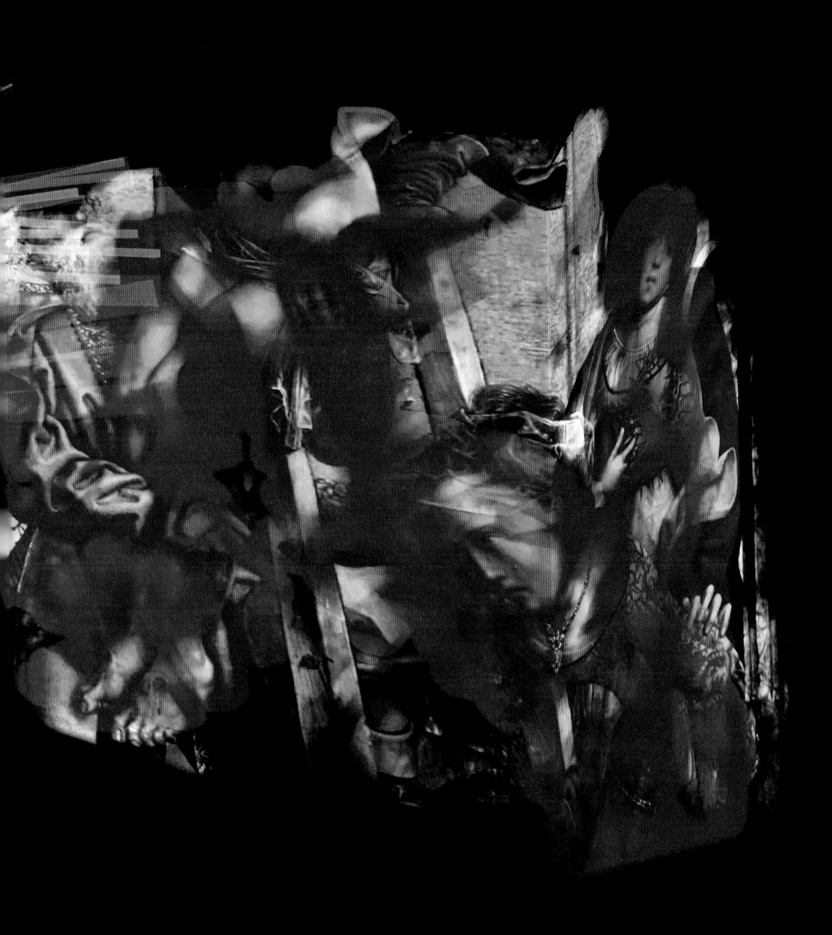

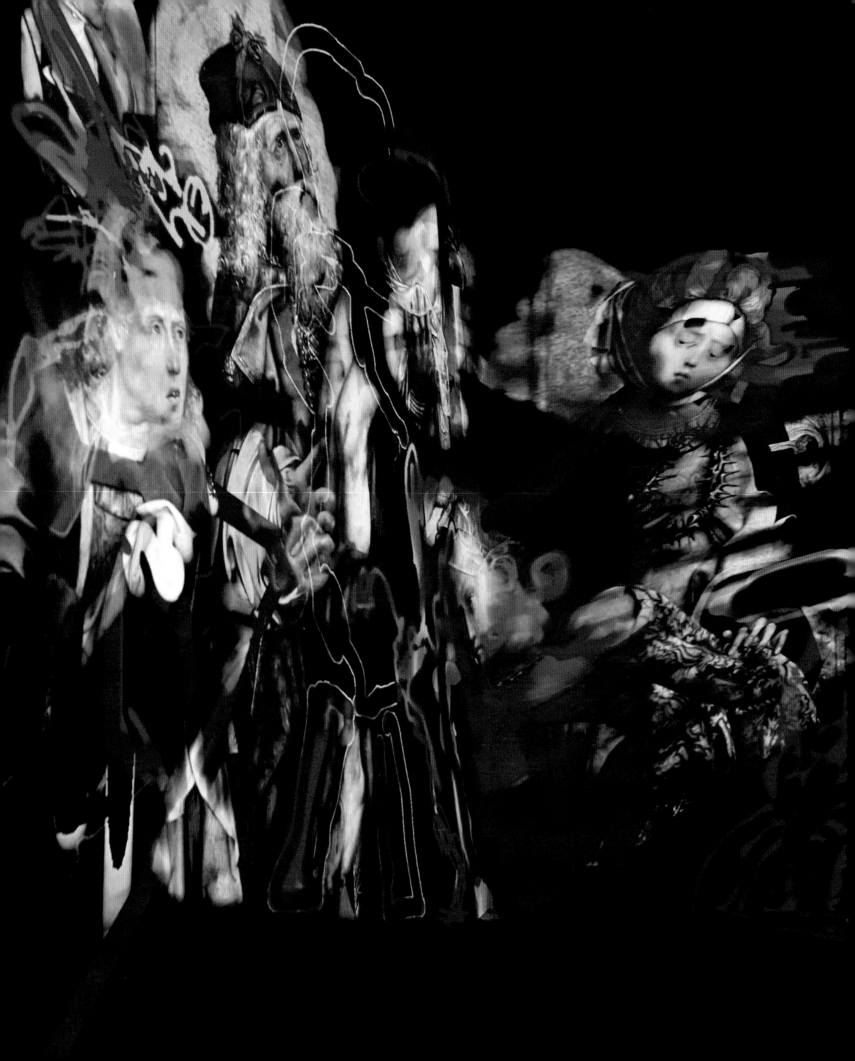

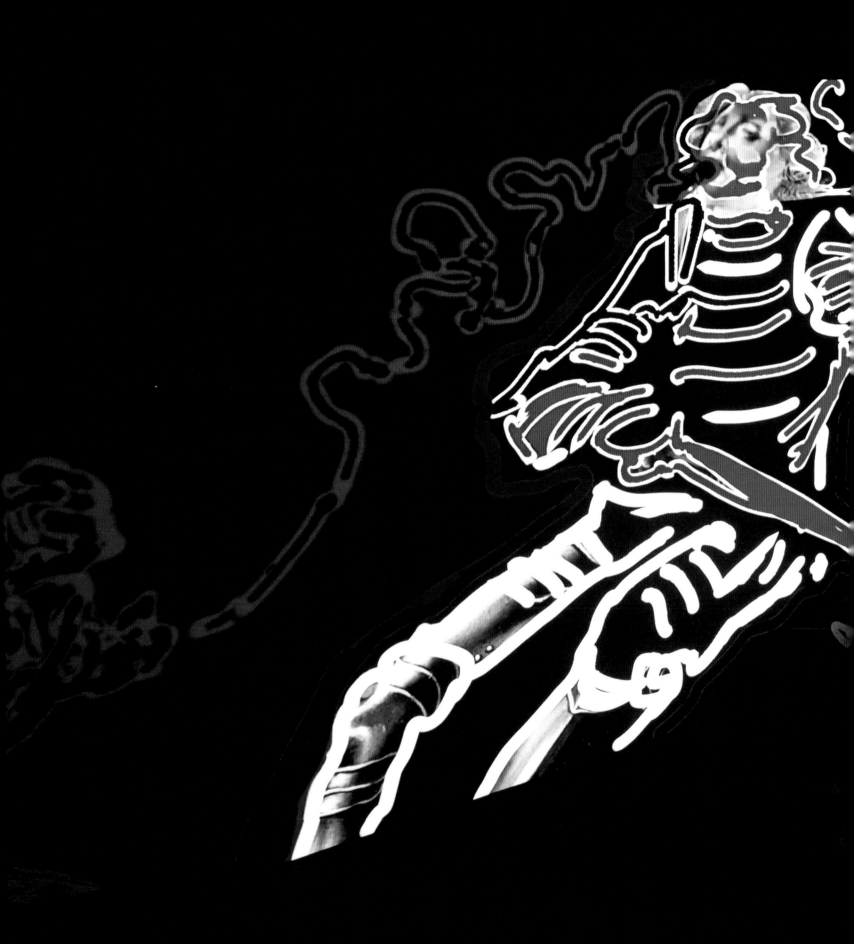

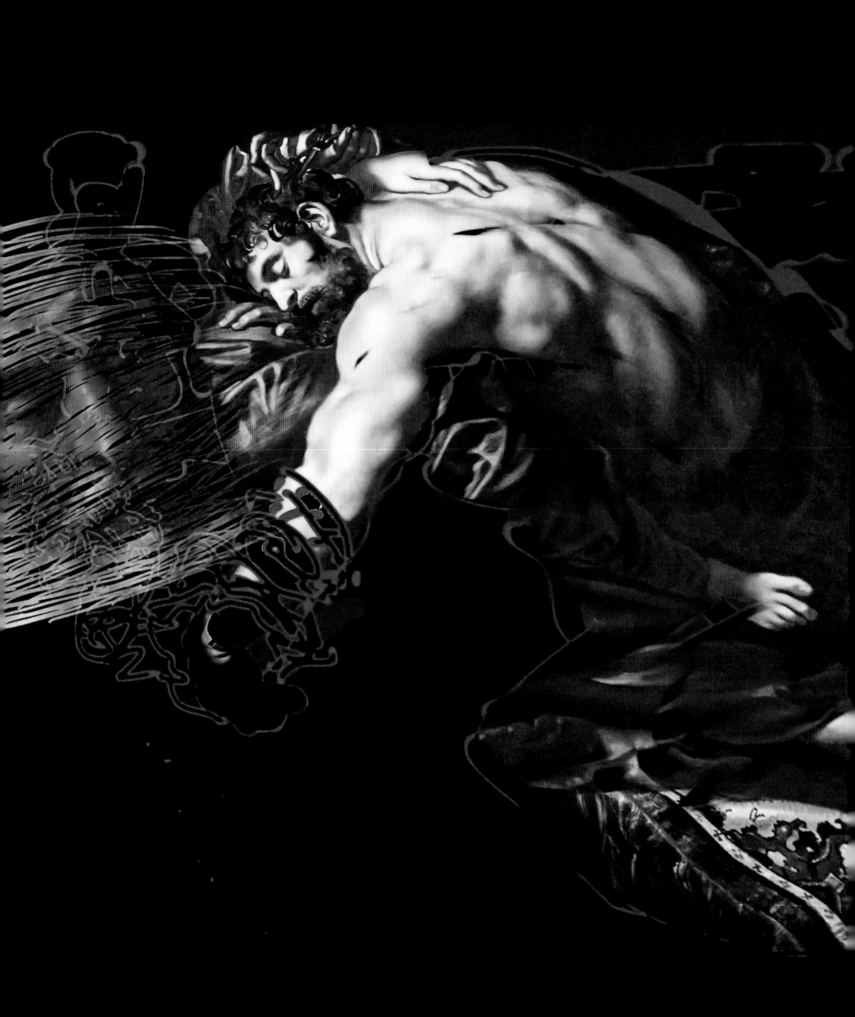

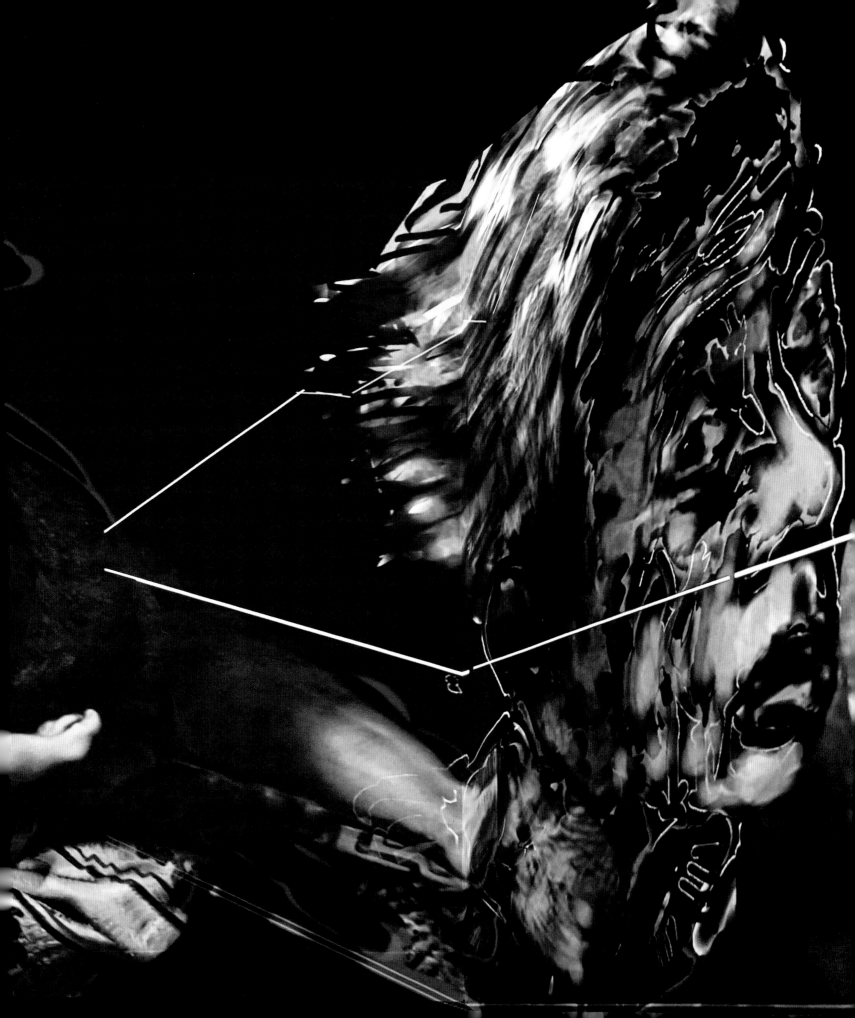

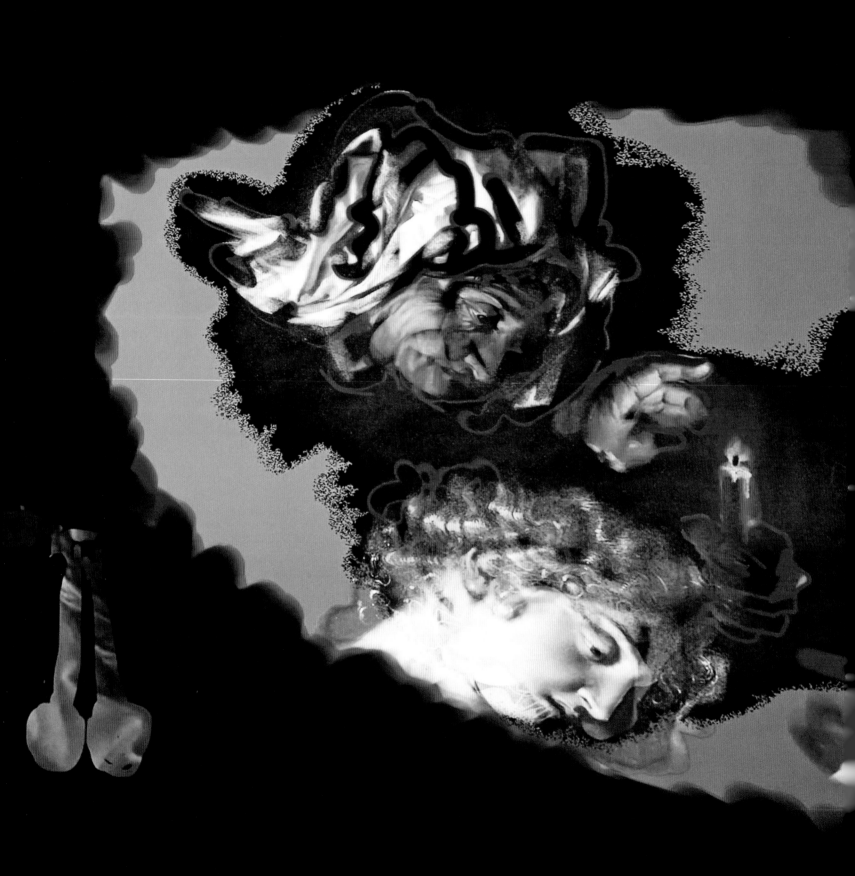

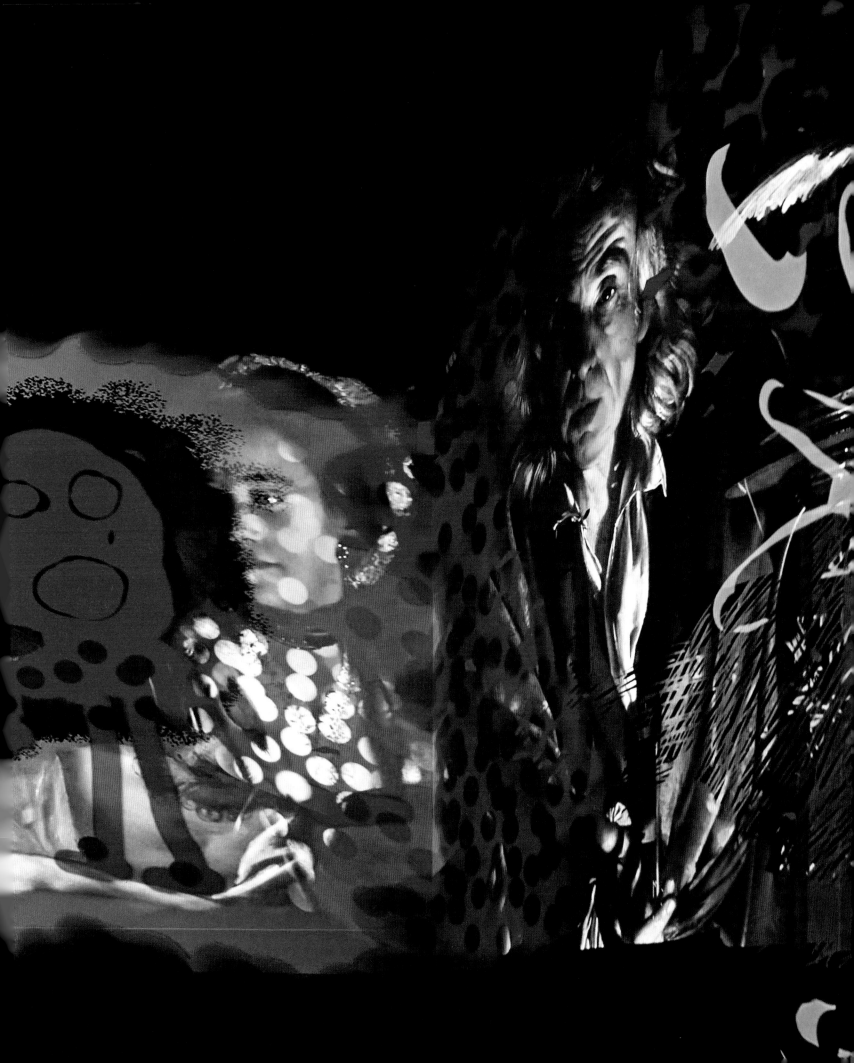

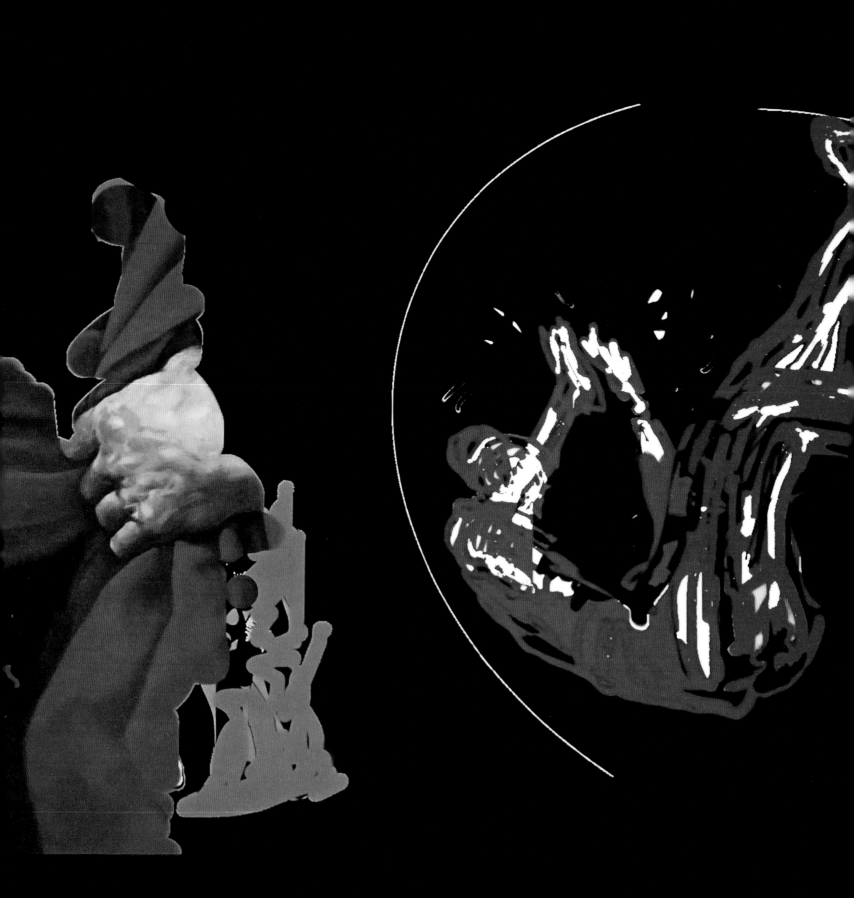

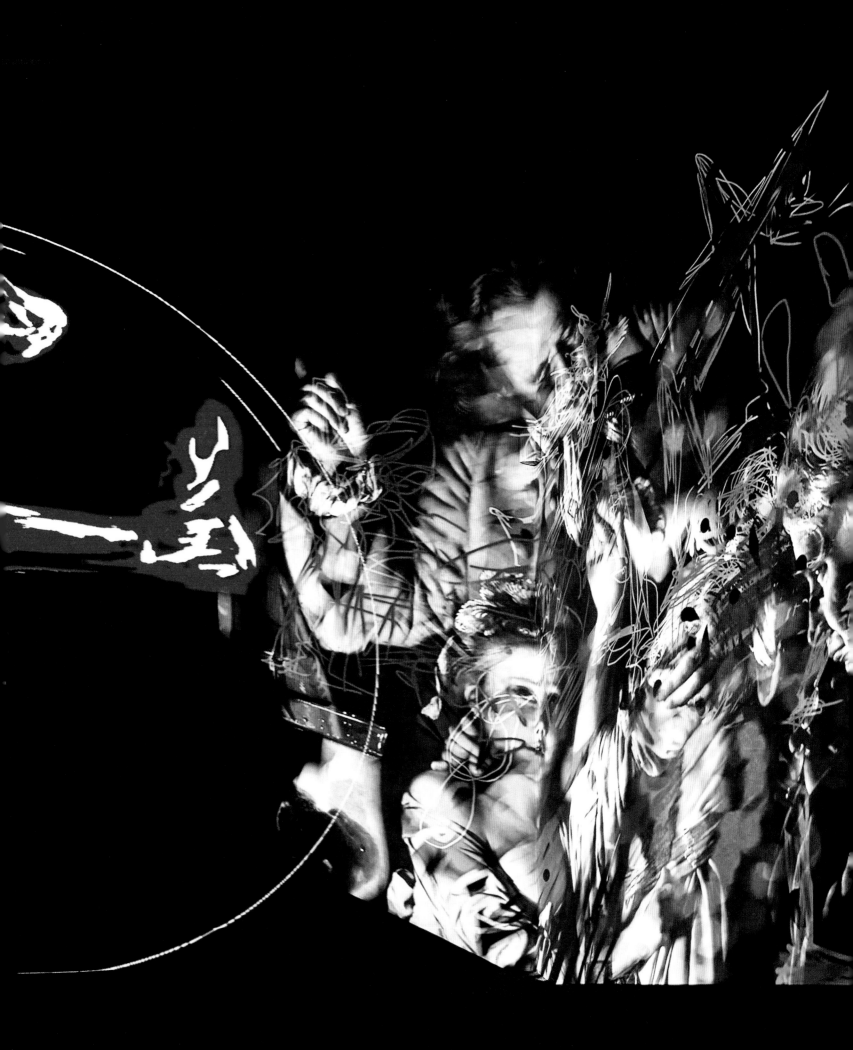

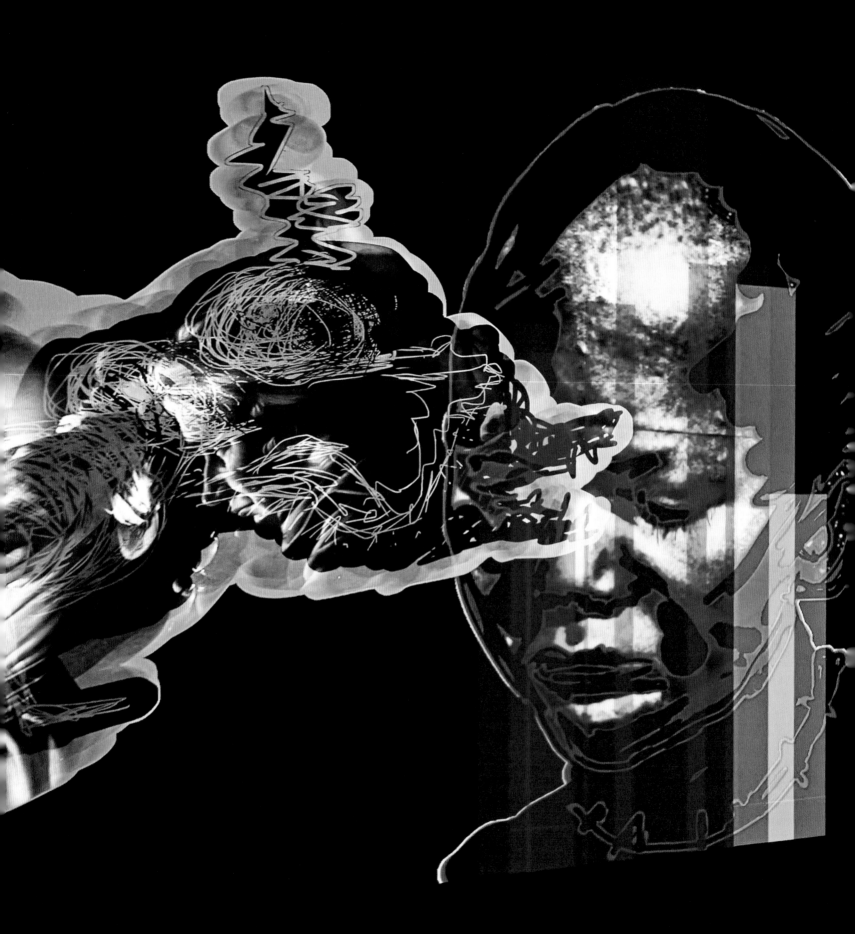

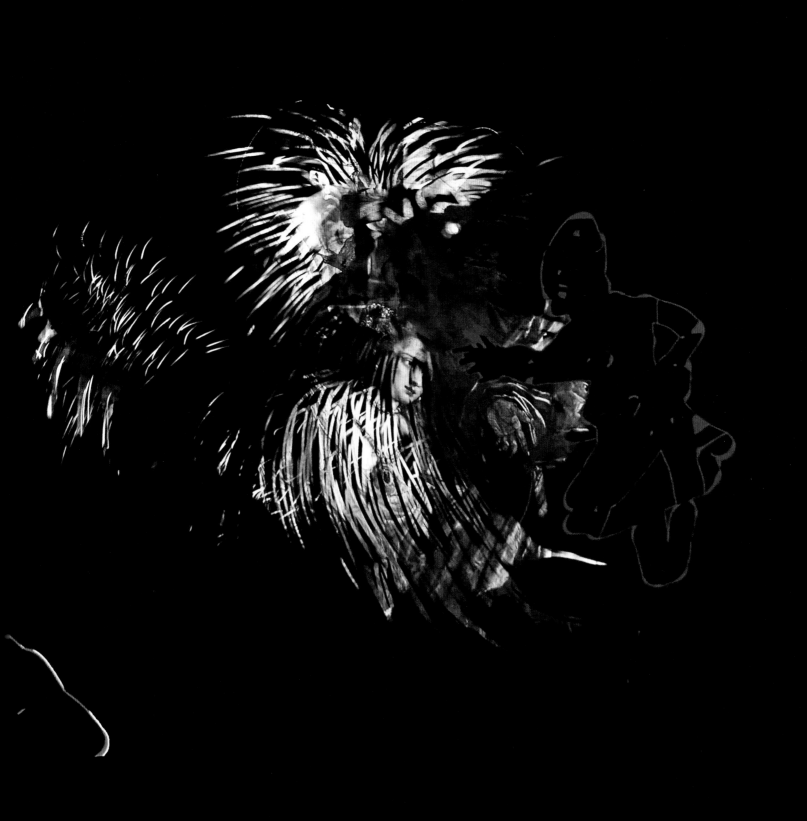

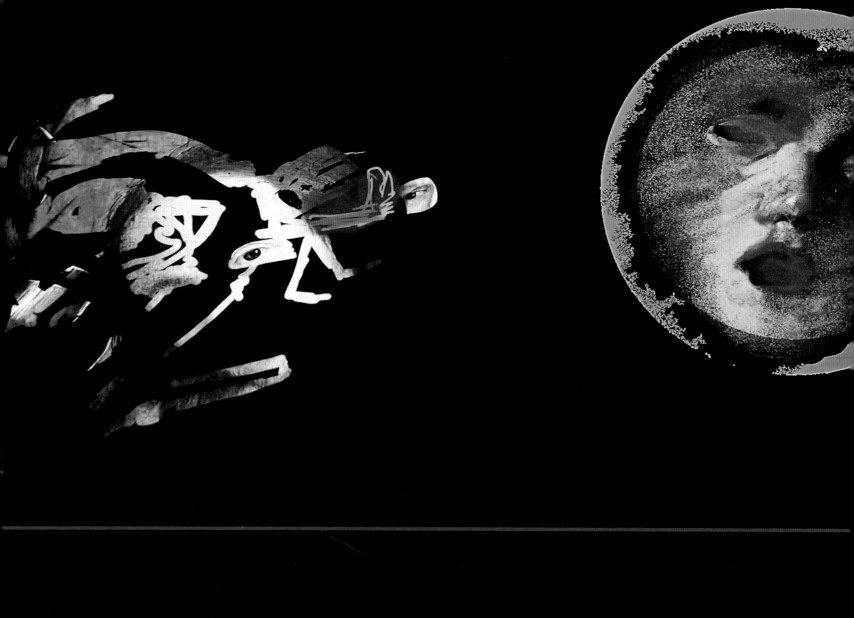
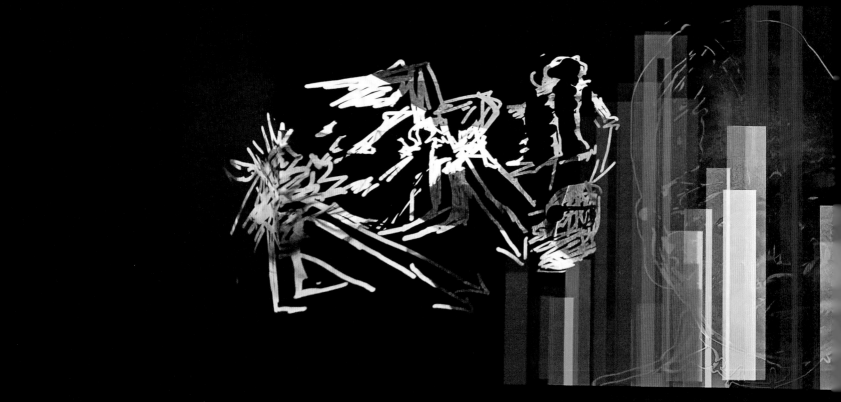

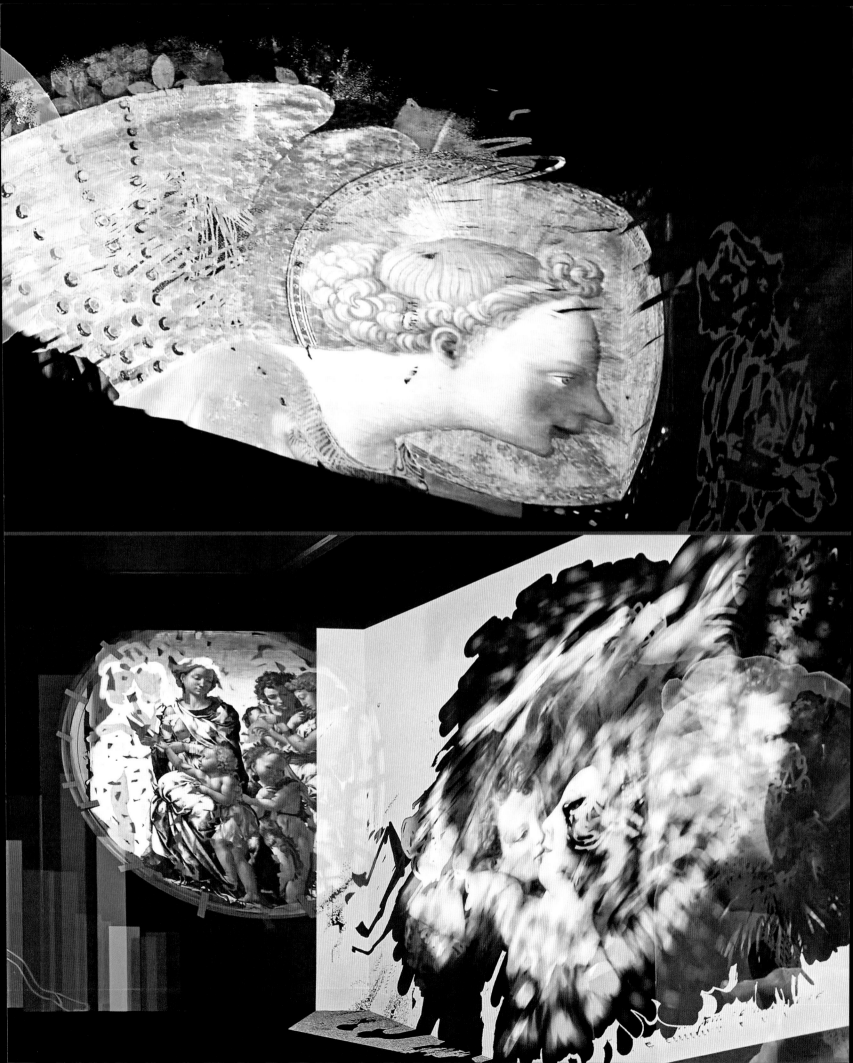

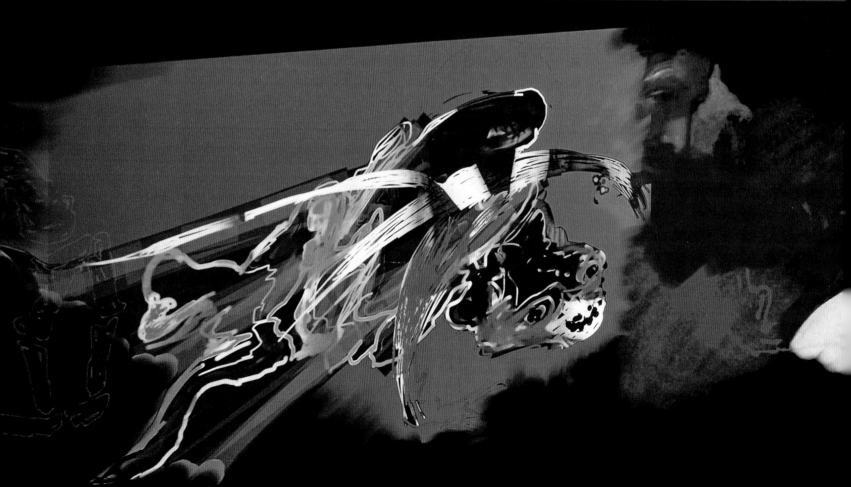

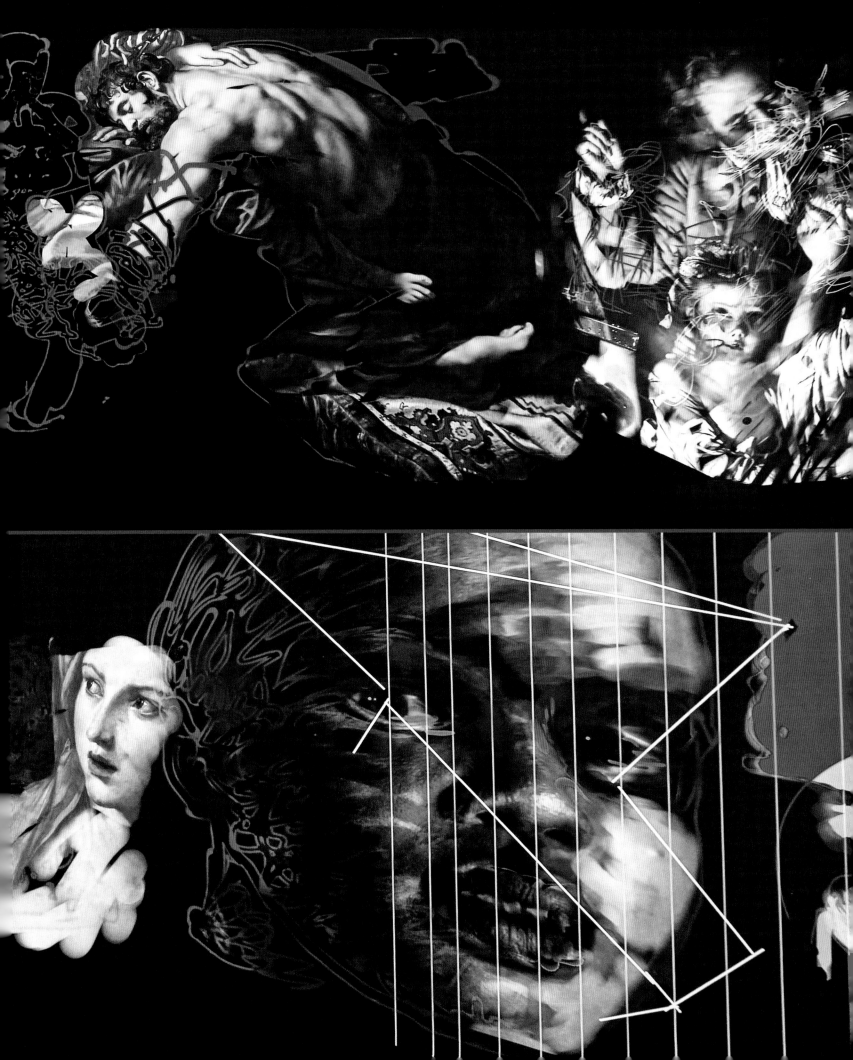

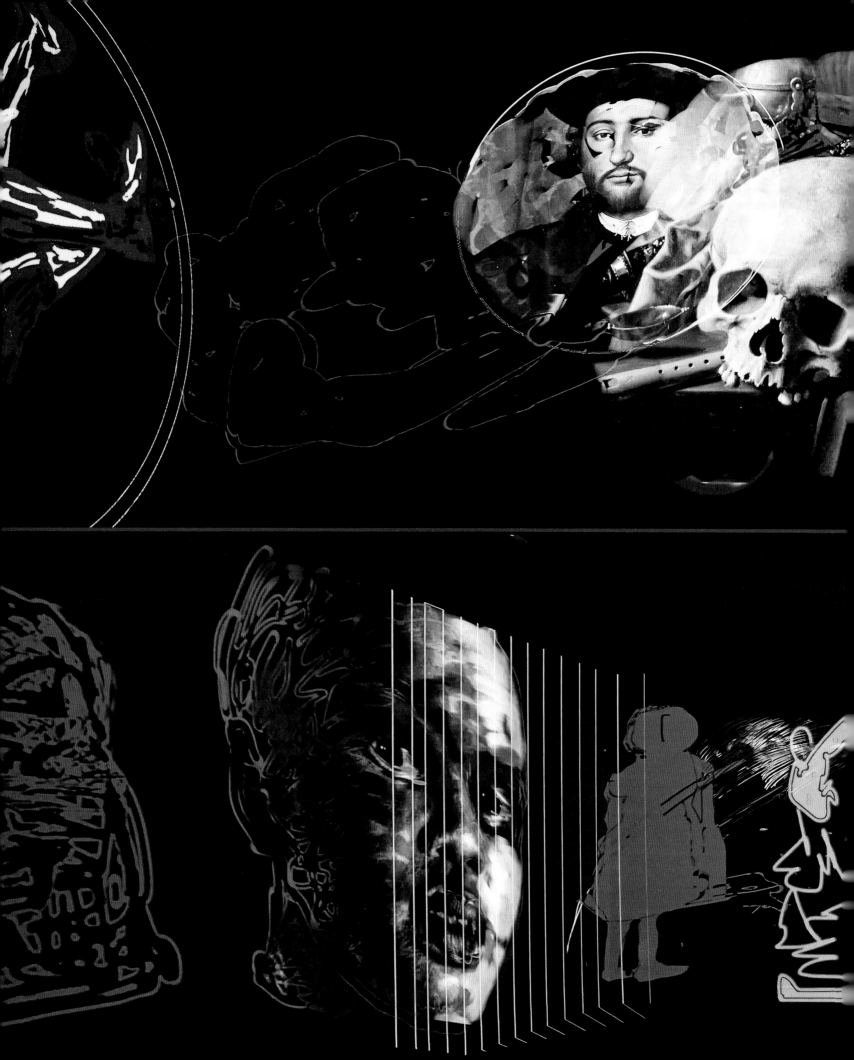

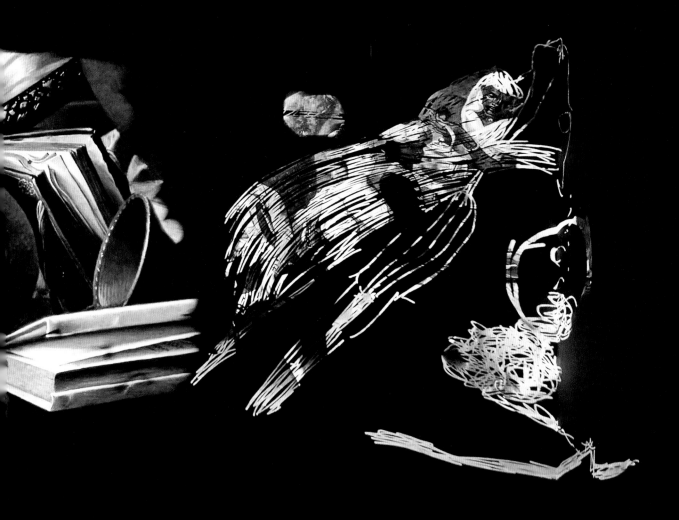
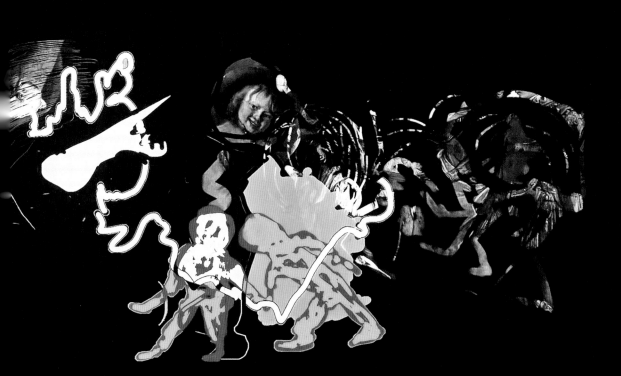

Inter-ships with Nalini Malani: The Foreshortening of Time

Mieke Bal

The preposition 'inter' refers to relation; to what happens between people, times, nations, disciplines, media. In an intercultural collaboration, Nalini Malani, one of the most productive creators of politically powerful, *activating* art, makes her viewers think, animated as they are by the experience of her work. She is currently the inaugural National Gallery Contemporary Fellow, a two-year research project preparing for exhibitions at the National Gallery in London and the Holburne Museum in Bath. The invitation included the request to respond, hence, to relate, to the museums' collections. This entails the challenging undertaking to establish, or rather, to *figure*, an *inter*relationship between historical still images such as paintings, and Malani's contemporary moving works. For these exhibitions she is working in her newly invented medium: animations made by tracing her fingers over an iPad screen. The animating, activating force of these works gives the genre-medium name 'animations' a second meaning. Inter-historical, intermedial and intercultural: no one is more apt to establish such multi-tentacled interrelationships than Malani. Bridging differences without erasing them, the central mode she deploys is narrative. But then, how does she tell stories so that they relate, steering clear of individualism and particularity?[1]

This project clearly performs what I have called 'pre-posterous history': an inter-temporal relationship where the past and the present are in conversation, instead of a conventional chrono-logic with one-directional linearity. Merging old master paintings and the contemporary in each animation is a perfect example of that. Since the work is still in the making as I write this essay, I cannot imagine a more radically contemporary work. That contemporaneity matters, especially in art that so insistently experiments with temporality, and in a project where history meets today in an intense form of what I have termed 'inter-ship'. Malani is constantly connecting, linking, integrating; her work is essentially performing *inter-ship*. The request to respond to the museums' paintings matches Malani's ongoing experimental, creative spirit.[2]

Intermediality

This artist does not simply make 'works'; instead, she experiments not only with content and artistic form, but also with media and the space in which her works appear. Thereby, she invents new media or media combinations. She gives the currently much-discussed topic of intermediality an entirely new, mobile and changing meaning. She does not 'adapt' one medium to another, as in cinematic versions of famous novels. Her intermediality is much more far-reaching than that. The result tends to be an interaction that moves both ways rather than a finished product. From the outset, she always gave her works a twist that enabled a transformation of the medium. One of her very first works, made in 1969, was a film animation of small, coloured blocks. Seven years later she paired this with a black-and-white film, juxtaposed alongside it. In the new sequence, a woman looks out, melancholic, at the little animated blocks that, through her gaze, *become* clearly architectural. And through this apposition, so does the work itself, now

Fig. 20 *Utopia*, 1969–76
16 mm black-and-white film and
8 mm colour stop-motion
animation film, transferred on
digital medium, double video
projection, 3:49 mins

a diptych called *Utopia* (fig. 20). In an inter-ship between art and social reality, the architectural aspect takes on an activist meaning as a plea for improvement to city housing, unfairly out of reach for the working-class woman. This intermedial intervention enhances the political impact of the animation, by means of the juxtaposed film.[3]

Malani continued to experiment with transforming media to create new forms and narrative possibilities. Another example is the way her multi-panel paintings play with the cinematic. The fragmentation of the invoked story over many (sometimes 16 or 32) panels, figures in a different mode or medium what in the cinematic is the temporal succession of frames. This unification in fragmentation is crucial both in her paintings and in film. She calls another medium she has invented 'erasure performances'. In these, she wipes out her wall paintings at the end of exhibitions to figure her solidarity with artists whose murals have been neglected. And so she goes on; her boundless creativity extends to exploring what a medium is, can be, and especially, what it can *do*. And here, let's remember that the term 'medium' is synonymous with the preposition 'inter'. Until a few years ago, her most famous and complex media invention consisted of 'video/shadow plays', begun in the 1990s and reaching worldwide renown in 2012 with *In Search of Vanished Blood*, commissioned by Carolyn Christov-Bakargiev for dOCUMENTA (13). As yet another inter-ship, there she included her own voice, distorted, bringing her subjectivity in connection with older stories. Here, in the Bath–London project, she makes paintings and drawn animations interact, also bringing in sound and addressing the space. This carries the old master paintings into the present, back to life, and renovates their relevance. It also intimates a critique of the Western tradition, where exploitation of workers (slavery) and of women (nudity) was standard. Thanks to her intervention, the paintings are no longer still – not as flat surfaces, and neither as taking-for-granted those subjections of people. This shakes up the museum as an institution where conservation is primary – a necessary task, but also one that resonates with 'conservatism'.[4]

Consistently experimenting with ways to substantiate and diversify Marshall McLuhan's 1964 dictum 'the medium is the message', this exhibition proposes yet another inter-medium: incorporating cut-outs from the old master paintings in ways that, in each instance, vary the dimensions and colours of the original works. After an in-depth study of the two collections, the artist has selected twenty-five paintings for a series of nine animations. But don't expect to see these presented in a new gallery display with the paintings. Given how rich each of these works is, I am severely limited in what I can account for in this essay. I have chosen two only, in order to bring up two aspects of Malani's constantly moving (in the two meanings of that verb), very special and affectively effective modes of intermedial storytelling. In both animations, hands play an important part, almost as a form of sign language. In Malani's earlier animation chambers, the spatiality of the projections' installation was of major importance. If I now combine (inter-relate) space, hands and the interaction between paintings and animations, one aspect that foregrounds the various functions of the hand is what is called 'foreshortening'. And in her dialogue with the historical paintings, the way Malani has cut out details from them draws attention to the synecdochic issue of the relationship between the part and the now-new whole.[5]

Becoming Baroque in Retrospect

We all need a helping hand to live. Art is one such hand. It displays horror and joy, grief and matter. Interacting with art can be consoling or socially helpful in other ways. One way is to make viewers think; to animate their minds, while allowing them to inter-relate with the works. Foreshortening is a millennia-old painterly technique of transforming a flat image into an illusion of three-dimensional space. This technique was frequently used during the Renaissance and reinvigorated in the Baroque, at its height in the seventeenth century. Not coincidentally, the three paintings selected for Malani's second

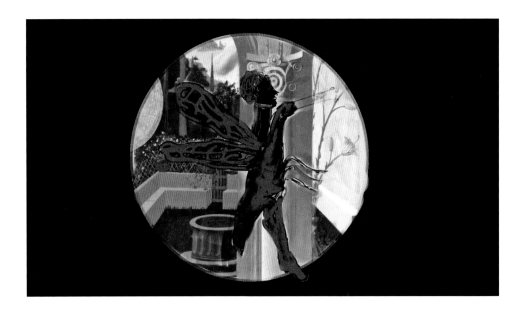

Fig. 21 Still from *My Reality is Different*, 2022

animation are all by Caravaggio (1571–1610), that quintessentially baroque painter who gained a reputation for not being good with space because he did not care for linear perspective. Instead, he deployed 'colour perspective': playing with light so that bright colours come forwards and dark ones recede. This transformation of spatiality is recognisable in Malani's animations, where the black background makes the brightly coloured moving figures stand out starkly, giving them an almost 3-D effect. Her creations burst into life out of a tomb-like blackness. This is profoundly different from linear perspective where the one-eyed viewer's gaze falls into the abyss of the 'vanishing point'. In some sections of the animations, a (Renaissance) painting made in linear perspective is thus made to quiver through the colour perspective, as we can see in fig. 21. Malani's hand-drawn angel also oversteps the circular frame, hinting at adult dimensions, countered, however, by the protrusions growing out of its body.[6]

Instead of receding, Malani's moving shapes and lines extend forwards into our space. This becomes even more prominent when her drawn lines contrast with a fragment from a quiet, classical-looking painting. The still from one of the animations above shows those multiple extensions of the figure's body, thus raising the question of ontology: who or what is this figure? This fits with the following 'imaged' vision in Christine Buci-Glucksmann's quotation from Francisco de Quevedo (1580–1645), which opens her study *Baroque Reason*:

> Imagine a city with several entrances, a labyrinthine proliferation of squares, crossroads, thoroughfares and side streets, a kind of multibody of the past and memory.[7]

The spatial, then bodily hecticity of this description resonates with the temporally hectic and variously impacting movements in Malani's animations. That multibody exists today, as a possibility.

The artist probes that possibility, for she doesn't take no for an answer. Her constant invention of new (inter-)media counters any attempt to pin her down to a fixed tradition. That is what makes Malani's 'baroque figuring' contemporary in its inter-ship with the historical Baroque and what came before it, as well as with other elements or aspects of art, people, space and the world. Her narrative figurations adopt fragments or scraps of baroque aesthetic and thought in a multiple practice of quotation, which takes from the outside in and ramifies from the inside out. They are arguably 'fictional', yet are neither parallel to nor, consequently, independent from the actual world. In fact, they militate against such autonomy, precisely by quoting the contrasting way baroque art militated for an enfolded, entrapped

relationship with the real world. This is how the still architecture is adopted in the animation. This inter-ship that activates Malani's integrated figurations neither entails something that is simply relativism, nor does it allow universalism or absolutism to assert itself. The term, rather, is 'entanglement'. This entanglement moves along, whether we are looking at cut-outs from the historical paintings, at later manifestations of a 'baroque style' or at ourselves in the tones that the Baroque has set for us so that we can have baroque (re-)visions. But in each case, the outcome – us, our view – is different, for it is differently entangled. Inter-ship is another word for this. The art gives us a hand in that delicate, wavering uncertainty.[8]

Give Me a Hand

In the three paintings by Caravaggio that Malani selected to bring to life and into the present in one sequence of the animations, hands play a main role, differently in each one: holding the plate carrying the head of John the Baptist, trying to shake off the lizard that bites the boy, but first of all, the hands of Christ blessing the meal, and the hands of those he addresses. It is their reaction that matters.

This last, best-known painting is Caravaggio's *The Supper at Emmaus* (1601). The somewhat baby-faced Christ appears after his death to some more elderly-looking apostles, who at first fail to recognise him. He reveals who he is through the gesture of his hand blessing the meal. The man on the right extends his hands in awe or welcome; the one on the left grabs his chair with his hand as if almost falling off it, astounded. But his gaze falls on the hand of Christ, riveted. They form a pair of storytelling devices: the gaze, which connects one figure to the other, and the extension of their hands, which produces the space. Malani connects their gaze and hands by means of abstract bars that suggest what in comics are called 'thought bubbles' (fig. 22). In many of the animations, Malani includes different forms of calligraphy as ways to connect elements of the narrative; a narrative syntax.

Here, the bars occupy the man's head and block our attempts to see *what* he thinks, suggesting instead his agitation due to the fact *that* he thinks. The two drawn-out hands of the man on the right figure the pictorial-narrative technique of foreshortening, a concept that is poorly defined in art reference books. *The Shorter Oxford English Dictionary* defines the verb *to foreshorten* as 'to cause to be apparently shortened in the direction not lying perpendicular to the line of sight. Also, to delineate so as to represent this

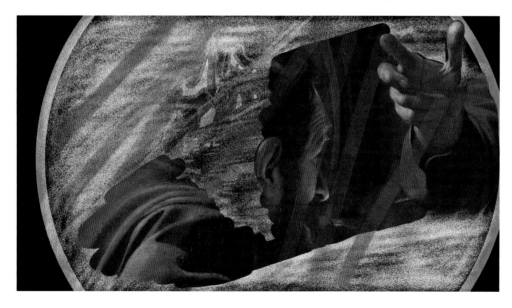

Fig. 22 Still from *My Reality is Different*, 2022

effect'. The discourse here is that of linear perspective. The definition is amusingly tautological: a transitive verb is defined as 'to cause to be', whereas 'apparently' begs the question of how this comes about. Another reference text defines foreshortening even more narrowly in terms of perspective: 'Depiction of three-dimensional forms on a two-dimensional surface with the third dimension diminished to emphasize depth; a *perspective* method for irregular forms such as human bodies.'[9]

Insofar as perspective is considered as a method for the technical perfection of the transformation of three-dimensional reality into a two-dimensional image – of representation into illusion – this may make some sense. But when considered as an alternative to perspective, foreshortening, while also involved in the production of a three-dimensional illusion, is the opposite of linear perspective in three ways. First, it extends space forwards, not backwards; second, it involves the body, which perspective had so efficiently reduced to a single eye; third, it flaunts distortion. Foreshortening is the systemic opposite of linear perspective. Forward, bodily and distorted, it is akin to the colour perspective that Malani and Caravaggio share. Through both, by means of distortion, space becomes more real, or at least more tangible.

Shortened in length and extended in width, limbs become longer, not on the picture plane, but towards us, perpendicular to it. Far from catering to the one-eyed, disembodied viewer, however, foreshortening creates the illusion that the object extends into the viewer's space. The object thus leaps off the canvas and pierces the imaginary wall that separates the represented space and everything that occurs there from the space where the viewer stands (or sits). As a result, foreshortening critiques the viewer's illusionary disembodiment. It is a perfect tool for an activating artist who deploys storytelling to shake us out of our passivity and complacency. Malani's engagement with foreshortening is one of the ways she enacts her commitment to binding; her political force.[10]

This is possible thanks to the paradox of foreshortening. Although allegedly serving the illusion of realistic representation, 'giving body' to the flat surfaces that constitute the figures in a scene, its political effect is very different. While linear perspective moves backwards, producing a space the viewer can possess, colonise, but not risk entering, foreshortening moves forwards, bringing the figures to life but, in the same move, challenging the viewer's imaginary safety and isolation from the presented (fictional) world. Animation as activation responds to this goal and multiplies its effects. As a result, foreshortening breaks the realistic illusion at the same time as supporting it. Or rather, it changes it and its modalities of viewing – from a distanced and disembodied mode of looking to an engaged and embodied one. This is a helping hand indeed. With foreshortening, the mode of the artwork shifts away from representation, with all its illusions, into a realm that binds the image to the viewer, visually and affectively. This compels the viewer to think. I cannot help but see the trick, hence refuse to fall for its illusionism, while at the same time wilfully allowing it to stimulate engagement. For what happens instead in the ambiguous realm where I know I am overstepping a boundary, yet feel required and delighted to risk doing so, is perhaps more crucial to what art can accomplish. This is how Malani intermedially transforms visual narrative, and the way we see it, from contemplation to interaction. She makes the work politically effective by stretching out a helping hand to promote thinking.

The inter-ship Malani establishes with Caravaggio is a visual discussion about the relevance of the creation of space in art as a way of engaging viewers to respond actively. As a principle of art's spatial *inter*-activity – a trigger of an experience of ontological transgression – in Caravaggio's time, foreshortening became a ground for experimentation and innovation *after* (post-)linear perspective. When the wonder of the visual mastery of extending space towards the horizon was no longer new, movement in the opposite direction became a source for an altogether different kind of wonder. One might call the experience of foreshortening – not the technique or the trick, but what it triggers interactively – 'baroque'. For me,

that term stands not for an art-historical movement but for a visual philosophy of perception, enticing inter-activity through the body – which I believe is crucial to Malani's art. Her hand-made animations, a feature made more emphatic by bringing the fingers forwards as the live tools of figuring, *perform* the creation of space for which foreshortening had been brought in. Thus, she embraces Caravaggio's innovative spatialisation and modifies it. Even in a large and rectangular gallery, a format that precludes the kind of installation Malani had in her previous 'animation chambers', a slight overlapping at the seams of each work enhances what the works contain and do: movement, in all possible senses. They speak to each other. And since they have different durations, that conversation is ongoing.

Foreshortening Time

The technique/medium of animation implies a profound questioning of the division that defines fiction as distinct from reality. Caravaggio as Malani's interlocutor in the animation that reflects on his *Supper* is so important because, in the wake of the general jubilant endorsement of a recently invented linear perspective, he embraced foreshortening as a typically baroque device. The technique took on a new life as a modifier of perspective. But, like all posteriorities, it also turns against what it seeks to bring to perfection. 'After' denotes chronological following, including the burden of antagonism and 'knowing better'. But 'post' also implies a movement *through* that which the later moment pretends to supersede. This is how a sense of 'working through' is inherent to posteriority. The interplay of hands in the old master painting and the superimposed animation achieves this. The baroque endorsement of fiction as part of reality, as a means of making us understand reality better, is the building block of the bridge Malani builds by means of her version of 'baroqueness': the lines flashing by at full speed interact with the extended hands she has incorporated into her moving figurations.[11]

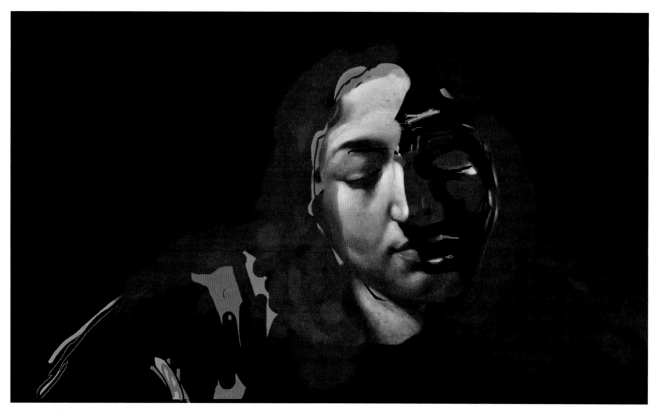

Fig. 23 Still from *My Reality is Different*, 2022

Foreshortening, if it is to be 'post-' linear perspective in this way, can be expected, either alternately or simultaneously, to be more illusionistic than Renaissance perspective, to be critical of perspectival illusionism, and to change it from within by 'working through' it. And since the technique is here deployed in hands, a follow-up question emerges. What is the point of all those hands as a figuration of story-telling? Shaking hands when meeting, holding hands when walking in couples, stretching out a helping hand, imploring for help ('give me a hand'); but also, the hostile hands of assaulting aggressors. And they are a tool for the visual artist whose 'hand-made' work is unique in its authentic handiwork. In the animation, first red, then blue, abstract, triangular forms connect all the hands for brief moments. The intense gaze of the man on the left is connected to Christ's outstretched hand as if imploring for the helping hand by means of those abstract liaisons. He looks at his hand, not his face.

In the *Supper* the figures are all male. This provokes one of Malani's enduring engagements: to counter the overlooking and, worse, exploitation of women. Someone in the kitchen of this house has cooked the meal; and we can bet it was a woman. Malani's commitment will not let that erasure pass unnoticed. Shooting arrows, as if furious, appear as Christ's head merges with a female figure like Mary Magdalene's, suggested by her mythical long hair growing over his: inter-gendering, one could say. And that face also turns half black, establishing yet another inter-ship (fig. 23). In different moments, the head of a man, a worker, also suggests a person of colour. And falling or prostrate men intimate the thought that common men are the victims. The inter-gender, inter-racial face bound to that of Christ responds to the brief flashes of the heads of non-white workers that we see appear every now and then. These heads look at the viewer looking back and, I would say, respond to Malani's urge for inter-ship. They look at us but, with their larger faces and stern gazes, they put us to shame for having overlooked them throughout the history of slavery and colonisation. Moreover, vertical coloured bars overlap with those faces, invoking the stock exchange market where their labour is transformed into capital.

The bonding with Caravaggio's special take on the Baroque continues, whether or not Malani's chosen paintings are historically considered baroque. Between violence and exploitation, death is an unavoidable motif. A skull announces it, before the head of John the Baptist appears, the plate held by a hand, and the head being held up by a hand that callously pulls it up by the hair. The skull reappears after this disturbing vision. The metamorphosis of the painted dead head and the animated drawn skull is an amazing intermedial inter-ship, where solidarity with the murdered man is given shape. The face of the dead John the Baptist is surrounded by the red lines that outline the skull, as its inevitable future (fig. 24). This is

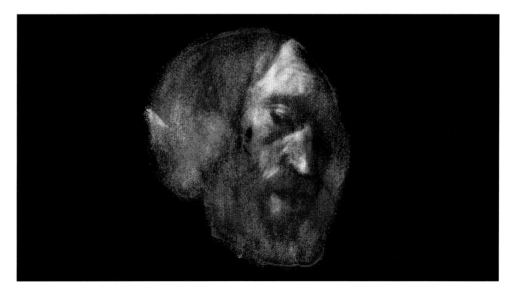

Fig. 24 Still from *My Reality is Different*, 2022

another instance, or different form of the foreshortening of time. This insistence on death must impact the tiny figures, also drawn in red lines, who move around the image. Those movements keep reminding us of time, for movement takes time and requires time.

But how does this activating art transform space into time? Malani installs her animation as spatially specifically as possible. Space, in Caravaggio, can be conceptualised as what Henri Bergson called a 'natural feeling', and not – as in Renaissance perspective – geometrical, hence measurable and identical for everyone perceiving it. This natural feeling is heterogeneous, different for everyone wherever they stand. Such space can neither be divided up nor measured. Bergson calls this boundless space 'extensity'. Emanating from the subject, it extends outwards. The term resonates with Malani's figurations of thoughts shooting outwards from agitated minds, as well as with the outstretched hands of the man on the right in the *Supper*. Extensity is foreshortening. Foreshortened space extends from the other towards the subject. Foreshortened space-time is distorted – made wider or thicker – and condensed. It thus comes forwards, touching the viewers, so that they experience the almost tangible push of a moment in time, like a pricking, a punctum à la Roland Barthes.[12]

The distortion also challenges the ontological temporal cut made between past and present. In terms of grammar, time becomes what French linguist Emile Benveniste called 'discourse' (as opposed to 'story'). It is expressed in the tenses that *connect* the past to the present, in contrast to those that separate them. It also shows in the verb forms of the first and second person, between whom speech emerges, rather than of the third person who is spoken about *in absentia*. The viewer is thus drawn into the work, because, as the second person to whom it speaks, she must take on the exchangeable role of first person in turn. This suggests the possibility of foreshortened *time*. Such an endorsement of communication also happens between the viewer's present and the past the artwork so precariously holds. But then, Malani turns foreshortening into a temporal device. Temporally, she gives her animations – in many different ways, so there is no fixed, standard device that can wear out – a foreshortened duration. And that creates a *lasting actuality*. This is what Malani creates with the pace of her animations. And that temporality is politically animating: actuality is *now*, but if we don't act upon it, it endures.[13]

This is the now-time of the viewers, the existence and significance of which they are hardly aware. To quote American art historian George Kubler's poetic account:

> Actuality is when the lighthouse is dark between flashes: it is the instant between the ticks of the watch: it is a void interval slipping forever through time: the rupture between past and future: the gap at the poles of the revolving magnetic field, infinitesimally small but ultimately real. It is the inter-chronic pause when nothing is happening. It is the void between events.[14]

Flashes: this word fits Malani's temporality in the animations perfectly, as moments of hurting that break up complacency. Time is foreshortened to the extent that it is distorted so as to reverse the black hole of linearity. In Malani's inter-ship move to turn spatial foreshortening temporal, time is both asymmetrical and heterogeneous. The heterogeneity of time is conveyed in moments when its foreshortening makes the viewer feel something that connects to – but *is* not – the past. This is the primary affective effect of the animations' speed. It is this artist's unique mode of narrative action, making the medium of animation politically effective.

Malani developed her newly invented medium on the basis of what she sees and thinks. Her animations often incorporate quotations, her own statements and poems by writers from all over the world. In the works for the current exhibitions, I see the cut-outs from the paintings as the visual equivalents of quotations. These accompany other quotations of recognisable figures, such as Lewis Carroll's Alice, a

recurring persona in Malani's work. This quotational aesthetic is yet another of Malani's inter-ships: she engages wider cultural settings to bring them all to actuality. Iwona Blazwick, the former director of the Whitechapel Gallery, described Malani's manifestations of her frequently returning characters, such as doomed Greek prophetess Cassandra and Indian goddess Sita, as 'shape-shifting'. In line with the artist's passionate interest in and engagement with the entire world and what is happening to it, Blazwick continues:

> They might mutate into animals or bacteria, inner organs or sign language. It is as if the real and the imagined, the animal, vegetal and mineral are all one pulsating organism.[15]

In other words, all these figures and lines are 'one pulsating organism': unified and live. This liveness also affects the cut-outs of the old master paintings, selected from the portions of images that she seeks to foreground and connect to today. The qualifier 'pulsating' in this quote begins to intimate the temporality of these animations, their rhythm, although it does not yet suggest their most immediately striking feature: their breathtaking speed. Malani's take on temporality indicates an overfilled imagination and memory, as well as a constant warning: urgency! Her head and heart are full of voices, and those voices end up in the animations to bring some order to chaos, while also, conversely, being affected by the chaotic state of the world.

This urgency concerns the need to heed; to see the world and listen to the voices that would otherwise threaten to remain buried in routine. The titles of exhibitions such as *Can You Hear Me?* at the Whitechapel Gallery and *You Don't Hear Me!* at the Miró Foundation in Barcelona (both 2020) responded to a real event of the utmost horror: the week-long gang rape, then murder by assault with a rock, of an eight-year-old girl by eight adults in India. How to address this deeply disturbing narrative in an art of lines, movement and speed? If we read the quote by George Orwell in one of the animations, 'Either we all live in a decent world or nobody does', the political thrust of their speed is driven home, along with the intercultural pervasiveness of violence and cruelty. This affects the viewer, in ways that also animate the old master paintings in their inter-ship between art and the political. In her short preface, Blazwick seems affected by the liveness of the animations. And her phrases 'life-blood pulses', 'muscle memory', 'sensory tactility of the hand', 'creative intelligence' and 'moving graffiti', all resulting in 'a dazzling blend of aesthetics and activism', point to the multi-tentacled aesthetic this artist deploys, where neither socio-political reality nor her own subjectivity and body can escape the bridges her inter-ship builds.[16]

Malani draws figures directly on her iPad with her index finger, a process she describes as follows:

> There is sensitivity with the fingertip, which is erotic, raw, and there is something very direct about this process of drawing, rubbing, scratching and erasing, to do with the messing around in one's mind. I feel like a woman with thoughts and fantasies shooting from my head.[17]

'Shooting from my head' connects this autobiographical comment to the turbulence she projects in the head of the right-hand man in the *Supper*. The phrase connotes both the violence she is concerned with (the ambiguity of shooting as killing and filming), and the speed of her animations (they move like lightning). The colours of the fast-moving lines underline that effect. The current project adds to this, as the still, old master works from the museums are integrated into the fast-moving contemporary images, fragmented, overwritten and brought into the orbit of the brightly coloured lines. And this bringing to actuality also entails the historical violence to which they were connected. Urgency is added to the need to look and listen. And given the dialogue between Malani's animations and the paintings, this intimates the need to look as a relevant, necessary act in the world of our time. This is how her acts of foreshortening time achieve their activating relevance.

Inter-ship between Details and the Whole

With the commitment to integrate her own visions with the state of the entire world, the artist introduces yet another inter-ship, one that counters the divisions of rhetorical analysis. One animation begins with fast-appearing and disappearing hand-drawn angels – or are they dragonflies? Dimensions are as distorted and unpredictable as durations. A Kalighat cat with a stolen fish in his mouth, alluding to an Indian painterly tradition, interrupts the series of angels/dragonflies. Of the four quoted paintings in another animation, the last one is an anonymous oil painting on oak dated 1500–5, *The Deposition* by 'the Master of the Saint Bartholomew Altarpiece' (fig. 25). The new work paints and writes over the old master image, adding to it and also partly erasing it; drawing as taking away. Over various details of the painting, moving around the frame, Malani has superimposed brightly coloured, mostly blood-red lines, combined with yellow, that travel incredibly fast. Due to the colour contrast with the animated figurations, the colours of the old painting seem more subdued than they are when we see the painting on its own. This painting as a whole attracted my attention due to a few details that seemed incongruous. The most striking of these materially brings time to the fore. For the drops of blood on Christ's face and the glistering tears on the other faces attract more attention than even the starkly outstretched arms of Christ on the Cross. Those drops say something about looking in detail, and material connection between past and present.

The first consequence of the animation is that, as with all the others, to really see this image, one needs to give it *time*, that key element in Malani's work that carries her political drive. Look! Listen! Not speed but slowed-down time is needed. What do we see, then, in the old master painting, so traditional in its figuration, that we must be compelled to stop and look? And we are, because of the details.

The tears on the faces of the figures look like glistering stones, and the drops of blood on the dead Christ's face look like rubies: in addition to temporal foreshortening, here we are facing material changes. Fluids

Fig. 25 **Master of the Saint Bartholomew Altarpiece** (active about 1470 to about 1510)
The Deposition (detail), about 1500–5
Oil on oak, 74.9 × 47.3 cm
The National Gallery, London, NG 6470

become solids. This became possible when oil painting began to be applied to wood. These are transformations of matter, as well as figures of inter-ship with Malini's red lines. These lines now also come to resemble blood; Malani brings the blood-rubies in as an acknowledgment of the bridge to the 'baroque past', and the 'lasting actuality' of bloodshed. Thus, we see the old painting better. This material change, from corruptible and soon vanishing blood to enduring precious stones, small as these signs are, tell us something that *matters*. We see other details perhaps more easily, such as the distraught faces, the exuberantly folded garments and particularly the hands of the figures, all differently busy.

These details may escape the viewer who is swiftly walking by, as in a traditional museum visit. Yet there is one central motif that is hard to miss but, once noticed, stops you in your tracks. For the skull in the lower centre remains an eye-catcher, realistically small as it is. It is a figuration and a sign. The skull has a long tradition as a symbol of death and a 'vanitas' motif: the Renaissance and Baroque cliché of death as a moral(istic) reminder that earthly goods, wealth and our own bodies are all subject to decay and disappearance in death. It is at the bottom here, but central. It must not be seen as a simple detail. Malani insists on this by aggrandising it, in addition to moving it through the frame. According to some mythical accounts, this skull is Adam's and would then recall the 'apple', the forbidden fruit. The seed from the fruit begins life and grows into a tree, in turn cut down to make the cross on which Christ was martyred. The position of the skull at the bottom of the frame suggests the integration of a literal and a figurative story of the Fall. But Malani's moving skull deflects that moralistic tale, emphasising instead the enduring actuality of violence (fig. 26).[18]

As an aspect of her critical take on the old master paintings, the engaged contemporary artist works with them first of all by irreverently cutting them up; selecting details that swirl around the image whose major components, in this case again the brightly coloured, fast-moving lines, make the source painting visible and invisible at the same time. Here the distinction between fragments and details is undermined and instead they are connected, as a rhetorical inter-ship. Fragments are parts of cut-up, mutilated wholes. They can be isolated, with the consequence that the whole from which they were broken off may never be seen or even imagined. Details, in contrast, are parts that remain in their correct positions. Instead of separating from the whole, they guide our attention. The urgency to heed Orwell's warning, to listen to the eight-year-old victimised girl, in relation to the already dead Christ and the grieving survivors: all come together in the intervention of drawing and erasure. Drawing entails working with lines, which rubs

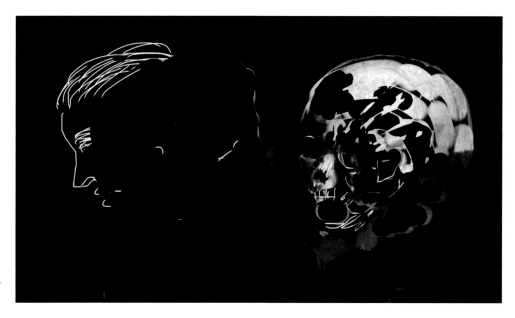

Fig. 26 Still from *My Reality is Different*, 2022

the old master painting the wrong way. For there, the lines are skilfully hidden behind the paintwork. And erasure is one of Malani's invented media that challenge time, as she has explored in her erasure performances of her wall paintings.[19]

Malani selected details from the painting that she then animated – or did she? Perhaps the painting was already animated and all she needed to do was make that live quality more prominent. For it is hard to keep that other distinction visible, the one between still and moving images. The impossibility of telling these apart makes sense, since the work as a whole consists of those lines/thoughts, shooting from Malani's head and heart, as well as from the figures. The finger-drawn images and those flashing, fast-shifting lines add, superimpose and take away, seemingly erasing the original painting or reframing certain portions of it. The dynamic between the (allegedly) still painting and the shooting lines can also remind us of nightmares; semi-conscious visions one prefers to forget because they are too scary.

In a reading of three of Malani's earlier animations, Ernst van Alphen wrote that they are 'moody', conveying a strong but multiple affective force. In the visual memory (a bad dream), the visitor sees pastness re-appear. Van Alphen describes the mood of the animations as 'funny, sad, energetic, hysterical and acute, and genre-wise, at the same time absurd, comical and satirical'. This description almost matches the turbulence of the animations, drawing attention to multiplicity. The pieces are quite short, and the pace at which they pass, and their overlapping, compel the most intense attention while also making it impossible to take them in. The resistance to dwelling on such horror stories, along with the impossibility of ignoring them, is the result of Malani's act of 'sculpting space' as well as of the blurring, the fast pace and the overlayering.[20]

This rhythm of the fleeting images links the animations to Malani's video/shadow plays, where the cylinders turn slowly but too fast to 'read' the complex images made in reverse painting, cut through by video projections, in a single revolution. As a result, visitors, who are also 'sculpted' into the space, are compelled to stay for another round. I have caught myself staying for long stretches of time in the video/shadow plays, simply because I wanted to see it all. There, however, the turning was slow; here, the movements are hectic. With the overlayering of the old master art, this sculptural aspect becomes prominent, suggesting more than a single flat image. The spatiality becomes a detail. Along with the pluralisation of figural elements, the layering also brings an awareness that whatever we see has some measure of volume. In her earlier work, Malani foregrounded this by reverse painting on Mylar plates that she then mounted at a slight distance from the acrylic surface. Thereby, shallow shadows appeared.

Seeing as Activism for Activation

The desire to see, impelled by the aesthetic quality of the images and the difficulty of seeing them due to their movement and pace, together produce the *activating* force of this work. If we consider those aspects as indispensable for the effect of the work as a whole, they become details on the same ground as the materially transformed drops of blood and tears. Both the affected visitors and the artist doing all those things I have mentioned (and many more) are, in this concept of the artwork, 'details' of it, unbreakably parts of the whole that is the artwork with all its effects. The cut-outs are no longer fragments. The pre-posterous inter-ship does this.

Malani's description of 'thoughts and fantasies shooting from my head' denotes the kind of subjectivity implied in these works. Her own visions shoot out to reach into the visions of others: what happens in the world, and what the old masters made of what happened then, merge in the 'lasting actuality'. For this artist, movement is crucial, but the combination of her own flashes of emotion, her history and that

of others, precludes any attempt to bring the choreography of the animations in sync. Instead, there is an effective affective chaos as an activating environment in which visitors can only stay seated for a long duration, their hearts beating faster.

A form of political agency resides in the inter-ship between activism (for better looking and seeing) and activation (for better thinking). Time, whether unbearably slow or hyper fast, is the primary tool to activate the act of seeing as a strategy of resistance. In spite of the literal-temporal contrast with what the theorist of vision W.J.T. Mitchell described as 'the unbearably slow strangulation' in the real time video of the murder of George Floyd as a (Deleuzian) time-image, the fast pace of Malani's animations has a comparable effect. It makes time itself sensuously strong; the experience of it, activating. So, we can only conclude that the foreshortening of time and the effect it has on the visitors is a detail – one that guides us to see what the whole, the work as a whole, must be: the flashing images to the inter-ship between past and present, I and you, painting and drawing, each animation and its neighbour, and the different cultures that interact in this intensely activating exhibition.[21]

1 I have added a hyphen between prepositions and nouns or qualifiers for terms which have been newly coined by me, as in 'inter-ship'. When the combination is in current use, hyphens have been added in exceptional cases for emphasis.

2 For the conception of 'pre-posterous history', see Bal 1999. For the conception of 'inter-ship', see Bal 2017.

3 On intermediality, see Elleström 2019 and 2021, and Bruhn and Schirrmacher 2022.

4 On Malani's first invented medium, in *Utopia*, see Pijnappel 2016. On the cinematic aspect of her multi-panel paintings, see Pijnappel 2012. She has exhibited 'animation chambers' on various occasions, including the exhibition at Fundació Joan Miró, Barcelona (2020) for the Joan Miró prize awarded to her in 2019, and at the Whitechapel Gallery, London (see London 2020–1). I use the verb 'to figure' to invoke Jean-François Lyotard's concept of the figural (see Lyotard 2020) as an overcoming of the word-image separation, best explained by Rodowick 2001. I have published a book on Malani's 'video/shadow plays' (Bal 2016). In its introductory chapter I also discuss the erasure performances.

5 For further information on McLuhan's theory on the methods of communication as the focus of study, see McLuhan 2001.

6 Gombrich 1950, pp. 53–4. On Caravaggio and perspective, see Marin 1995.

7 Buci-Glucksmann 1994, p. 39.

8 For an extensive study of baroque thinking and narrating today, see Bal 1999.

9 The Shorter Oxford English Dictionary, 6th edition and Grieder 1996, p. 505.

10 The breakthrough study of perspective's illusionism is Hubert Damisch's famous sceptical view of it (Damisch 1994).

11 For the conception of 'baroque' that I am sketching too briefly here, see my book on the subject (Bal 1999).

12 See Bergson 1991 and Barthes 1981.

13 See Beneviste 1971.

14 Kubler 1962, p. 17.

15 London 2020–1, p. 46.

16 Originally from Orwell's review of *Letters on India* by Mulk Raj Anand, published in *Tribune* on 19 March 1943. London 2020–1, p. 46.

17 London 2020–1, p. 57.

18 For a very different interpretation of the story of creation and the Fall, see the last chapter of Bal 1987.

19 For a brilliant theory of the detail and its (feminist) political potential, see Schor 1987 and 1980.

20 Van Alphen 2020, p. 49. Malani made those three animations for the exhibition *Shame! and Masculinity*, at H401, Amsterdam, curated by Ernst van Alphen (2020). The phrase 'sculpting space' alludes to Polish sculptor Katarzyna Kobro (1898–1951). See van Alphen 2022. On this artist's un-still sculptures, see Słoboda and Jędrzejczyk 2021.

21 Mitchell is one of the most prominent theorists of visual art. See Mitchell 2021 for a haunting description of the video of the murder of Floyd. Malani's animation chamber *Can You Hear Me?* was included in the exhibition *Resistance Anew*, at the Musée cantonal des Beaux-Arts, Lausanne (2022).

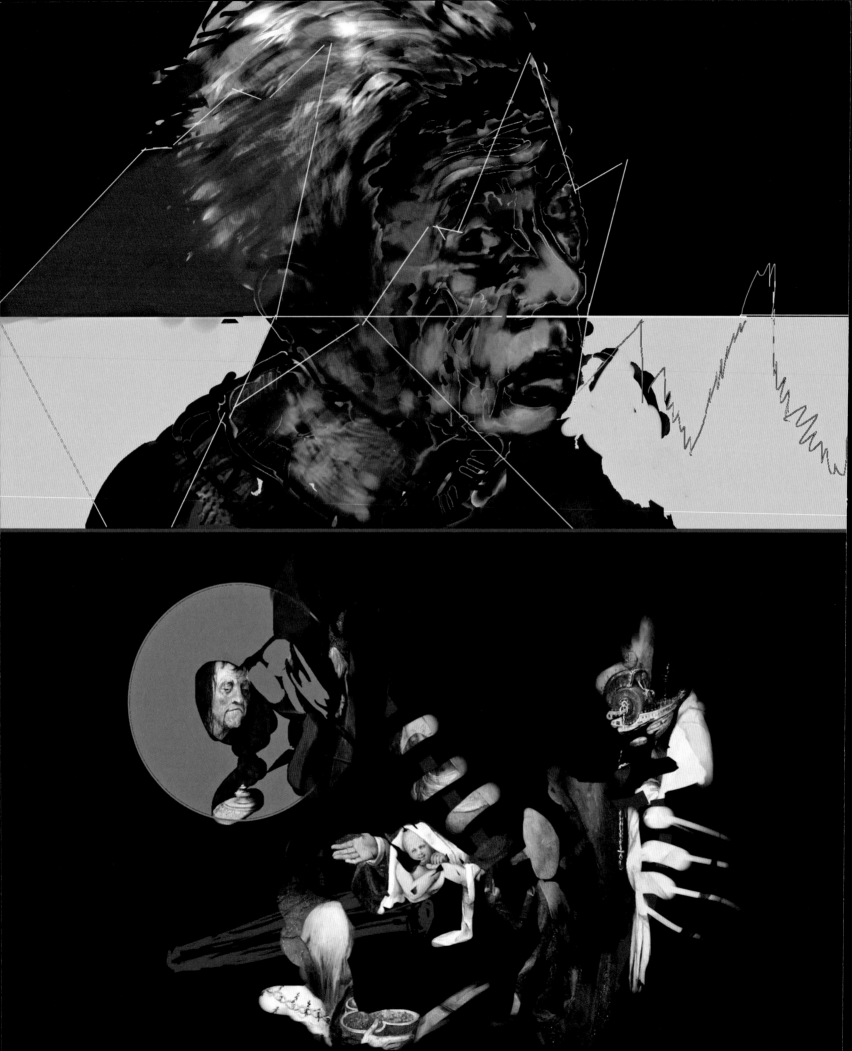

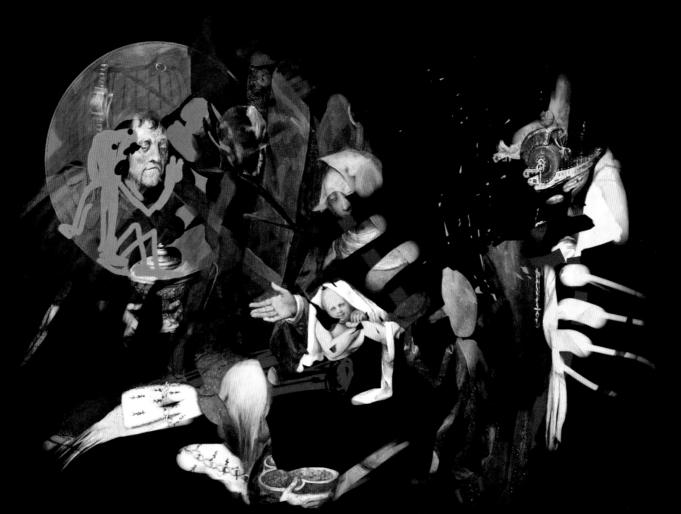

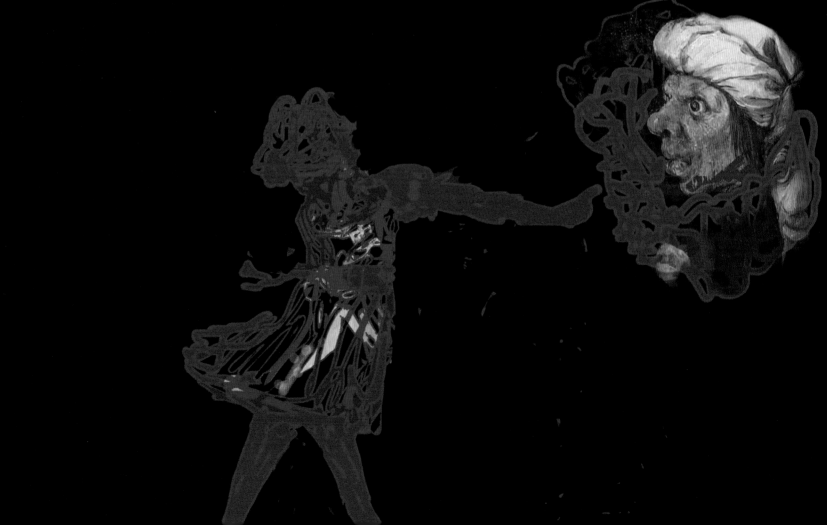

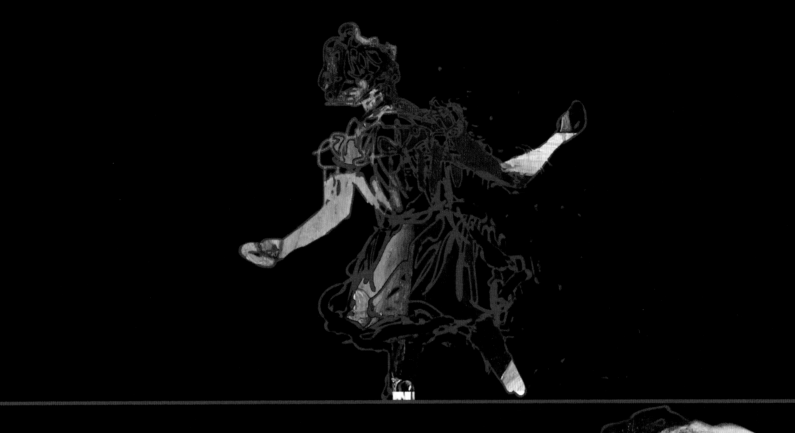

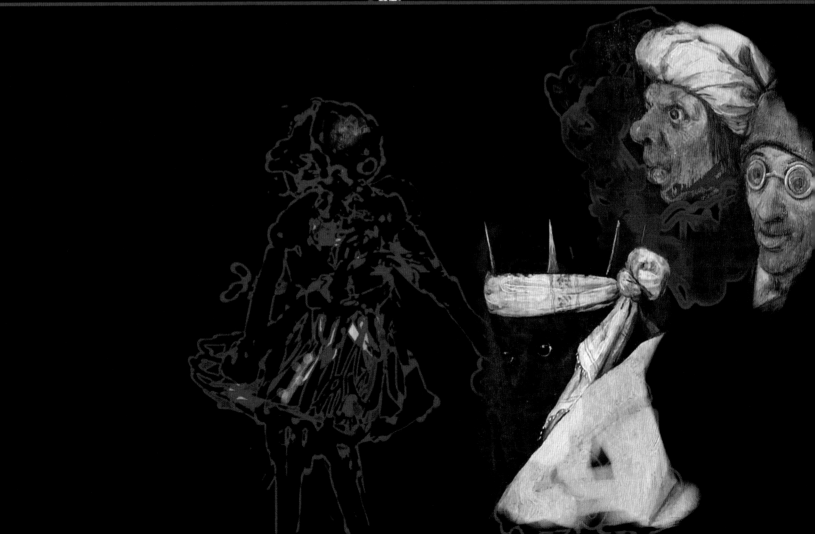

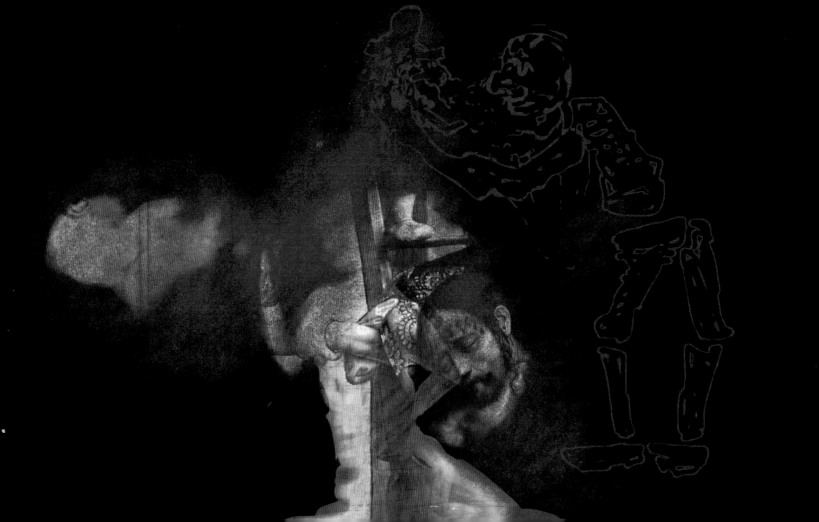

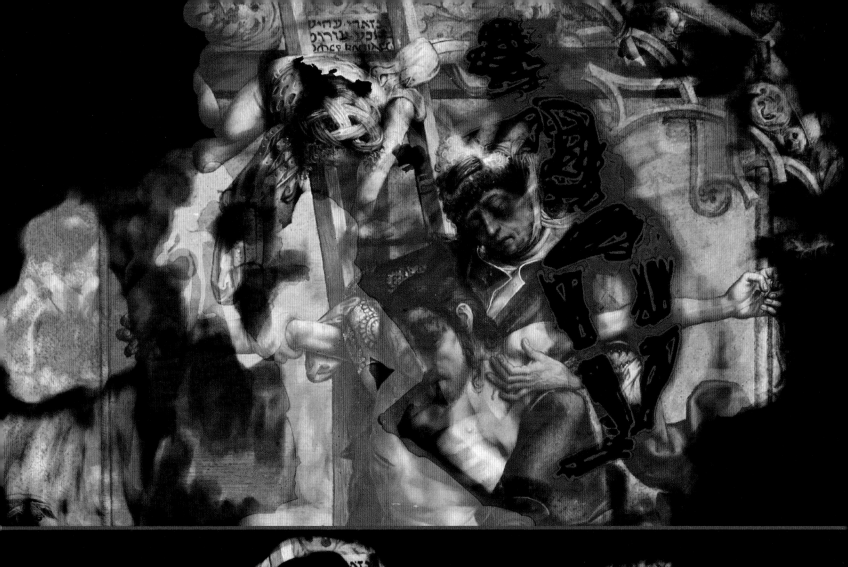
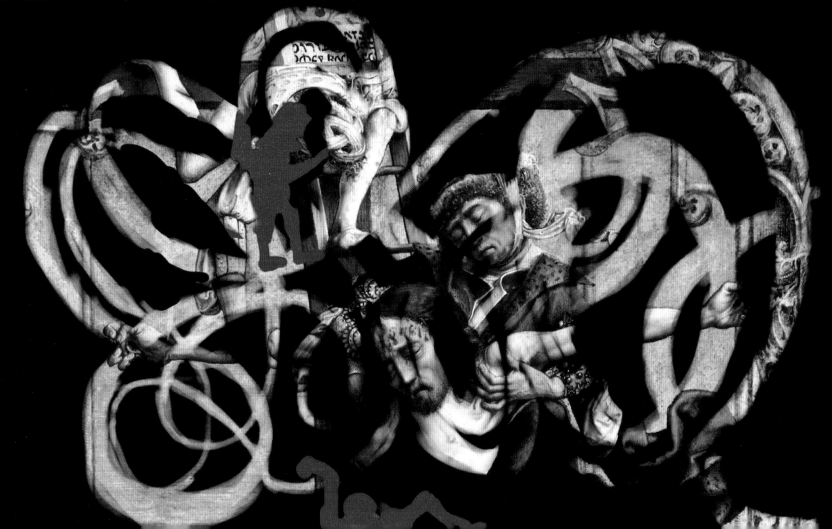

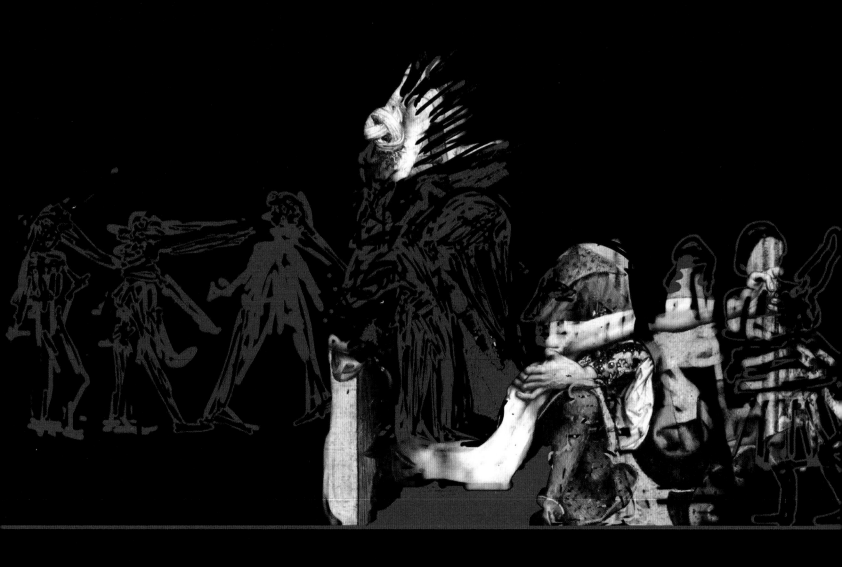
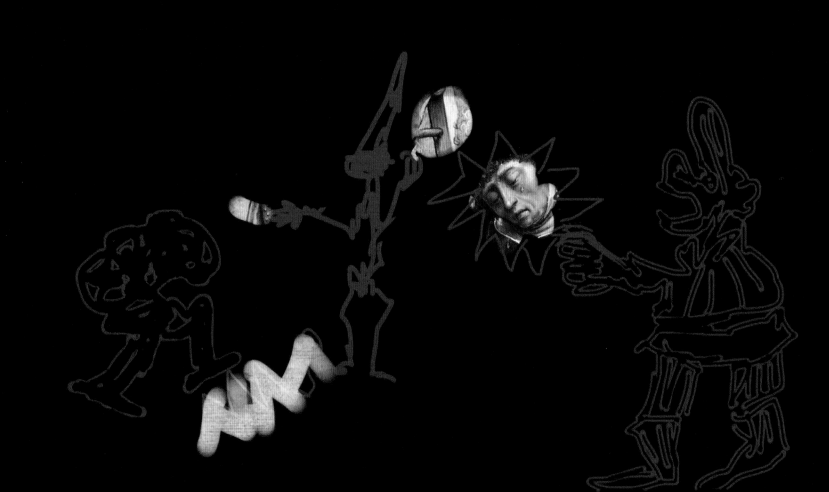

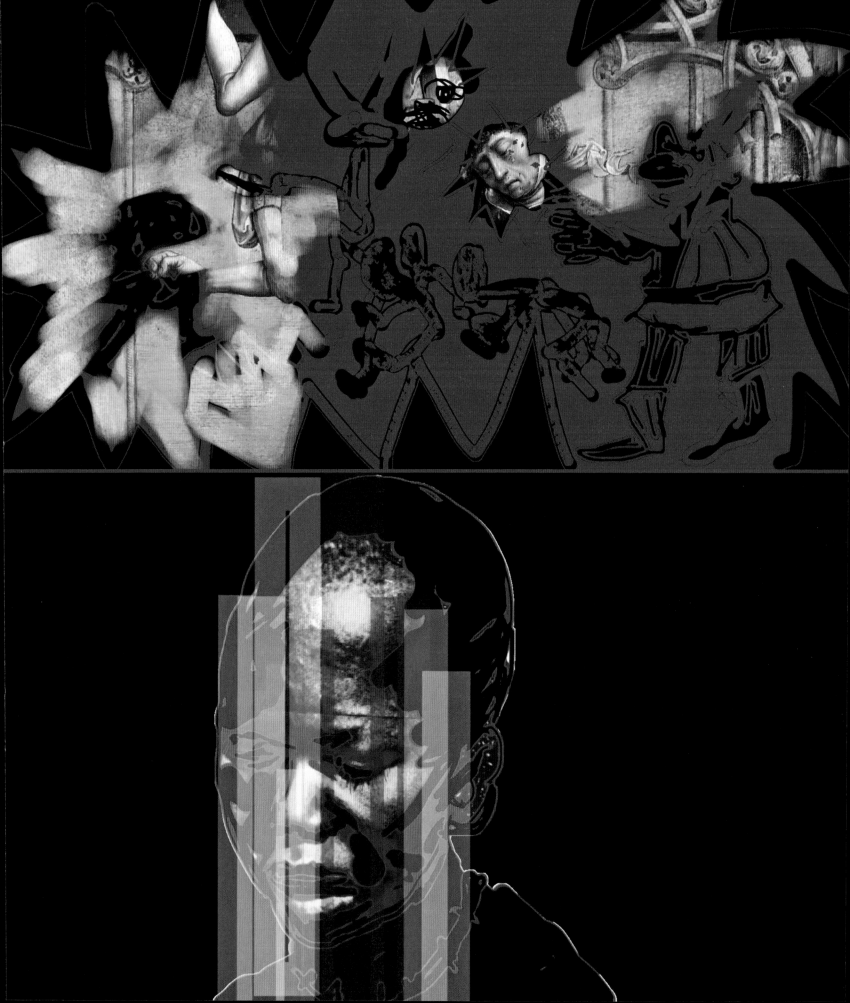

From Certainty to Doubt: Exploring the Palimpsest in the Work of Nalini Malani

Will Cooper and Daniel F. Herrmann

Here Comes Caravaggio

Out of the dark comes a subtle glow. It's *The Supper at Emmaus*. A climactic picture, showing gripping action right at the moment of a turning narrative. We know the story well: on their way home from the crucifixion of Jesus, bereft, at a loss and in mourning, two of his disciples encounter a stranger; they share a meal. The disciples realise at the same time: he is the resurrected Christ, returned after his death. Gestures of surprise abound: Cleophas, to the left, pushes back his chair, his head drawn low and eyes wide as he stares at the Messiah. Saint Peter, to the right, throws up his arms as if having touched a stovetop. At the very moment of their recognition, Christ disappears: 'And their eyes were opened, and they knew him; and he vanished out of their sight'.[1] It's a crucial moment of revelation.

Much has been said about the way Caravaggio stages this very moment: about having a young, beardless and very real-seeming Christ in the middle of the composition, of Caravaggio's committed inclusion of the poor for his depiction of the pilgrims to better reflect society, the apathy of the innkeeper and the basket of fruit in the very foreground of the painting, precariously positioned at the table's edge as if about to fall down.[2] As Peter seems to reach out of the painting, we feel compelled to reach in, keeping the fruit from tumbling down and out of the canvas. The fruit basket's *trompe l'oeil* is not only an effective painterly tool to evoke the turning point of the narrative and engage us as viewers, but also a joyful masterstroke on behalf of Caravaggio himself, celebrating his own success, skill and inventiveness.

Ah – Caravaggio! Of course, we know Caravaggio.

Or so we thought … The image, one of many images in Nalini Malani's installation, shifts. It flickers, as if shaken about, zooms into the detail of a piece of bread on the table, surrounded by black, a larger-than-

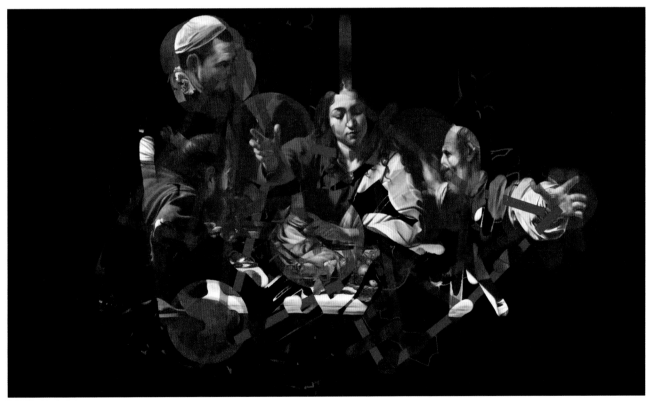

Fig. 27 Still from *My Reality is Different*, 2022

life vignette on the dark background of its projection support. Here are the elements of the meal that we just viewed in the context of its iconographical narrative. Bread, wine glasses, grapes, apples and roast fowl now become overlaid by numbers, highlighted by strong, red marks drawn by an invisible hand – they fade, become smaller. *The Supper at Emmaus*, moment of miraculous revelation and turning point in the faith of the apostles, seems to dissolve into a flood of numerical shapes, merely indicating quantities instead of allowing for any contemplation of belief. Now, the numbers melt into makeshift stick figures, clamouring about the famous image, scaling its table and scuttling past the blessed meal like mice scattering at the opening of a basement door. Their movements leave traces. Lines connect the hands of the apostles, circles highlight points of interest and connections – sight lines, perspectival connections, echoes of details in clothing, texture and brushwork (fig. 27). The animated finger marks introducing these annotations in the first place soon return, reducing elements of the initially visible Caravaggio image until only the diagrammatic circles, lines and connections are visible. The analytic structure surpasses the narrative image and becomes abstract form. Caravaggio is gone. In his stead remains a system of looking, of making connections and creating meaning, superimposed over the historic image.

Beginning her project for the fellowship programme with the National Gallery and the Holburne Museum titled *My Reality is Different*, Malani used high-resolution images of masterpieces by such illustrious names as Caravaggio, Hans Holbein the Younger, Guido Reni, Jan van der Venne, Johann Zoffany and many others – mainly men, given the historically small fraction of female artists represented in either one of the two collections. Malani began to systematically apply her carefully developed repertoire of drawing to this treasure trove of digital images. In the past, the artist had been well known for both her 'Hinterglassmalerei' – elaborate paintings on a transparent medium such as glass (or, as in Malani's case, the polyester resin Mylar), in which layers of translucent pigment are carefully built up in reverse to be viewed from the other side of the glass. The fluidity of the medium allows her to create radically ambiguous figures that subvert expected depictions of traditional iconographies, while also holding and reflecting ambient light. These could find their form in her famous 'video/shadow plays', including projections of drawings on rotating translucent cylinders, ever-revolving and casting their combinatory narratives onto surrounding walls, or in made-for-social-media animations, impishly drawn figures on her Instagram account, inserting social commentary and artistic observation into her followers' feeds.

For her new commission, the artist now seems to logically combine these predecessors. Her animations begin with a digital image of often iconic, well-known representatives from the canon of Western European painting on her iPad. Initially, these pictures are occluded by a black screen, not unlike a layer of wax, into which subsequently an invisible stylus scratches its sgraffito. The artist's finger strokes on her digital canvas, strategically removing parts of the black surface layer, partially revealing the image underneath. Whole sections might get swiped away in a single stroke; others get smudged into revealing their underlying content like a scratch card. Invisible fingers add red lines to these revelations, annotating the image with visual commentary and subversive humour. In little time, the animations both reveal the well-known image lying at their foundation and add to them through the overpainted coloured strokes. Malani's drawings reveal new connections between visual elements that we had not witnessed before, but they also emphasise the process of making connections itself as both intellectually stimulating and deeply satisfying. Her palimpsest of visual commentary is therefore far more than a simple act of 'defacing' cherished artworks (as she sometimes likes to claim, with tongue firmly in cheek). Instead, her drawings add new layers of meaning, allowing for the multiple narratives to co-exist simultaneously.

Of course, this description does not do Malani's animation of Caravaggio justice. For *The Supper at Emmaus* is only one of many images which Malani annotates with her drawing, and all of them are given an even more open-ended form. Divided across nine individual projectors, each series of animations plays on continuous loop, arranged across all four walls of the exhibition space to cast a spellbinding panoramic

frieze of interlocking, multilayered images all around the beholder. Since each of the nine sequences of animations differs in length, the viewer can encounter a near infinite number of permutations in which the projections are visible – overlapping in space and time and creating new connections every time they are witnessed. Every time we step into Malani's installation, we will encounter her moving drawings interacting in different ways, juxtaposing images and connections, forming new dialogues and arguments. Every time we encounter them, they undoubtedly make us think differently about the underlying images and the collections in which they originated: we might have known Caravaggio, but we have never seen him like this.

The Palimpsest

The concept of palimpsest is frequently used in various socio-scientific fields. In urban studies it can be applied to explain the construction stages of historical buildings and monuments and the development of urban morphology. A landscape often shows traces of older forms and symbols, not just recent features. Therefore, what exists in any given place are layers of meaning that are waiting to be revealed, interpreted, and understood by those who encounter them.[3]

In *My Reality is Different*, we, as spectators of the work, can make use of the word palimpsest in several ways. Malani's technique of overpainting to obscure and subsequent erasing allows for the meaning or narrative within paintings to be updated, amended or altered to re-tell a particular story with a deliberate point of view. The use of the palimpsest can be viewed as a means for these collections and their artworks to better speak of Malani's reality – that of a woman born in Karachi before Partition and now living in Mumbai, who has lived in the wake of Britain's colonial hegemony over South Asia as well as many other nations and territories across the globe.

By taking control of and employing the palimpsest as an artistic tool or methodological system, Malani's act of inscribing, re-writing, annotating and erasing historical texts, images and contexts becomes an act of both radical empowerment and staunch criticality. Taking Alan Marvell and David Simm's definition of palimpsest (quoted above), Malani's digital sgraffiti, her animation chamber of annotated digital images, has scratched away layers of meaning in the collections of the National Gallery and the Holburne to reveal truths previously hidden, passed over or relegated to the margins.

This is exemplified in her treatment of Johann Zoffany's *The Auriol and Dashwood Families* (about 1783–7), on display at the Holburne Museum (fig. 28). In the painting, a group of seven wealthy Europeans sit in the shade of a jackfruit tree, enjoying their lives in colonial Bengal while being waited upon by four unnamed men and a single, indentured child, all of Asian heritage. While the white Europeans are easily identifiable as members of three influential families – the Auriols, Dashwoods and Prinseps, all of whom had active links to the powerful East India Company – it is towards the five Asian figures in the painting that Malani draws our focus.[4] With a flick of her finger across her iPad, Malani repositions the work and focuses our attention on the treatment of the five Indian servants. Is that a bloodied hand now gouging the eyes of one scarved figure? What is that mysterious black creature flashing in front of the indentured child? Malani does not need to explicitly answer these questions. Instead, her annotations, erasures and amendments draw our focus to the very real violence of indentured servitude or enslavement that scenes of this nature often hide. In doing so, she creates an updated and more accurate depiction of the reality of a life in service in the British colonies.[5]

While it would be optimistic to hope for any kind of complete biography of the Asian sitters, research can fill in some of the blanks; a *hookahburdar* stands near a tree and prepares John Prinsep's smoking

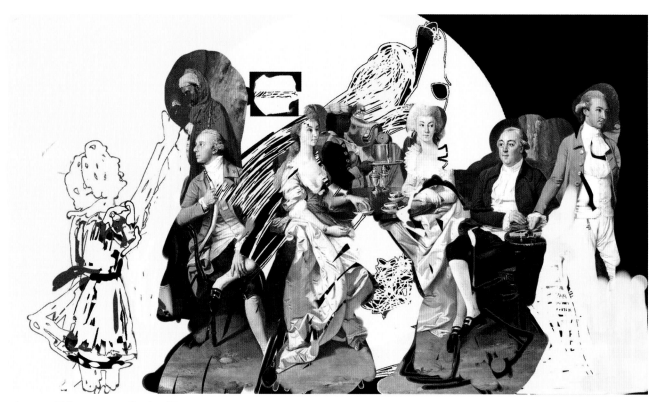

Fig. 28 Still from *My Reality is Different*, 2022

pipe, while next to him Charles and John Auriol are deep in conversation.[6] To their left, a mail carrier hands a letter to their brother James Auriol while his *sakar* awaits command nearby with a stack of unopened bills in his hand.[7] It is, however, the figure at the centre of the painting that comes to represent a more severe case of exploitation of indigenous populations by colonisers. Here, a servant pours water into a silver teapot held by a young child in exquisite dress – a sign of his owner's status, not his own. Although we do not know the precise details for the method of his 'employment', the child was John Auriol's personal servant, and we have record of him later being 'gifted' to the influential lawyer William Hickey, who travelled with him from India back to England. In England the boy, mockingly named Nabob by his owners (*Nabob* was the local term for a royal deputy, an elevated status he most certainly did not enjoy), was passed around Hickey's children where he was kept as at best a curiosity, but in reality more comparable to a pet, until he was returned to India some years later.[8] This treatment of a child is harrowing to reflect on, and was far from an isolated case.[9]

In contrast to the Asian sitters in Zoffany's painting that were mostly based on real people, Malani has produced a series of anonymous, fictionalised characters that appear interspersed among her iPad animations, obliquely commenting on themes embedded within the 25 works from the two museum collections. Referred to as 'stoppers' by the artist throughout production, these portraits of 'subaltern' figures tell us much of the reality Malani is presenting to us (fig. 29).[10] Akin to the annotations that engulf *The Supper at Emmaus*, scribbled over these faces are bar charts, stock market tickers and other visual signifiers commonly associated with the transference of wealth, and here replacing their humanity with cold, hard financial information. Like the indentured workers in *The Auriol and Dashwood Families*, these figures represent people as anonymous commodities that are owned, traded and ultimately exploited by those to whom they are in enforced service. But perhaps most importantly, these figures, who supply so much of the labour that underpins global economic systems, are not offered the same opportunity for progression that these structures promise us in the West.

Fig. 29 Still from *My Reality is Different*, 2022

One only has to look at the Holburne's Plantation Day Book (the only surviving accounting ledger belonging to Sir William Holburne's great-grandfather, Guy Ball, the owner of several plantations on Barbados, Jamaica, and Antigua) to see this reality played out in front of you; here human life is noted and assessed as if it were no different to the candles, beef, cocoa stocks or other recorded commodities (see fig. 15). This is where Malani makes her point with such clarity: the reality for anyone not born in the West is that survival is constantly threatened by unseen, unrelenting and unwavering market forces, where the value of a person's life can be calculated, assessed and ultimately reduced to numerical data.

Data, Knowledge and the City

Malani, however, does more than simply reveal this difficult truth; her actions and her approach disrupt what German media theorist Friedrich Kittler calls a 'Discourse Network': a system of 'technologies and institutions that allow a given culture to select, store, and produce relevant data'.[11] Through Malani's vital criticality, her work calls into question *what* technology and *which* institution should hold this power over our shared and collective data – data that we could very easily refer to as *our* reality. This reality speaks to the prevailing narratives of nationhood that are readily communicated through the paintings that hang in the halls of the National Gallery and the Holburne Museum. One need only look back to most traditional readings of Zoffany's painting, which tended to focus on the family lineage of each white sitter, their political status in Britain and India, and what details of their lives can be ascertained through their dress, activities and pastimes, to see why Malani wants to disrupt this network to open up necessary, and perhaps more honest, accounts that are more inclusive of *all* the histories depicted.

The concept of data is so abstract that we are encouraged to think about its storage, transference and manipulation as parts of something we do understand: the city. The American sociologist Lewis Mumford has identified how the language we use for technology, systems, media and data is intentionally drawn from metropolitan terminology. 'Capital', 'gates', 'ports', 'traffic' and even 'buses' are terms appropriated from urban spaces to help us better understand technology. Mumford proposes:

> Through its concentration of physical and cultural power, the city heightened the tempo of human intercourse and translated its products into forms that could be stored and reproduced. Through its monuments, written records, and orderly habits of association, the city enlarged the scope of all

human activities, extending them backwards and forwards in time. By means of its storage facilities (buildings, vaults, archives, monuments, tablets, books) the city became capable of transmitting a complex culture from generation to generation, for it marshalled together not only the physical means but the human agents needed to pass on and enlarge this heritage.[12]

In both Kittler and Mumford's conceptions of cities, the Holburne Museum and the National Gallery constitute repositories of cultural data and interpretation within the power centres of London and Bath. Thus, in effect, the National Gallery and the Holburne Museum have invited a new *human agent* in Malani to intercept our shared heritage, changing and updating the very data that is passed on and transmitted to museum visitors. By working with the collections of the National Gallery and the Holburne Museum – or in Kittler's terms, within these specific *storage facilities* – Malani can better communicate our shared, global heritage; she creates agency where before there was none.

She has, with astute observation and skilled criticality, come into these networks to disrupt what and whose heritage is being passed on for future generations. In both Kittler's understanding of the city as a 'Discourse Network' and Mumford's thesis of the city as a data transmitter, we recognise the important role the city must take in our interpretation of *My Reality is Different*, and how the very fabric in which we store, display and communicate our culture is, in fact, the very culture itself.

Writing in 1990 in *On Memory (Electronic or Otherwise)*, the philosopher Vilém Flusser successfully un-packs ideas of shared and collective memory and how storage devices – from the rudimentary tool to contemporary digital storage – support the way that information is controlled and disseminated. He talks of 'the library', which in our context could be replaced with 'the museum', both acting as sites of stored knowledge and as 'monuments that store information of spoken language'.[13] Flusser goes on to elaborate on the power this storage bears: 'the library was not constructed as a store of acquired information into which we feed information acquired by ourselves (through writing), and from which we can recover information acquired by others (through reading). Rather, it was considered a superhuman memory that transcends individuals, hovers over them, and to which they must aspire.'[14]

It is here that we can see Malani's work breaking from this theory and correcting its misunderstandings, for what she shows us is that, yes, libraries and museums store information, but it need not hover over us, immovable and unchallenged. Rather, it can be manipulated, corrected and overwritten to tell better, more accurate stories by people more directly affected by its subjects and who can provide alternative, perhaps more complete, versions of whatever chosen story is being discussed.

Reality Renewed

For every stored and collected piece of information, something else is not stored, saved or collected.[15] The decision as to what should be remembered and what is erased and forgotten is part of the long shadow Britain's colonial past throws over our shared global culture. Throughout her career, Malani has looked to construct her own reality using her own active erasure, manipulation and amendment of this inherited 'data', reclaiming power that has been stripped away over the past few hundreds of years.

When thinking like this about contemporary artists who critically engage with major public collections, we should take a moment to consider how these collections came into being in the first place. The National Gallery's collection was founded on the philanthropy of collectors: the financier John Julius Angerstein, whose collection was sold to the state for public benefit following his death, and Sir George Beaumont, 7th Baronet, who gifted paintings to the collection on the condition that a suitable building

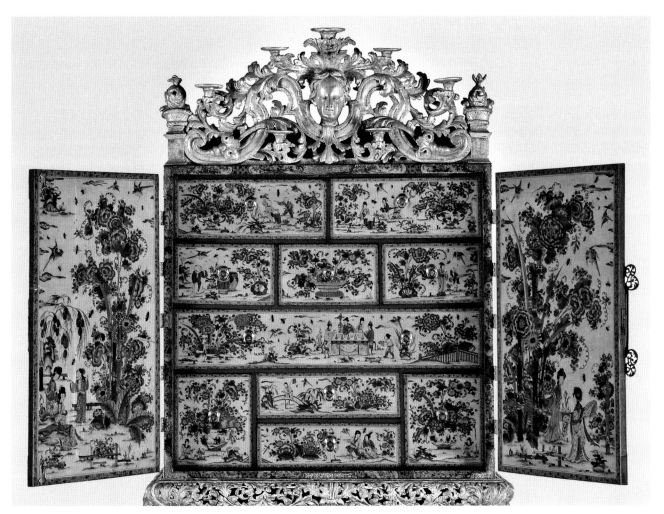

Fig. 30 **English**
The Witcombe Cabinet (detail), about 1697
Japanned and silvered wood, 203 × 120 × 60 cm
The Holburne Museum, Bath, 2006.4

would be found to present and conserve them. Angerstein founded his career and fortune in the marine insurance business, part of which was based on bilateral West Indian trade, bringing over produce made by enslaved people.[16] While Angerstein began his collection through the help of painters Thomas Lawrence and Benjamin West, Beaumont, a landscape painter who also sat as an MP for Bere Alston, acquired his taste for the old masters during the undertaking of the customary Grand Tour. For the Holburne, the kernel of the museum's holdings was drawn from objects Sir William Holburne also picked up on his own Grand Tour. From the 1830s onwards, Sir William added to the family's collections, amassing a small but unique collection of paintings, furniture and sculptures, as well as smaller domestic items (fig. 30). These items remained a private collection for over 50 years after his death until, in 1882, Sir William's eldest sister, Mary Anne, gifted the collection to the city of Bath. It was from this gift that the museum's collection has grown to what we know it to be today.[17]

The importance of the collection to Bath is indicative of the developing status of the city as a popular urban centre, which can be traced back to the first century AD but came into its own during the long eighteenth century. Shortly after their successful invasion of Britain, the Romans settled near the natural hot springs which were enjoyed, much like they are today, as a therapeutic thermal spa. Upon arrival, the Romans

built the temple of Sulis Minerva, and it was from this that we get Bath's Roman name, Aquae Sulis. This relatively modest development remained until the Middle Ages when the local wool trade funded the next round of urban development, which in turn was superseded by wealthy Georgian developers creating the city that we now know. Particularly relevant in the context of Malani's commission is that the major moments in Bath's development were the direct result of, first, invasion, then the exploitation of natural materials and the extraction of wealth from foreign nations.

Like Bath, the National Gallery's site reflects the changing attitudes and politics of eighteenth- and nineteenth-century Britain. Prior to its development as a public square, what is now Trafalgar Square was known as Royal Mews (not to be confused with the current Royal Mews, situated in the grounds of Buckingham Palace) and had been the site of numerous public executions and floggings. However, as British attitudes shifted, the land was repurposed for the building of a grand square to commemorate British military, naval and political heroes. Initial proposals for a building to house the burgeoning National Gallery's collection along the north edge of the square coincided with separate plans to include a pillared memorial dedicated to the late Vice-Admiral Nelson, whose heroic naval victories in the French Revolution and Napoleonic Wars were a source of great national pride. Nelson's Column was later sur-rounded by statues commemorating subsequent Navy admirals, as well as Kings William IV and George IV, who joined the earlier equestrian statue of Charles I on Whitehall.[18] In the development of the city, Charing Cross became a symbolic meeting point between the working-class East End and upper-class West End, yet as the centre of London, and therefore the British Empire, the language of its architecture and monuments was chosen to appeal to the dominant, ruling classes. However, in the past century, the square and its context have provided a platform for activists and protestors of an increasingly broad range of political causes (fig. 31). As historian Rodney Mace points out:

Fig. 31 A Black Lives Matter protest at Trafalgar Square in front of the National Gallery, 31 May 2020

To the mass of ordinary people whose exploitation and death through nearly three centuries had enabled the ideal of Empire to be realised, the Square offers no bronze or granite memorial; yet it is they and their descendants who in the course of time by the use of the site as a public forum have given it its real significance.[19]

By evaluating Malani's working methodology in relation to certain geographical or architectural analyses of Bath and London, we can explore where layering, annotation and the palimpsest exist in the physical cities we inhabit, and how their analysis through the same means Malani employs in her work will yield similar revelatory moments.

Returning to Flusser, Malani's work protects us from one of the risks he attaches to information stored in a digital age. He says electronic information storage will 'enhance our ability to obliterate information', while potentially stored indefinitely, electronic information can also be deleted forever, permanently wiped out with the simple click of a button.[20] While Flusser recognises the importance of being able to forget, he perhaps doesn't do enough to acknowledge that forgetting is not always benign. The paintings in the collections of the National Gallery and the Holburne Museum successfully adhere to Flusser's thesis; they 'forget more efficiently than human memories', and their display shows us only too well that the artworks have forgotten the pain and trauma associated with their production, transaction, and collection.[21] Through Malani's new animations as well as the portraits of the subaltern figures inserted between her scribed interventions, we are reminded of their reality. Her reality. And what, in truth, needs to be our reality too.

Malani's reality is our reality. At best, we just didn't know it. Or perhaps, more accurately, didn't want to acknowledge it.

1 Luke 24: 30–31, KJV.

2 For further reference, see writings by Berger 1983, Hibbard 1983, Puglisi 1998, Pericolo 2007 and Schütze 2009.

3 Marvell and Simm 2016, p. 126.

4 By the time Zoffany painted *The Auriol and Dashwood Families*, James Peter Auriol (in green, on the right) had risen through the ranks of the East India Company to become Secretary of the Governing Council of Bengal. Sophia Auriol (in pink) married John Prinsep (seated on the left), who established the indigo and cotton-printing industries in Bengal and became immensely rich. Meanwhile, Charlotte Auriol married Thomas Dashwood (depicted playing chess), who was in charge of stationery supplies.

5 Zoffany's *The Auriol and Dashwood Families* shows a scene of British colonial rule. We could, of course, broaden this conversation out to include Spain's rule over much of South America, France's exploitation of West Africa, North America (prior to the Seven Years' War) and much of South East Asia, or the Dutch hold over parts of the Caribbean and other key naval territories in Africa, North America and Asia. However, due to the nature of the two collections from which Malani has worked, the conversation when discussing colonialism focuses on British colonial power.

6 A *hookahburdar* is an Indian servant tasked with preparing their master's pipe.

7 A *sakar* is an Indian servant tasked as personal manager or caddy.

8 Fisher 2006, pp. 199 and 202.

9 For further reading on the extent of indentured labour in India under British Colonialism, see Sen 2016.

10 For a definition of subaltern, see Nalini Malani's essay 'My Reality is Different' in this catalogue, note 5, p. 55.

11 Kittler 1990, p. 369.

12 Mumford 1961, p. 569.

13 Flusser 1990, p. 398.

14 Ibid., p. 398.

15 Kittler and Griffin 1996, p. 723.

16 For further information on Angerstein's relationship to the slave trade, see the National Gallery's ongoing research: www.nationalgallery.org.uk/people/john-julius-angerstein (accessed 16 August 2022).

17 In the context of this commission, it feels pertinent to remind readers that it was Sir William Holburne's sister, Mary Anne Barbara Holburne, who facilitated the transition from private collection to public museum.

18 For further information on the development of Trafalgar Square, see Riding 2015.

19 Mace 1976, p. 19.

20 Flusser 1990, p. 399.

21 Ibid., p. 399.

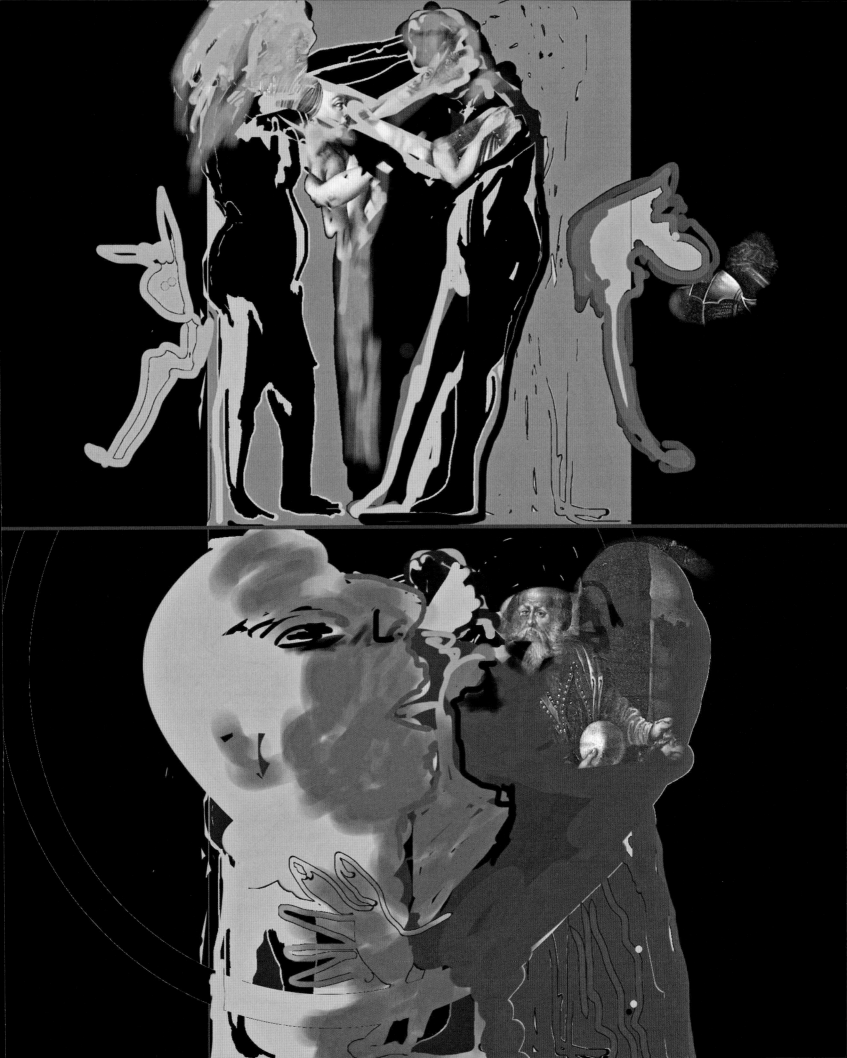

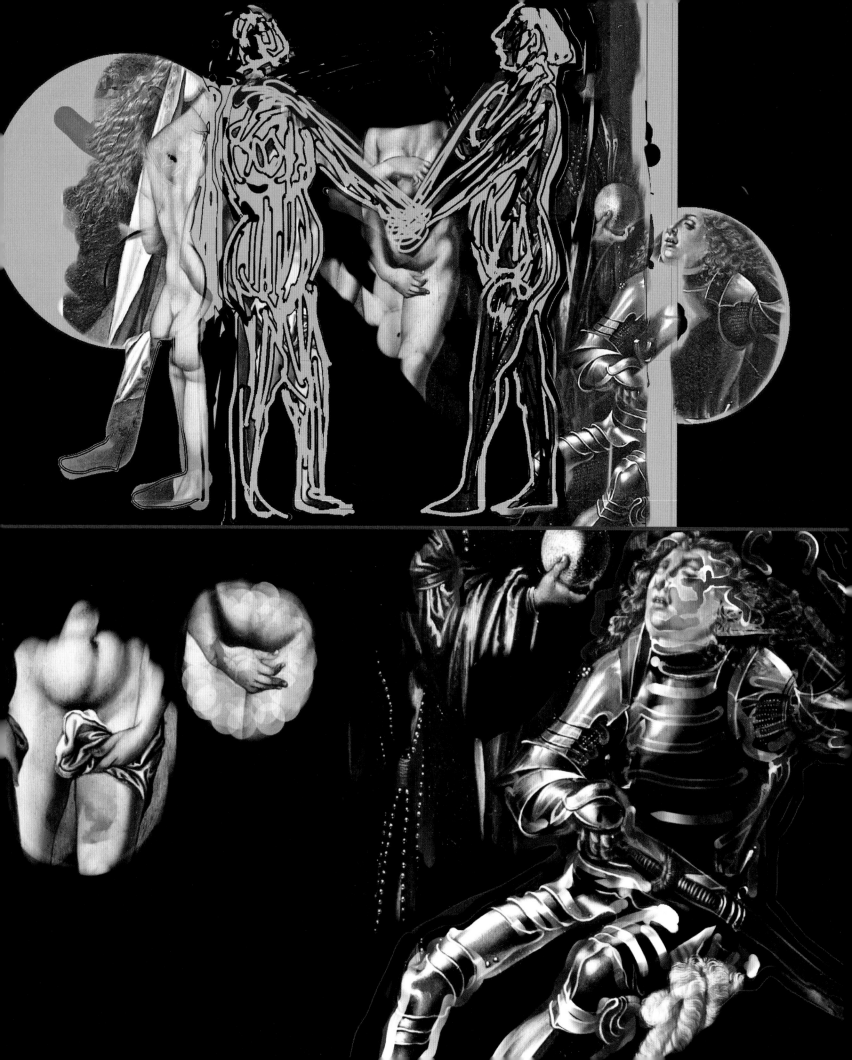

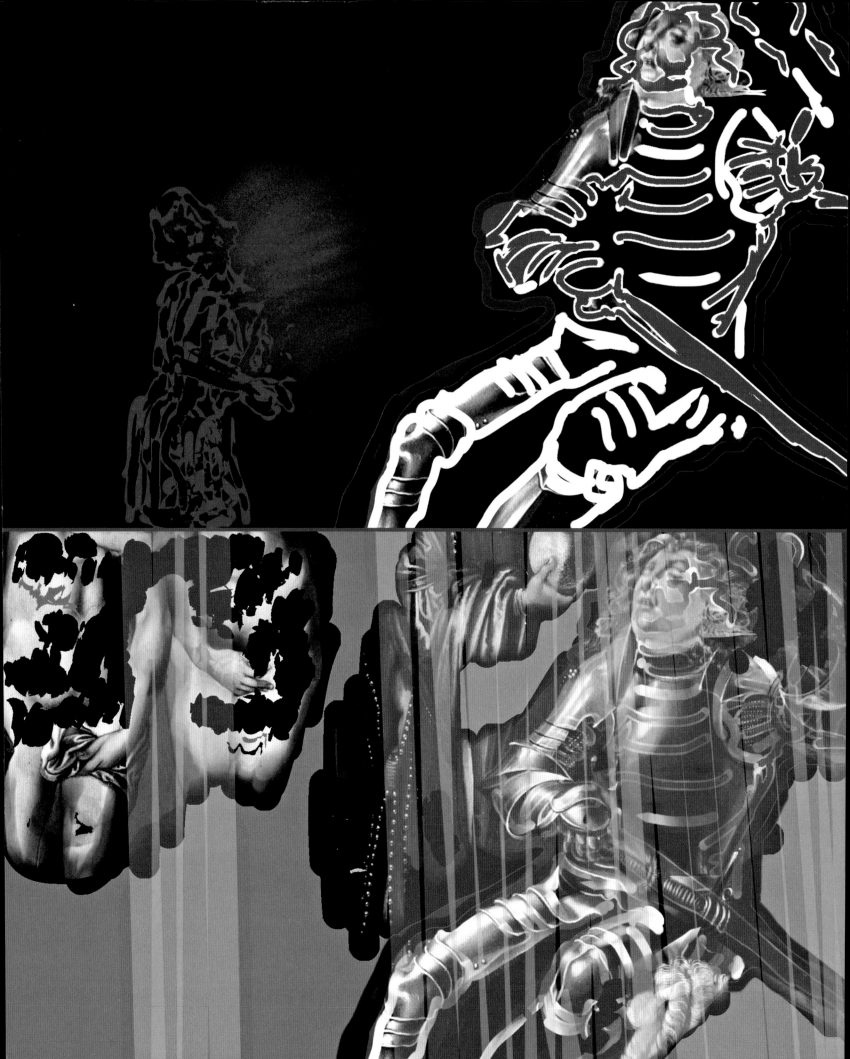

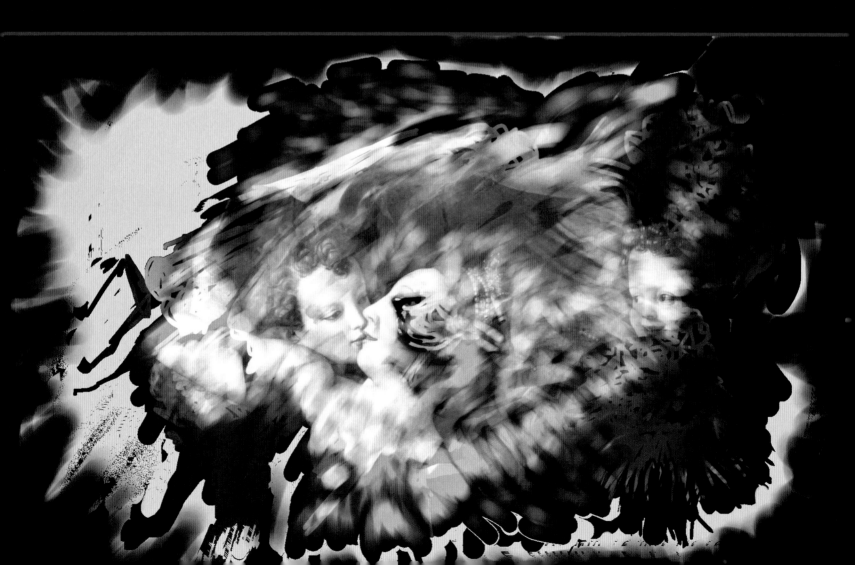

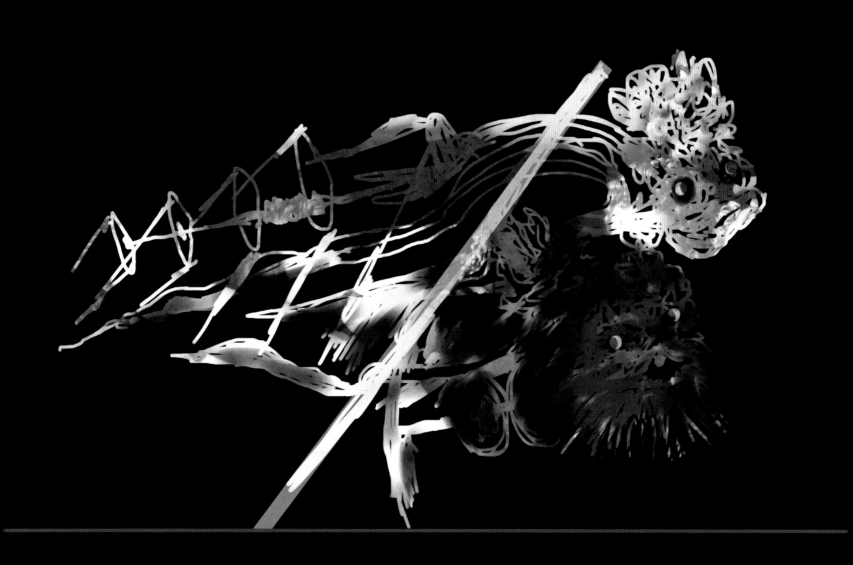
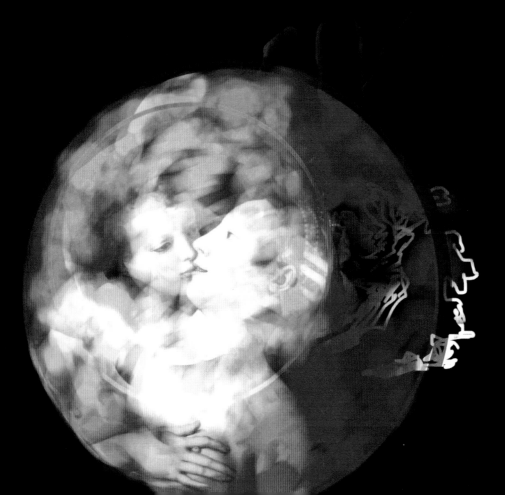

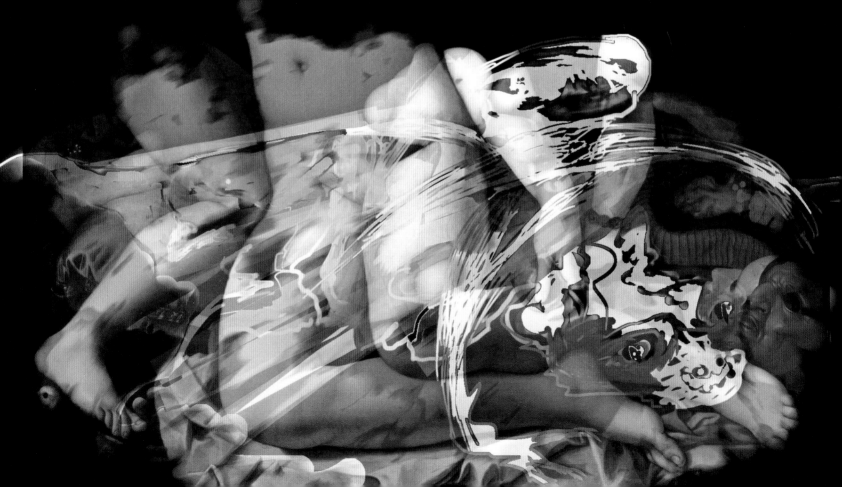

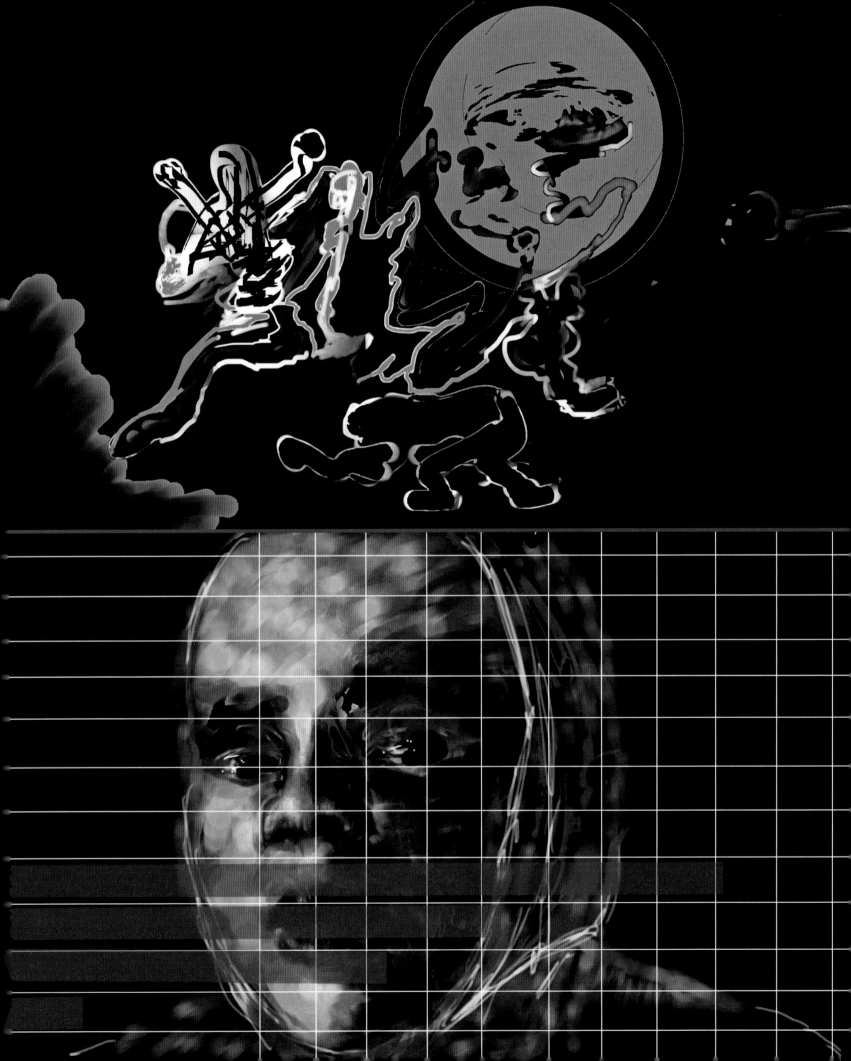

Artist's Biography

As the pioneer of video art in India, Nalini Malani has increasingly questioned conventions of painting and drawing, expanding new forms of media to reach wider audiences and speak up against the rise of political oppression. In an experimental and evolving practice that has developed across five decades, Malani has established innovative forms of immersive video installations, known as 'video plays', her signature 'video/shadow plays' and 'animation chambers'. Alongside her other pioneering art forms that continue to disregard conventional divisions between disciplines, such as her collaborative theatre plays, ephemeral wall drawings/erasure performances and multi-panel reverse paintings, Malani has embodied the role of the artist as social activist, giving voice to those marginalised or oppressed across history and the modern day. Her forms of visual storytelling focus on themes of transnational politics, the ramifications of globalisation and the critical examination of gender roles, often reimagining narratives and figures from mythologies, and referencing diverse sources of enquiry from philosophy, literature, critical theory and art history.

Malani, who lives and works in Mumbai, was born in Karachi, British India, in 1946 and was forced to leave with her family as a refugee due to Partition the following year. Their imposed poverty in a land with unfamiliar languages and cultures made relocation extremely difficult. Malani graduated from the Sir J.J. School of Art, Mumbai, in 1969, after which her practice began with cameraless photography, experimental animation and film at the Vision Exchange Workshop. In 1970–2 she studied Fine Art in Paris under a scholarship programme.

Since 2000, Malani has had five retrospectives: at Castello di Rivoli, Rivoli (2018); the Centre Pompidou, Paris (2017); the Kiran Nadar Museum of Art, New Delhi (2014); the Museé cantonal des Beaux-Arts, Lausanne (2010); and the Peabody Essex Museum, Salem (2004). In this same period, she has also had over 15 solo exhibitions at museums including M+, Hong Kong (2022); the Kunstmuseum Den Haag, The Hague (2021); Whitechapel Gallery, London (2021); the Fundació Joan Miró, Barcelona (2020); the Dr. Bhau Daji Lad Mumbai City Museum, Mumbai (2020); the Stedelijk Museum, Amsterdam (2017); the Institute of Contemporary Art, Boston (2016); the Art Gallery of New South Wales, Sydney (2012); and the New Museum of Contemporary Art, New York (2002). In 2019 she won the Joan Miró Prize, Barcelona; in 2016 the Asian Art Game Changers Award, Hong Kong; in 2014 the St. Moritz Art Masters Lifetime Achievement Award; and in 2013 the Fukuoka Arts and Culture Prize.

Malani was awarded the 2022 National Gallery Contemporary Fellowship with Art Fund, in collaboration with the Holburne Museum, Bath. The fellowship was awarded by an international jury, comprised of Daniel F. Herrmann, Curator of Modern and Contemporary Projects, the National Gallery, London; Sunjung Kim, President, Gwangju Biennale Foundation; Charlotte Klonk, Professor of Art History and New Media, Humboldt University of Berlin; Patrizia Sandretto Re Rebaudengo, President, Fondazione Sandretto Re Rebaudengo, Turin; Chris Stephens, Director, the Holburne Museum; and Richard Wentworth, artist.

Exhibited Artwork

My Reality is Different, 2022

Animation chamber, 9-channel installation, sound: 25:15 mins

Channel 1: 3:47 mins, looped. Visual sources: *Christ Mocked (The Crowning with Thorns)* by Bosch, *The Adoration of the Kings* by Bruegel the Elder and *Pietà* possibly by workshop of van der Weyden.
Channel 2: 3:47 mins, looped. Visual sources: *Boy bitten by a Lizard*, *The Supper at Emmaus* and *Salome receives the Head of John the Baptist* by Caravaggio.
Channel 3: 6:56 mins, looped. Visual sources: *The Way to Calvary* by Bassano, *The Deposition* by the Master of the Saint Bartholomew Altarpiece, *'The Manchester Madonna'* by Michelangelo and *The Annunciation* by Strozzi.

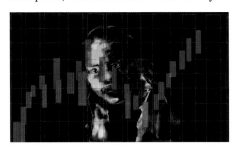 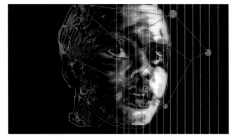

Channel 4: 3:50 mins, looped. Visual sources: *The Judgement of Paris* from the German School and *An Allegory with Venus and Cupid* by Bronzino.
Channel 5: 3:09 mins, looped. Visual sources: *Lot and his Daughters leaving Sodom*, *Susannah and the Elders* and *Saint Mary Magdalene* by Reni.
Channel 6: 3:06 mins, looped. Visual sources: *The Temptation of Saint Anthony* by van der Venne, *Perseus turning Phineas and his Followers to Stone* by Giordano and *Samson and Delilah* by Rubens.

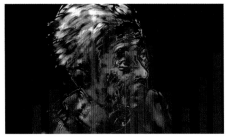 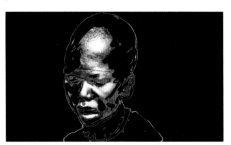 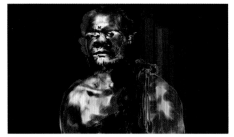

Channel 7: 4:29 mins, looped. Visual sources: *The Execution of Lady Jane Grey* by Delaroche, *The Ambassadors* by Holbein the Younger and *An Experiment on a Bird in the Air Pump* by Wright 'of Derby'.
Channel 8: 2:45 mins, looped. Visual sources: *The Effects of Intemperance* by Jan Steen and *Still Life: An Allegory of the Vanities of Human Life* by Steenwyck.
Channel 9: 3:20 mins, looped. Visual sources: *The Auriol and Dashwood Families* by Zoffany and *The Family of Darius before Alexander* by Veronese.

Audio Transcription

IT WAS HERE.
This is where she stood.
The stone lions looked at her.
Now they no longer have heads.

The walls, today as in the past, the gate, where no trace of blood can be seen seeping out from beneath.
Into the darkness. Into the slaughterhouse. And alone.

Keeping step with the story, I make my way into death.

Why did I want the gift of prophecy? To speak with my voice? There's something of everyone in me, so I have belonged completely to no one. I have even understood their hatred for me.

Troy's end was in sight. We were lost. Aeneas had pulled out with his people.
What I grasp between now and evening will perish with me.
'She's laughing!' I hear the women say. They do not know I speak their language.

Who was Penthesilea?
I knew Penthesilea was going to fall in battle. I rejoiced to see her, a woman, put on her weapons. Who will find a voice again, and when?
You are lying, when you prophesy we're all doomed. War gives its people their shape.
Nothing left to describe the world but the language of the past. The language of the present has shrivelled.
The language of the future. Today, I will be killed. A lie is to change one's image of oneself.
Apollo – he conferred on me the gift of prophecy. Then approached me as a man.
Due to my terror, he transformed into a wolf with mice, spat furiously into my mouth.

Dream image: the sea was burning.
The last thing in my life will be a picture, not a word.
How many realities were there in Troy beside mine?
One day I announced, Troy will fall.

A hot terror.

Will I split myself in two until the end – will I? I, the unbeliever.
If Apollo spits into your mouth that means you have the gift to see the future, but no one will believe you.
Craving for more and more events, finally, for war. That was the first thing I really saw.

Helenus. Oh Helenus, my brother. Identical in appearance, the image of me if I'd been a man. I stopped being a Trojan when I was caged in the basket. Now that Troy no longer exists, I am one again – a Trojan woman.

Image: a boy in white leading a young white bull by the cord.
The first cycle, I set my voice free. Oh, Aeneas, limbs shaking out of control, I clung to him.

I am very tired. I haven't had a solid sleep for days.
The wide-open eyes of my dead brothers, the eyes of Penthesilea – my father's open dead eyes. Didn't see my sister's dead eyes – like ants we walk into every fire, water, river of blood, so as not to have to see – what? Ourselves.

The place had no doors – a palace of silence, unlike this by-world – counter-world – carefree.

The vengeance of Clytemnestra rose up huge. Security net, a new word – mental armament is defamation of the enemy, tragedy to burlesque.
Don't treat yourself as tragic. When I see, I saw time stood still; the ultimate split from myself.

DO NOT LET THE SHIPS DEPART.

Eumelos' men dragged me out. Black both day and night. Dark milk, bitter water, sour bread. I ate with my fingers like an animal. My hair filthy around my head.

COME TO THE SURFACE, CASSANDRA.
I hissed at her like a cat.

Helen – the name struck us like a blow. Beautiful, beautiful Helen.
I saw how a news report was manufactured. Ten years of war, enough to forget how it was started. When Paris arrived on an Egyptian ship, he took a heavily veiled woman off board.
Helen, Helen – Helen didn't show herself. I refuse to recognise, there was no beautiful Helen in Troy. The name tasted of ashes, gangrene, decay. She doesn't exist. There is no Helen. Father, no one can win a war waged for a phantom.
WHY NOT?
End this war.
SHE'S MAD.

Now, his wife is butchering Agamemnon. It will be my turn. Kill me, Clytemnestra.
Hurry.
If I still have time, I should speak of my body.
One coil in the rope that bound me snapped.

Achilles, let the earth vomit his ashes.

Time is running out, I'm very tired.
I have a fear memory.
A feeling memory.
The war gave birth to abortions.
I was living what my brother Hector became, DEAD.
Achilles cremated his beloved Patroclus.
He butchered twelve captives as sacrifice. Thirteen funeral pyres.
Red flames, black sky.
No. The only word left to me.
Between killing and dying as a third alternative.
LIVING.

Penthesilea and her women had only one breast. They'd burned out the other to hold their bows better. Achilles, amazed, saw a woman greet him with a sword. She scratched him with her dagger, forced him to kill her. He had horses drag her across the fields. The Greek hero desecrates the dead woman. Amazons, Trojan women, nothing but women. The howling was in their hair, teeth, fingernails. The rhythm transferred to me.

Exit from time.
You will keep silent.
NO.

My father, King Priam, said, 'Seize her!'
Her place uncanny.
Mustn't lose my mind now. My voice.

The underworld. A snake twisted herself round my neck.
You don't agree?
NO.
You will keep silent.
NO.

One day, the woman pushed something into me. Wood.
When I got out, I couldn't tolerate the light.
I saw Penthesilea naked, covered with scars.
My skin was smooth until the end.
Until now.
No one recognised me in the streets of Troy.
I know they'll be coming soon.

Paris was wounded. Paris is DEAD.
I went to my brother's funeral.
Wanted to see Troy again and found a grave – ghosts.
The collapse came swiftly.
The people believed what they saw, not what they knew.
My sister screamed and sang. We stopped her mouth with dough.

Ajax was on top of me.
And Hecuba, my mother, as they held her fast, uttered curses.
'A BITCH,' yelled Ajax, 'THE QUEEN OF THE TROJANS IS A HOWLING BITCH.'

The Greeks will tell their own version of what happened. Blood flowed.
The wail Troy uttered! I've heard it since, night and day.

Ajax raped me in the grave of the HEROES.
YES, that's how it was.
Now the light is coming.

I stood on the wall with Aeneas. He tried to order me to leave. Leave the city with our children, to found
a new Troy somewhere else.
'The new masters would dictate their laws to us,' I said. 'You were their leader. You will have to become
a hero.'
I can't love a hero.
I don't want to see you being transformed into a statue.

I'm staying behind.
The light went out – is going out.
They're coming.

HERE'S THE PLACE.
These stone lions looked at her.
They seem to move in the shifting light.

Text adapted by Nalini Malani and Alaknanda Samarth from *Cassandra: A Novel and Four Essays* by Christa Wolf.

In *My Reality is Different*, the audio of Samarth's performance is accompanied by a complex soundscape of a large sailing ship in a storm, combined with drums, the patriotic song 'Rule, Britannia!' and the voice of an Indian woman, singing a phrase from a folk song recorded in the Buddhist caves at Kanheri in Bombay.

List of Visual Sources

The Holburne Museum, Bath

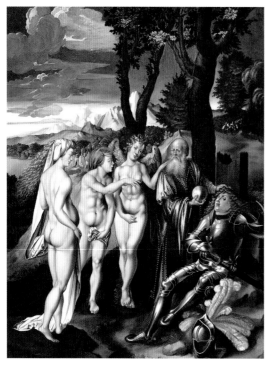

1 **German School**
The Judgement of Paris,
mid-sixteenth century
Oil on panel, 52.3 × 39.7 cm
A154

2 **Jan van der Venne**
(active 1616; died before 1651)
The Temptation of Saint Anthony
Oil on panel, 53.1 × 73.7 cm
A35

3 **Johann Zoffany** (1733–1810)
The Auriol and Dashwood Families,
about 1783–7
Oil on canvas, 142 × 198 cm
L2013.1

The National Gallery, London

4 **Jacopo Bassano**
(active about 1535; died 1592)
The Way to Calvary, about 1544–5
Oil on canvas, 145.3 × 132.5 cm
NG 6490

5 **Hieronymus Bosch**
(living 1474; died 1516)
Christ Mocked (The Crowning with Thorns), about 1510
Oil on oak, 73.8 × 59 cm
NG 4744

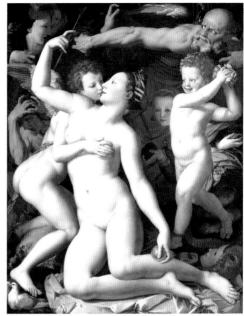

6 **Pieter Bruegel the Elder**
(active 1550/1; died 1569)
The Adoration of the Kings, 1564
Oil on oak, 112.1 × 83.9 cm
NG 3556

7 **Bronzino** (1503–1572)
An Allegory with Venus and Cupid,
about 1545
Oil on wood, 146.1 × 116.2 cm
NG 651

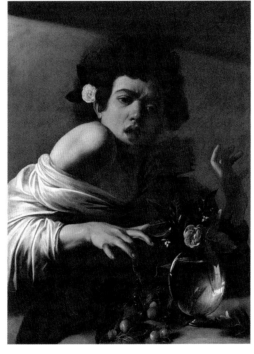

8 **Michelangelo Merisi da
Caravaggio** (1571–1610)
Boy bitten by a Lizard, about 1594–5
Oil on canvas, 66 × 49.5 cm
NG 6504

9 **Michelangelo Merisi da
Caravaggio** (1571–1610)
The Supper at Emmaus, 1601
Oil and tempera on canvas,
141 × 196.2 cm
NG 172

10 **Michelangelo Merisi da
Caravaggio** (1571–1610)
*Salome receives the Head of John the
Baptist*, about 1609–10
Oil on canvas, 91.5 × 106.7 cm
NG 6389

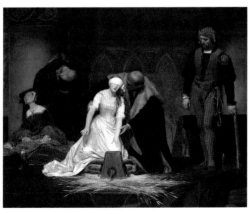

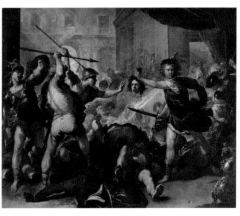

11 **Paul Delaroche** (1797–1856)
The Execution of Lady Jane Grey, 1833
Oil on canvas, 246 × 297 cm
NG 1909

12 **Luca Giordano** (1634–1705)
*Perseus turning Phineas and his
Followers to Stone*, about 1660
Oil on canvas, 285 × 366 cm
NG 6487

13 **Hans Holbein the Younger**
(1497/8–1543)
*Jean de Dinteville and Georges de
Selve ('The Ambassadors')*, 1533
Oil on oak, 207 × 209.5 cm
NG 1314

14 **Master of the Saint Bartholomew
Altarpiece** (active about 1470 to
about 1510)
The Deposition, about 1500–5
Oil on oak, 74.9 × 47.3 cm
NG 6470

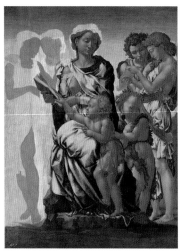

15 **Michelangelo** (1475–1564)
*The Virgin and Child with Saint
John and Angels ('The Manchester
Madonna')*, about 1494
Tempera on wood, 104.5 × 77 cm
NG 809

16 **Guido Reni** (1575–1642)
*Lot and his Daughters leaving
Sodom*, about 1614–15
Oil on canvas, 111.2 × 149.2 cm
NG 193

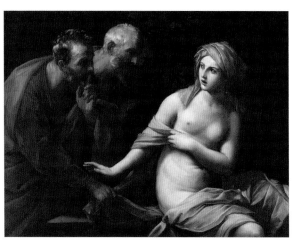

17 **Guido Reni** (1575–1642)
Susannah and the Elders,
about 1622–3
Oil on canvas, 116.6 × 150.5 cm
NG 196

18 **Guido Reni** (1575–1642)
Saint Mary Magdalene,
about 1634–5
Oil on canvas, 79.3 × 68.5 cm
NG 177

19 Peter Paul Rubens (1577–1640)
Samson and Delilah, about 1609–10
Oil on wood, 185 × 205 cm
NG 6461

20 Jan Steen (1626–1679)
The Effects of Intemperance,
about 1663–5
Oil on wood, 76 × 106.5 cm
NG 6442

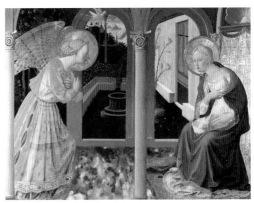

21 Harmen Steenwyck (1612–1656)
Still Life: An Allegory of the Vanities of Human Life, about 1640
Oil on oak, 39.2 × 50.7 cm
NG 1256

22 Zanobi Strozzi (1412–1468)
The Annunciation, about 1440–5
Egg tempera on wood, 104.5 × 142 cm
NG 1406

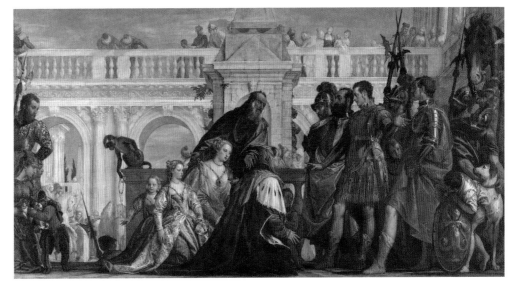

23 Paolo Veronese (1528–1588)
The Family of Darius before Alexander, 1565–7
Oil on canvas, 236.2 × 474.9 cm
NG 294

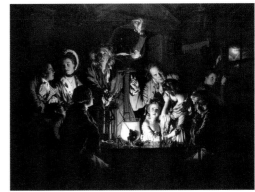

24 Probably by the workshop of Rogier van der Weyden
(about 1399–1464)
Pietà, probably about 1465
Oil with egg tempera on oak,
35.5 × 45 cm
NG 6265

25 Joseph Wright 'of Derby'
(1734–1797)
An Experiment on a Bird in the Air Pump, 1768
Oil on canvas, 183 × 244 cm
NG 725

References

van Alphen 2022
E. van Alphen, *Seven Logics of Sculpture*, Amsterdam 2022

van Alphen 2020
E. van Alphen, *Shame! and Masculinity*, Amsterdam 2020

van Alphen 1993
E. van Alphen, *Francis Bacon and the Loss of Self*, Cambridge, MA, 1993

Armitage 2000
D. Armitage, *The Ideological Origins of the British Empire (Ideas in Context)*, Cambridge 2000

Artaud 1958
A. Artaud, *The Theater and Its Double*, New York 1958

Baker and Henry 1995
C. Baker and T. Henry, *The National Gallery: Complete Illustrated Catalogue*, London 1995

Bal 2022
M. Bal, *Image-Thinking: Artmaking as Cultural Analysis*, Edinburgh 2022

Bal 2021
M. Bal, *Narratology in Practice*, Toronto 2021

Bal 2017
M. Bal, 'Intership: Anachronism between Loyalty and the Case', in T. Leitch (ed.), *The Oxford Handbook of Adaptation Studies*, New York and Oxford 2017, pp. 179–96

Bal 2016
M. Bal, *In Medias Res: Inside Nalini Malani's Shadow Plays*, Ostfildern 2016

Bal 1999
M. Bal, *Quoting Caravaggio: Contemporary Art, Preposterous History*, Chicago 1999

Bal 1987
M. Bal, *Lethal Love: Feminist Literary Readings of Biblical Love Stories*, Bloomington and Indianapolis 1987

Barthes 1981
R. Barthes, *Camera Lucida: Reflections on Photography*, trans. R. Howard, New York 1981

Benveniste 1971
E. Benveniste, *Problems in General Linguistics*, trans. M.E. Meek, Coral Gables 1971

Berger 1983
J. Berger, 'Caravaggio: A Contemporary View', *Studio International*, 196, no. 998 (1983)

Bergson 1991
H. Bergson, *Matter and Memory*, trans. N.M. Paul and W.S. Palmer, New York 1991 (1896)

Brook 2008
T. Brook, *Vermeer's Hat: The Seventeenth Century and the Dawn of the Global World*, New York 2008

Bruhn and Schirrmacher 2022
J. Bruhn and B. Schirrmacher (eds), *Intermedial Studies: An Introduction to Meaning Across Media*, London and New York 2022

Buci-Glucksmann 1994
C. Buci-Glucksmann, *Baroque Reason: The Aesthetics of Modernity*, trans. P. Camiller, with an introduction by B.S. Turner, London, Thousand Oaks and New Delhi 1994 (1984)

Colah 2012
Z. Colah (ed.), *Nalini Malani: In Search of Vanished Blood*, Ostfildern 2012

Conlin 2006
J. Conlin, *The Nation's Mantelpiece: A History of the National Gallery*, London 2006

Damisch 1994
H. Damisch, *The Origin of Perspective*, trans. J. Goodman, Cambridge, MA, 1994 (1987)

Das 2020
V. Das, *Textures of the Ordinary: Doing Anthropology after Wittgenstein*, Hyderabad 2020

Das 1998
V. Das, *Social Suffering*, New Delhi 1998

Das 1996a
V. Das, *Critical Events: An Anthropological Perspective on Contemporary India*, New Delhi 1996

Das 1996b
V. Das, 'Language and Body: Transactions in the Construction of Pain', *Daedalus*, 125, no. 1 (1996), pp. 67–91

von Drathen 2010
D. von Drathen, 'The Continuous Flow of Living Presence', in *Nalini Malani: Splitting the Other: Retrospective 1992–2009*, Ostfildern 2010, pp. 25–32

Elleström 2021
L. Elleström (ed.), *Beyond Media Borders: Intermedial Relations among Multimodal Media*, vols 1 and 2, Basingstoke 2021

Elleström 2019
L. Elleström, *Transmedial Narration: Narratives and Stories in Different Media*, Basingstoke 2019

Faiz 1991
F.A. Faiz, *The Rebel's Silhouette*, Amherst 1991

Fanon 1963
F. Fanon, *The Wretched of the Earth*, New York 1963

Fibicher 2022
B. Fibicher (ed.), *Resistance Anew: Artworks, Culture, & Democracy*, Lausanne 2022

Fisher 2006
M.H. Fisher, 'Bound for Britain: Changing Conditions of Servitude, 1600–1857', in I. Chatterjee and R. Eaton (eds), *Slavery & South Asian History*, Bloomington 2006, pp. 187–209

Flusser 1990
V. Flusser, 'On Memory (Electronic or Otherwise)', *Leonardo*, 23, no. 4 (1990), pp. 397–9

Fryer 2018
P. Fryer, *Staying Power: The History of Black People in Britain*, London 2018

Gatens and Lloyd 1999
M. Gatens and G. Lloyd, *Collective Imaginings: Spinoza, Past and Present*, London and New York 1999

Gombrich 1950
E. Gombrich, *The Story of Art*, New York 1950

Grieder 1996
T. Grieder, *Artist and Audience*, Madison 1996 (2nd edn)

Guha 2007
R. Guha, *India After Gandhi: The History of the World's Largest Democracy*, London 2007

Hibbard 1983
H. Hibbard, *Caravaggio*, New York 1983 (1st edn)

Kapur 2007
G. Kapur, 'Secular Artist, Citizen Artist', in W. Bradley and C. Esche (eds), *Art and Social Change: A Critical Reader*, London 2007, pp. 422–39

Kapur 2000
G. Kapur, *When Was Modernism: Essays on Contemporary Cultural Practice in India*, New Delhi 2000

Kapur and Cossman 1996
R. Kapur and B. Cossman (eds), *Subversive Sites: Feminist Engagements with Law in India*, New Delhi 1996

Khullar 2015
S. Khullar, *Worldly Affiliations: Artistic Practice, National Identity, and Modernism in India, 1930–1990*, Oakland 2015
Kittler 1990
F. Kittler, *Discourse Networks 1880/1900*, Stanford 1990
Kittler and Griffin 1996
F.A. Kittler and M. Griffin, 'The City Is a Medium', *New Literary History*, 27, no. 4 (Autumn 1996), pp. 717–29
Kubler 1962
G. Kubler, *The Shape of Time: Remarks on the History of Things*, New Haven 1962

Langmuir 2016
E. Langmuir, *The National Gallery Companion Guide*, London 2016
London 2020–1
E. Butler (ed.) with I. Costa and J. Pijnappel, *Nalini Malani: Can You Hear Me?*, exh. cat., Whitechapel Gallery, London 2020
Lyotard 2020
J.-F. Lyotard, *Discourse, Figure*, trans. A. Hudek and M. Lydon, Minneapolis 2020 (1971)

Mace 1976
R. Mace, *Trafalgar Square: Emblem of Empire*, London 1976
Marin 1995
L. Marin, *To Destroy Painting*, trans. M. Hjort, Chicago 1995 (1977)
Marvell and Simm 2016
A. Marvell and D. Simm, 'Unravelling the Geographical Palimpsest through Fieldwork: Discovering a Sense of Place', *Geography*, 101, no. 3 (2016), pp. 125–36
McEvilley 2002
T. McEvilley, *The Shape of Ancient Thought: Comparative Studies in Greek and Indian Philosophies*, New York 2002
McEvilley 1992
T. McEvilley, *Art & Otherness: Crisis in Cultural Identity*, New York 1992
McLuhan 2001
M. McLuhan, *Understanding Media: The Extensions of Man*, London and New York 2001 (1964)
Mitchell 2021
W.J.T. Mitchell, 'Present Tense 2020: An Iconology of the Epoch', *Critical Inquiry*, 47 (2021), pp. 371–406
Mumbai 1973
A. Jussawalla in *Nalini Malani*, exh. cat., Pundole Art Gallery, Mumbai 1973
Mumford 1961
L. Mumford, *The City in History: Its Origins, its Transformations, and its Prospects*, New York 1961

Needham and Rajan 2007
A.D. Needham and R.S. Rajan (eds), *The Crisis of Secularism in India*, Durham, NC, 2007

New Delhi 2014
R. Karode (ed.), *Nalini Malani: You Can't Keep Acid in a Paper Bag, 1969–2014*, exh. cat., Kiran Nadar Museum of Art, New Delhi 2014

Pereira and Seabrook 1994
W. Pereira and J. Seabrook, *Global Parasites: Five Hundred Years of Western Culture*, Bombay 1994
Pericolo 2007
L. Pericolo, 'Visualizing Appearance and Disappearance: On Caravaggio's London *Supper at Emmaus*', *The Art Bulletin*, 89 (2007), pp. 519–39
Pijnappel 2016
J. Pijnappel, 'Utopia: Nalini Malani's Rediscovered Films from the Period 1969–1976', *MIRAJ*, 4:1/4:2 (2016), pp. 198–215
Pijnappel 2012
J. Pijnappel, 'Selected Biography: Compulsions toward a Filmic View', in Colah 2012, pp. 60–86
Procter 2020
A. Procter, *The Whole Picture: The Colonial Story of the Art in Our Museums & Why We Need to Talk about It*, London 2020
Puglisi 1998
C.R. Puglisi, *Caravaggio*, London 1998

Ramanujan 1987
A.K. Ramanujan, 'Three Hundred Rāmāyaṇas: Five Examples and Three Thoughts on Translation', in *The Collected Essays of A.K. Ramanujan*, Oxford 1987, pp. 131–60
Riding 2015
C. Riding, 'Public Memorials, Symbolic Spaces', in C. Riding (ed.), *Art and the War at Sea: 1914–1945*, London 2015, pp. 168–79
Rodowick 2001
D.N. Rodowick, *Reading the Figural, or, Philosophy after the New Media*, Durham, NC, and London 2001

Sambrani 2004
C. Sambrani, 'Nalini Malani: Apocalypse Recalled': www.nalinimalani.com/texts/chaitanya.htm
Sambrani 1997
C. Sambrani, 'The Medeaprojekt and Beyond', reprinted in New Delhi 2014, pp. 150–63
Schor 1987
N. Schor, *Reading in Detail: Aesthetics and the Feminine*, New York and London 1987
Schor 1980
N. Schor, 'Le détail chez Freud', *Littérature*, 37 (1980), pp. 3–14
Schütze 2009
S. Schütze, *Caravaggio: The Complete Works*, Cologne 2009
Sen 2016
S. Sen, 'Indentured Labour from India in

the Age of Empire', *Social Scientist*, 44, no. 1/2 (2016), pp. 35–74
Sharma 2003
J. Sharma, *Hindutva: Exploring the Idea of Hindu Nationalism*, New Delhi 2003
Słoboda and Jędrzejczyk 2021
K. Słoboda and M. Jędrzejczyk, *Katarzyna Kobro: The Movement of Space-Time*, Lodz and Cologne 2021
Spivak 1988
G.C. Spivak, 'Can the Subaltern Speak?', in C. Nelson and L. Grossberg (eds), *Marxism and the Interpretation of Culture*, Basingstoke 1988
Szymborska 2015
W. Szymborska, *Map: Collected and Last Poems*, Boston, MA, and New York 2015

van der Tuin and Verhoeff 2022
I. van der Tuin and N. Verhoeff, *Critical Concepts for the Creative Humanities*, London 2022

Weber 1992
C. Weber (ed.), *Hamletmachine and Other Texts for the Stage by Heiner Müller*, New York 1992
Willett 1964
J. Willett (ed. and trans.), *Brecht on Theatre: The Development of an Aesthetic*, London 1964
Wolf 1984
C. Wolf, *Cassandra: A Novel and Four Essays*, London 1984

Zamindar 2007
V.F.-Y. Zamindar, *The Long Partition and the Making of Modern South Asia: Refugees, Boundaries, Histories*, New York and Chichester 2007

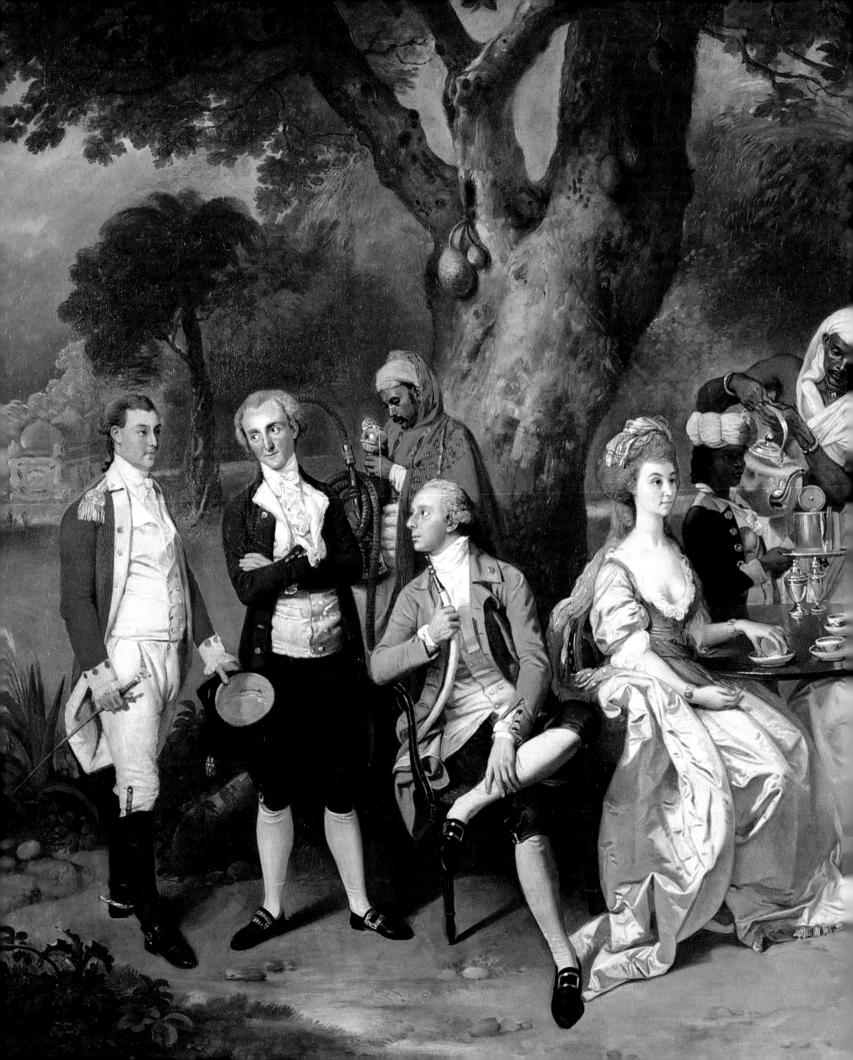

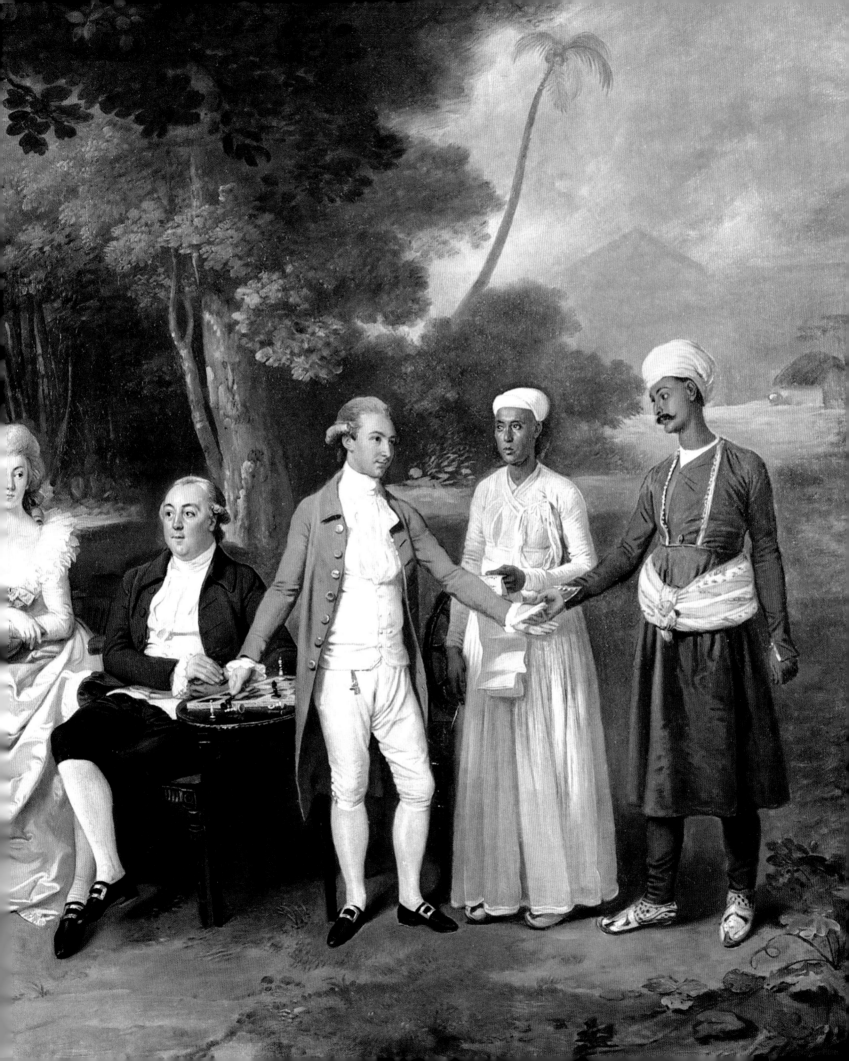

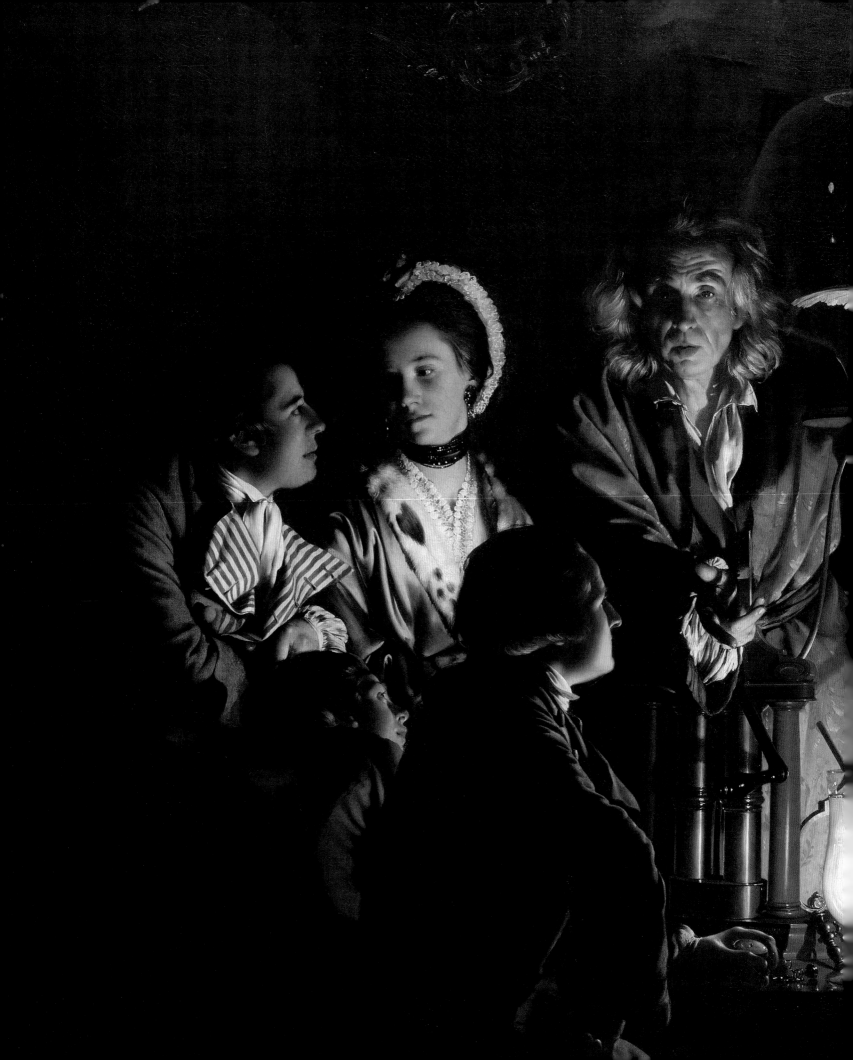

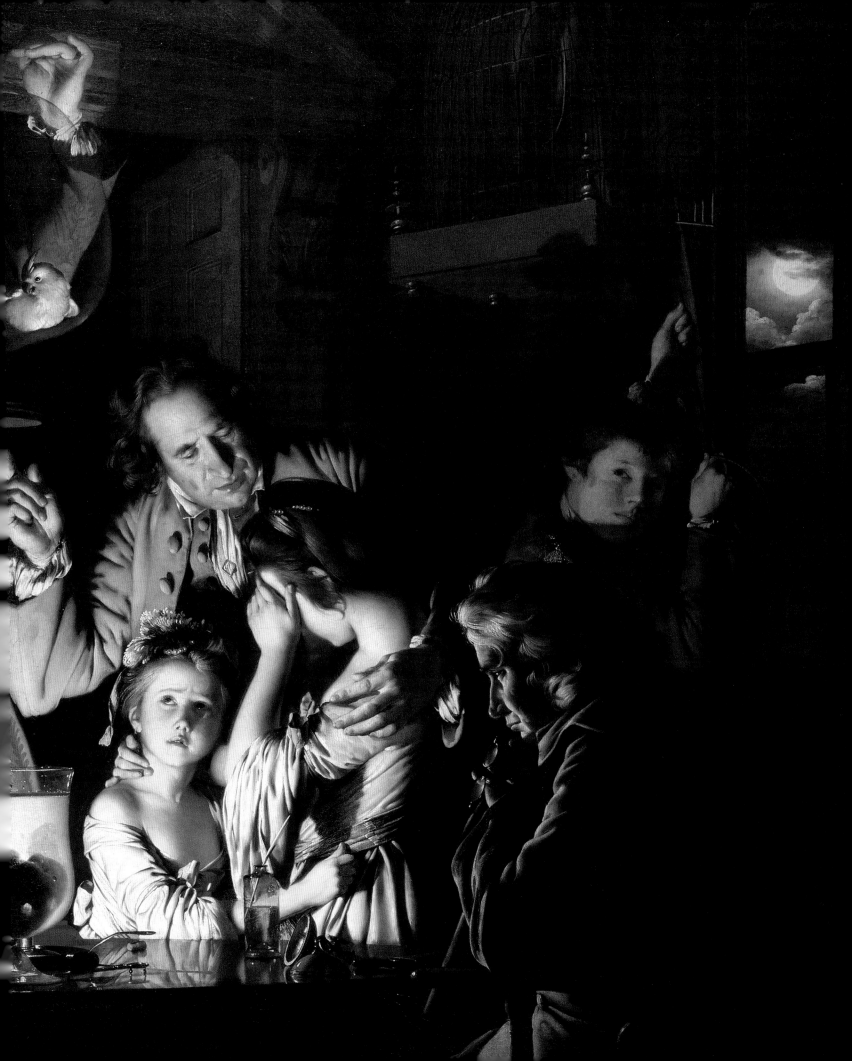

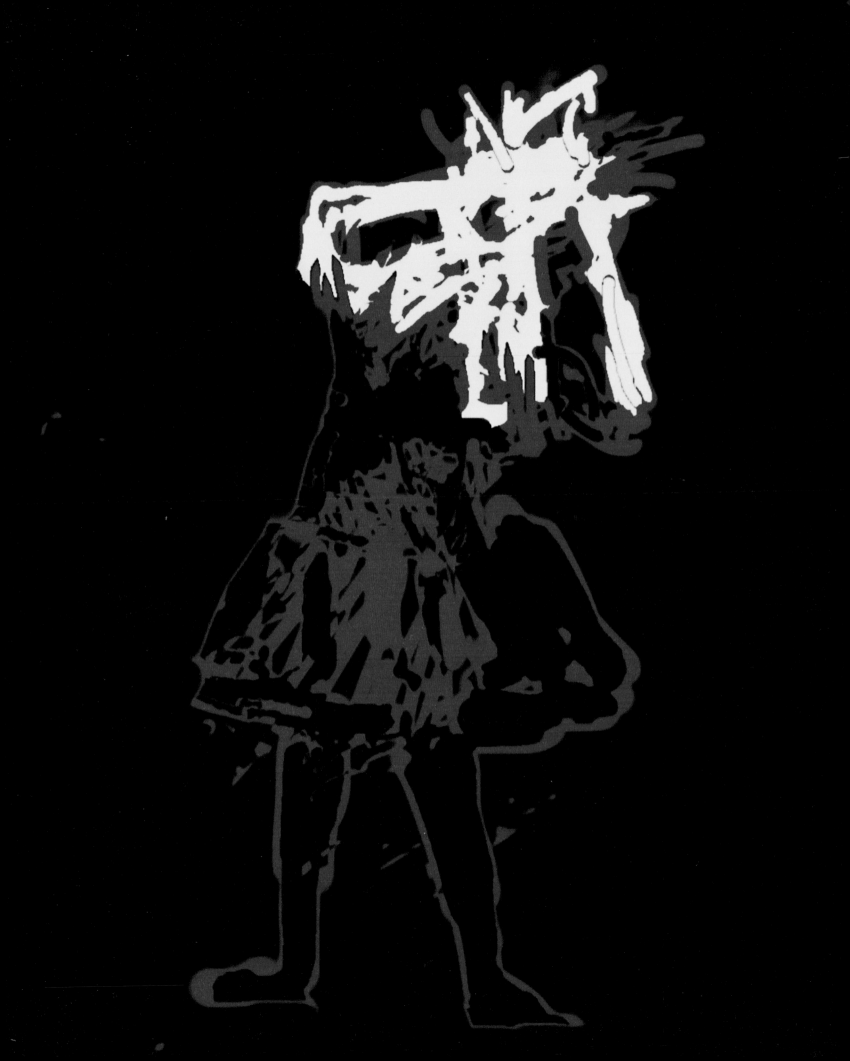